THE SHORT STORY OF PHOTO-GRAPHY

LAURENCE KING

Published in 2018
by Laurence King Publishing Ltd
361–373 City Road
London EC1V 1LR
Tel +44 20 7841 6900
Fax +44 20 7841 6910
E enquiries@laurenceking.com
www.laurenceking.com

A catalogue record for this book is available from the British Library.

ISBN 978-1-78067-7201-0
Designed by John Round Design
Printed in China

p.10 *After the Bath, Woman Drying her Back*, Edgard Degas
p.44 *The Kiss at the Hotel de Ville* (detail), Robert Doisneau
p.154 *James Dean on Times Square* (detail), Dennis Stock
p.188 *Ceylon*, Anna Atkins and Anne Dixon

THE SHORT STORY OF PHOTO-GRAPHY

A Pocket Guide to Key Genres, Works, Themes & Techniques

Ian Haydn Smith

Laurence King Publishing

Contents

Introduction

HENRI CARTIER-BRESSON: 'IT IS AN ILLUSION THAT PHOTOS ARE MADE WITH THE CAMERA... THEY ARE MADE WITH THE EYE, HEART AND HEAD.'

Photography can hold a mirror up to the world or delve within, exploring the complexity of human psychology and emotions. It can capture a fleeting moment or mark the slow passage of time. Across its almost 200-year existence, it has developed faster than any other visual art.

The first cameras appeared at a time of great industrial change. Some people embraced photography as an adjunct to fine art, while others regarded it as a tool to capture the reality of everyday life. But both groups saw it as a serious discipline that required time and attention. This early splintering of approaches became manifold at the beginning of the twentieth century, as various artistic and design movements embraced photography, experimenting with both form and technique. The medium's commercial potential was also recognized, first in the selling of newspapers, then in the nascent worlds of fashion and advertising. These various arenas often intersected, as some photographers financed their personal work through commercial projects and commercial photographers or photojournalists saw their corpus recognized as art.

This book presents a brief history of photography, highlighting the most significant genres and styles in the medium's development. It traces the technological advances that witnessed the early camera obscura's transformation into the modern digital SLR. And it highlights 50 key works, from Pictorialism and photojournalism to abstraction and straight photography, which have had an indelible impact on the course photography has taken. It is not an exhaustive history, but it highlights how important photography has become in understanding the world around us.

Genres

ROBERT CAPA: 'IF YOUR PICTURES AREN'T GOOD ENOUGH, YOU AREN'T CLOSE ENOUGH.'

No specific style or movement has completely dominated the history of photography. In the early years, there was a significant division between those interested in accurately representing the world around them and photographers keen to embrace the aesthetic principles of fine art. Subsequent

movements often embellished one of these positions or existed in contrast to them. As styles changed, many photographers associated with one specific movement shifted their focus, as evinced by the work of Alfred Stieglitz, who, like Henry Peach Robinson, was one of the pioneers of Pictorialism, but later distanced himself from it, instead embracing abstraction and a modernist mode of photographic representation and expression.

This section not only focuses on the aesthetic approaches to photographic practice, but also marks the ideological and commercial development of the medium, from photojournalism, paparazzi photography and propaganda, to advertising, fashion and politics. It traces developments in science and nature, as well as the shift in subject and style in portraiture, from the pioneering work of Nadar in the late nineteenth century to the appearance of the selfie.

The Works

EVE ARNOLD: 'WHAT I HAVE TRIED TO DO IS INVOLVE THE PEOPLE I WAS PHOTOGRAPHING… IF THEY WERE WILLING TO GIVE, I WAS WILLING TO PHOTOGRAPH.'

Among the trillions of photographs taken since Nicéphore Niépce's shot through the window of his family home in 1826, a key number of images stand out as important milestones in the development of photography and representatives of specific movements, styles, eras or moments. These images range from the innovative to the iconic. Some, like Alberto Korda's portrait of Che Guevara (1960), Robert H. Jackson's *Jack Ruby Killing Lee Harvey Oswald* (1963) and Richard Drew's *Falling Man* (2001), were shot in the moment. Others, such as Roger Fenton's *Still Life with Fruit and Decanter* (1860) Edward Weston's *Pepper (No. 30)* (1930) and Gregory Crewdson's *Beneath the Roses* (2014) were meticulously constructed. This section charts the development of portraiture, from Nadar's *Self-Portrait* (c.1855) and Julia Margaret Cameron's *Beatrice* (1866) to Andy Warhol's *Self-Portrait in Drag* (1981) and Rineke Dijkstra's *Hilton Head Island, S.C., USA, June 24, 1992* (1992), and highlights the role certain photographs have played in a cultural, social or political context.

The aesthetic and cultural importance of these photographs is discussed, alongside biographies of the photographers, demonstrating the importance of each in the medium's relatively short history.

Themes

NAN GOLDIN: 'FOR ME IT IS NOT A DETACHMENT TO TAKE A PICTURE. IT'S A WAY OF TOUCHING SOMEBODY – IT'S A CARESS.'

Themes often encompass a variety of genres throughout the history of photography, highlighting the different approaches taken by photographers, yet traversing the varying styles of any given period. They help in our understanding of how innovation and technological development have aided the medium, and how attitudes towards certain subjects have changed. They provide a record of the way we perceive ourselves and the world around us, both natural and urban environments.

Techniques

ALFRED STIEGLITZ: 'WHEREVER THERE IS LIGHT, ONE CAN PHOTOGRAPH.'

Although the function of a camera remains the same, there is a vast gulf between the earliest photographic equipment and the technical complexity of today's cameras. This section charts the camera's development, from the earliest incarnations and key components, through to its increasing portability and sophisticated use of light, and the emergence of technology that not only records an image but can also manipulate it beyond recognition. It highlights the role of individual photographers and technicians in the development of certain elements, from monochrome and colour to shutter mechanisms and the appearance of the charged-couple device. Each entry refers to the genres, key works and themes previously covered, highlighting the medium's rich history.

How to use this book

This book is divided into four sections: Genres, Works, Themes and Techniques. Each section can be read in isolation or in conjunction with the others. The core of the book – Works – features 50 key images by acclaimed photographers. Useful cross-references at the foot of each page direct the reader from one section to another, while information boxes include key developments or biographies.

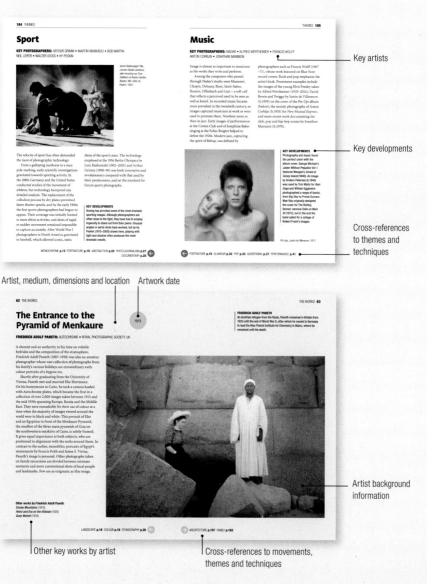

Key artists

Key developments

Cross-references to themes and techniques

Artist, medium, dimensions and location Artwork date

Artist background information

Other key works by artist Cross-references to movements, themes and techniques

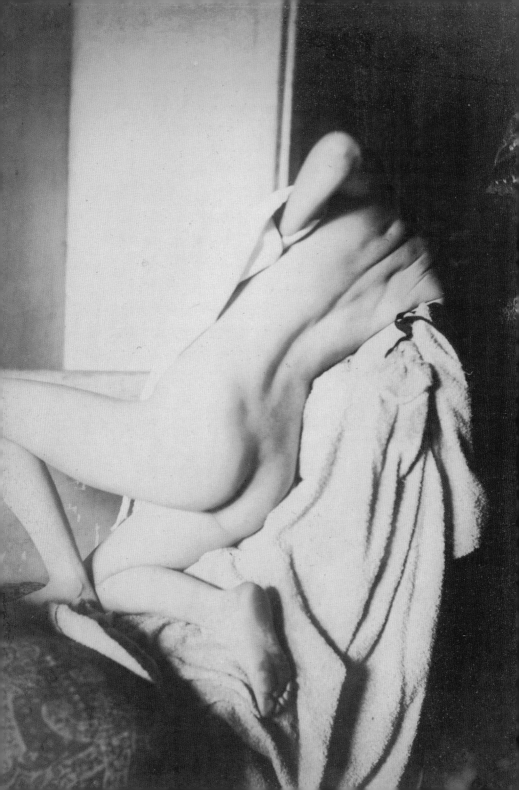

GENRES

Monochrome

KEY PHOTOGRAPHERS: NICÉPHORE NIÉPCE • ALFRED STIEGLITZ • EDWARD WESTON
DOROTHEA LANGE • WEEGEE • SEBASTIÃO SALGADO

Denoting tones of a single colour, 'monochrome' generally means black and white, which dominated serious use of the medium of photography until colour began to attract critical attention in the 1970s.

That early photographs could capture the world only in black and white proved no obstacle for audiences fascinated by the new medium. The tone of an image differed with each process, from daguerreotype to calotype (see pages 191 and 192), while the cyanotype presented its subject through a blue hue (see page 193) and platinum prints (see page 197), such as this portrait of Aubrey Beardsley by Frederick H. Evans (1853–1943), added lustre. By the early

twentieth century, conventional black and white had become the norm, with the proliferation of newspapers establishing it as the trusted representation of reality. Serious photography, from photojournalism and documentary work to more artistically inclined work, mostly ignored developments in colour film. Magazines eventually began to use colour, but 'real' news remained black and white. Only in the 1970s, with the work of photographers such as William Eggleston and Joel Meyerowitz (b.1938), did the critical establishment accept colour as an equal to monochrome.

Portrait of Aubrey Beardsley, Frederick H. Evans, 1894, gelatin silver print, 14.9 x 10.8 cm (5⅞ x 4¼ in), The J. Paul Getty Museum, Los Angeles, USA

KEY DEVELOPMENTS
A slight variation on conventional black and white was achieved in the nineteenth century with tinting, which was commonly produced through the use of dyed printing papers. A single colour was used, which is visible in the highlights and midtones of a developed image. Albumen papers were made available in subtle shades of pink and blue from the 1870s, and mauve or pink was available with gelatin silver print papers a decade later.

VIEW FROM THE WINDOW AT LE GRAS **p.46** THE STEERAGE **p.60** PHOTOGRAM **p.84** COP KILLER **p.86** THE DECISIVE MOMENT **p.174** DAGUERREOTYPE **p.191** CALOTYPE **p.192**

Pictorialism

KEY PHOTOGRAPHERS: HENRY PEACH ROBINSON • FRANK MEADOW SUTCLIFFE
ALFRED STIEGLITZ • EDWARD STEICHEN • PAUL STRAND • CLARENCE H. WHITE

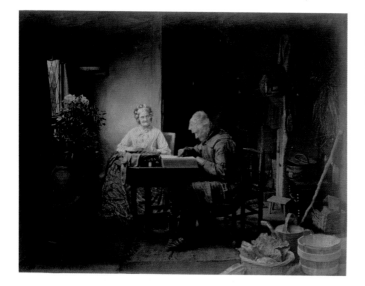

When the Day's Work Is Done, Henry Peach Robinson, 1877, albumen silver print, 56 x 74.5 cm (22¹⁄₁₆ x 29⁵⁄₁₆ in), The J. Paul Getty Museum, Los Angeles, USA

The Pictorialist movement marked a departure from documentary towards a discipline that would find photographs aiming for the aesthetic quality of painting.

The movement, which roughly spanned the years 1880 to 1910, had its theoretical perspective outlined in the book *Pictorial Effect in Photography* (1869). The author, Henry Peach Robinson (1830–1901), suggested that if a photographer were a genuine artist, the vision of the world he captured would possess more truth than any documentary facsimile. He condoned the use of effects or trickery to achieve this vision. This rebellion against the dogma of most photography societies resulted in a series of secessions by these artist photographers, who included in their ranks Robinson, Frank Meadow Sutcliffe, Alfred Stieglitz, Fred Holland Day (1864–1933), Heinrich Kühn (1866–1944), Clarence H. White (1871–1925) and Edward Steichen (1879–1973). An artistic approach had been taken by earlier photographers, such as Julia Margaret Cameron, but the Pictorialists and the Secession groups were the first coherent movement to argue for personal expression in the medium.

KEY DEVELOPMENTS

Alfred Stieglitz played a significant role in the US Pictorialist movement. In 1902 he oversaw the creation of the Photo-Secession and worked closely with Edward Steichen in promoting it. However, he would later shun the movement.

BEATRICE **p.56** THE MUDLARKS **p.58** WEATHER **p.156** BEAUTY **p.158**
PLATINUM PRINTS **p.197**

Straight Photography

KEY PHOTOGRAPHERS: ALFRED STIEGLITZ • PAUL STRAND • ANSEL ADAMS
EDWARD WESTON • WILLARD VAN DYKE • IMOGEN CUNNINGHAM

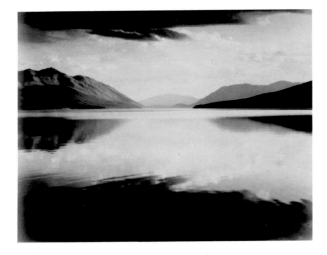

Looking across Lake toward Mountains, 'Evening, McDonald Lake, Glacier National Park', Montana, Ansel Adams, 1941–42, National Archives, Washington D.C., USA

The earliest extant image is an example of straight photography, a term that took on greater meaning when it was adopted by a group that reacted against Pictorialism.

It was the Japanese-born, German-raised critic Sadakichi Hartmann who coined the term 'straight photography'. Though not a practising photographer, he poured scorn on those who sought to equate the medium with painting rather than accept it on its own terms. This shift took place as Modernism was picking up traction in all art forms. In America, Alfred Stieglitz, followed by former Pictorialists Edward Steichen and Paul Strand (1890–1976), edged towards a documentary style that also embraced abstraction. Within a few years, this new trend had produced the key works *The Steerage* (see page 60), *Wall Street, New York* (1921) and later *Wheels* (1939) by Charles Sheeler (1883–1965). In California, Edward Weston co-founded the group f/64, which promoted the application of straight photography, employing large-format cameras, eschewing any effects and achieving sharp, focused prints. His pepper series extolled the beauty and purity of form through abstraction (see page 22).

KEY DEVELOPMENTS

Group f/64 was more than a collective of like-minded photographers. It was formed at the apartment-cum-gallery of Willard Van Dyke (1906–86) in Oakland, California, and took a political stand in its promotion of a modernist aesthetic. The group's first exhibition was held on 15 November 1932 and featured the work of founding members Ansel Adams, Imogen Cunningham (1883–1976), John Paul Edwards (1884–1968), Sonya Noskowiak (1900–75), Henry Swift (1891–1962), Edward Weston and Van Dyke.

THE STEERAGE **p.60** PEPPER (NO. 30) **p.74** TRANSMISSION LINES IN MOJAVE DESERT **p.90**
MODERNITY **p.176**

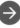

Portraiture

KEY PHOTOGRAPHERS: NADAR • CECIL BEATON • YOUSUF KARSH • ARNOLD NEWMAN
EVE ARNOLD

Within a year of Louis Daguerre (1787–1851) producing an image of a Parisian boulevard, photographic portraits began to appear, although they required considerable patience on the part of the sitter.

In October 1839, Robert Cornelius (1809–93) took a self-portrait. It was soon followed by John William Draper (1811–82), who produced a portrait of his sister. Both pictures required the subject to remain absolutely still for over a minute. As lenses became more sophisticated and exposure time decreased, portraits improved in quality. Julia Margaret Cameron used a large-format camera to produce evocative portraits that presaged the Pictorialist style. Contemporaries criticized her technical blunders, a far cry from the work of Nadar, who significantly advanced the potential of portraiture by capturing aspects of his subjects' characters and eschewing the starchy posturing of earlier portraits. Queen Victoria was regularly photographed. Photography was used by Hollywood to promote movie stars and their seemingly glamorous lives, and became a staple of the fashion industry; it is now a daily practice on social media.

KEY DEVELOPMENTS
This portrait of Abraham Lincoln in 1865 by Alexander Gardner (1821–82) was not the first photograph of an incumbent US President, but it remains one of the most iconic. Gardner photographed Lincoln on seven occasions, including his funeral. He was also the author of the two-volume *Gardner's Photographic Sketch Book of the War* (1866; see page 52).

Abraham Lincoln, three-quarter-length portrait, seated and holding his spectacles and a pencil, Alexander Gardner, 1865, Library of Congress, Washington D.C., USA

→ BEATRICE **p.56** PORTRAIT OF MOTHER **p.68** MIGRANT MOTHER, NIPOMO, CALIFORNIA **p.80**
MALCOLM X **p.106** CELEBRITY **p.167** POWER **p.180**

Landscape

KEY PHOTOGRAPHERS: CARLETON WATKINS • WILLIAM HENRY JACKSON
TIMOTHY H. O'SULLIVAN • EDWARD WESTON • ANSEL ADAMS

After initially reflecting the romanticism of nineteenth-century painting, landscape photography diversified to encompass the scientific study of land formation and human impact on the environment.

Both J.M.W. Turner (1775–1851) and John Constable (1776–1837) were alive at the inception of photography, and their approach to landscape is reflected in the painterly techniques of early photographers who set out to capture the natural world. If the Pictorialists were keen to embrace elements of fine art in their work, many American documentary photographers from the 1860s sought to capture an accurate vision of the country's vast landscape. In 1861 Carleton Watkins (1829–1916) photographed Yosemite, and thereby set the standard. During the following decade an extraordinary body of work, much of it from geological surveys that featured the photography of William Henry Jackson and Timothy H. O'Sullivan, was produced. The incorporation of abstraction in the work of Alfred Stieglitz and Edward Weston added ambiguity to shape and form, and along with the nineteenth-century pioneers set the standard for landscape photography.

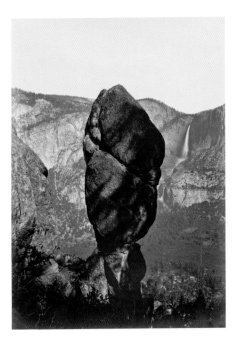

KEY DEVELOPMENTS

William Henry Jackson's intention in his photographs of Yellowstone was to persuade the US Congress to preserve the area for future generations, which it did in 1872 by making the area the first US National Park. Jackson's work was continued by a long line of North American photographers concerned with humanity's impact on the environment. In 1861 Carleton Watkins (1829–1916) undertook a vast survey of Yosemite, employing a huge glass-plate camera to capture stunning images of the landscape. Laters pioneers include the perennially popular Ansel Adams, Eliot Porter (1901–90), Philip Hyde (1921–2006), Robert Glenn Ketchum (b.1947) and Edward Burtynsky.

Agassiz Rock and the Yosemite Falls, from Union Point, Carleton Watkins, 1878, 54.4 x 39.2 cm (21⅜ x 15⅜ in), The J. Paul Getty Museum, Los Angeles, USA

TRANSMISSION LINES IN MOJAVE DESERT **p.90** SALT PANS #13 **p.152** WEATHER **p.156** NATURE **p.163**
AERIAL PHOTOGRAPHY **p.203**

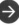

Street Photography

KEY PHOTOGRAPHERS: JACOB RIIS • EUGÈNE ATGET • BRASSAÏ • HENRI CARTIER-BRESSON
VIVIAN MAIER • SAUL LEITER • ROBERT FRANK • DIANE ARBUS • MARTIN PARR

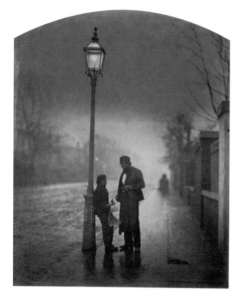

KEY DEVELOPMENTS
Admired by Prince Albert, Camille-Léon-Louis
Silvy (1834–1910) was a portrait photographer
and one of the earliest street photographers.
Born in Paris, he learned his craft from Count
Olympe Aguado (1827–94), an acolyte of Gustave
Le Gray (1820–84). In 1858 Silvy moved to England
and created a series of images that captured life
on the streets of London.

Twilight, Camille Silvy, 1859–60,
albumen silver print, 27.4 x 22 cm
(10¾ x 8⅝ in), The J. Paul Getty
Museum, Los Angeles, USA

Photographers took their ever-more
portable cameras out on to the streets of
the world's towns and cities to capture life,
quite often unexpectedly.

The influx of people into metropolitan
areas in the late nineteenth and early
twentieth centuries gave photographers
rich opportunities to record the hubbub of
human activity. *Chimney Sweeps Walking*
(1851) by Charles Nègre (1820–80) is
an early example, but its matter-of-fact
approach pointed to the later work of Jacob
Riis (1849–1914), Eugène Atget (1857–1927),
Alice Austen (1866–1952) and Lewis
Hine. Paris, both during the day and after
hours, was captured by Brassaï, then Henri
Cartier-Bresson (1908–2004) and Robert

Doisneau, whose humanist photography
influenced later generations. In New York,
Saul Leiter (1923–2013) employed colour
subtly, often shooting through glass or
with blurred objects in the foreground.
Robert Frank's book *The Americans*
(1958) transformed street photography,
presenting a more personal vision of a
world. The following year Shigeichi Nagano
(b.1925) began documenting the social and
infrastructural transformation of Tokyo.
Gary Winogrand (1928–84), Diane Arbus
(1923–71) and Martin Parr followed, blur-
ring the line between street and vernacular
photography.

→ THE KISS AT THE HOTEL DE VILLE **p.96** PARADE, HOBOKEN, NEW JERSEY **p.98** NEW BRIGHTON, ENGLAND **p.126**
OVERPASS **p.146** THE DECISIVE MOMENT **p.174** VERNACULAR **p.183** YOUTH CULTURE **p.186** SLR **p.208**

Colour

KEY PHOTOGRAPHERS: WILLIAM EGGLESTON • MARIE COSINDAS • JOEL MEYEROWITZ
STEVE MCCURRY • MARTIN PARR • ANDRES SERRANO • NOBUYOSHI ARAKI

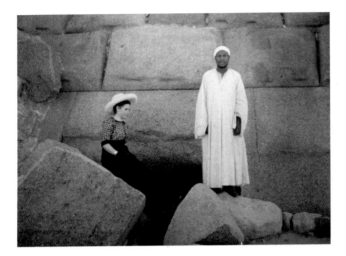

The Entrance to the Pyramid of Menkaure, Friedrich Adolf Paneth, 1913, autochrome, Royal Photographic Society, UK

At first, colour photography faced an uphill struggle against critics who saw no artistic value in it, until their opinion was changed by a new generation of photographers.

Early attempts at colour photography, such as the tartan ribbon by James Clerk Maxwell (1831–79) or the view of Agen in France by Louis Arthur Ducos du Hauron (1837–1920) in 1877, were rudimentary experiments. Autochrome and Kodachrome fully realized the potential of colour film, but the critical establishment and most photographers refused to embrace the innovation, regarding it as a distraction from an image's composition and the use of light. Some saw it as little more than a gimmick, better used by tourists than serious photographers. Ferenc Berko (1916–2000) disagreed and incorporated it into his work. Saul Leiter used colour evocatively in his depictions of 1950s New York. The emergence of Marie Cosindas (1925–2017), Joel Meyerowitz and William Eggleston transformed critical opinion, and colour photography now has an equal footing with black and white.

KEY DEVELOPMENTS
In 1962, Marie Cosindas was one of the select few invited by Polaroid Corporation founder Edwin H. Land to experiment with his company's new instantly developing film. Previously Cosindas had used only black and white. Embracing the new technology, she went on to explore the potential of colour in fine art photography. Her solo show at MoMA in New York in 1966 was one of the museum's first to feature colour photography.

THE ENTRANCE TO THE PYRAMID OF MENKAURE **p.62** ALGIERS, LOUISIANA **p.114** UNTITLED #96 **p.122**
CYANOTYPE **p.193** HAND-COLOURING **p.198** COLOUR **p.199** KODACHROME **p.207**

Nude

KEY PHOTOGRAPHERS: ROBERT DEMACHY • MAN RAY • ANDRÉ KERTÉSZ
ALFRED STIEGLITZ • EDWARD WESTON • RUTH BERNARD • NOBUYOSHI ARAKI

Inspired by painting, nude photography has encompassed eroticism, anatomy and pornography as well as the study of form and gender identity.

Nowhere is the painterly quality of nude photography more evident than in the series of studies made by Eugène Durieu (1800–74) in 1854 for the painter Eugène Delacroix (1798–1863), or in the Degas-like *Académie* (1900) by Robert Demachy (1859–1936), his young subject's seemingly uninterested expression simultaneously distancing and attracting the curiosity of the viewer. The 'Orpheus' series (1907) by Frederick Holland Day (1864–1933) was the epitome of Pictorialism in its evocation of classical characters, a stark contrast to the emerging movements in the early twentieth century that brought an entirely different quality to representations of the nude. Man Ray (see page 66) and André Kertész shot their models through the prism of Surrealism, and this was continued by Bill Brandt (1904–83) in his 'Perspective of Nudes' series (1961). In America, Alfred Stieglitz and Edward Weston employed abstraction in their study of form, while Ruth Bernard (1905–2006) stands out as one of the few female photographers known for nude studies, exploring the female form from a less sexualized perspective than most of her male counterparts.

KEY DEVELOPMENTS
By the end of the nineteenth century, Edgar Degas (1834–1917) had become a passionate advocate of photography. Most of his images were taken in the evening, often after a dinner party and using lamplight to create mood and to emphasize the psychological over the physical. His passion for the medium may have been brief, but it has facilitated comparisons with his work in other art forms.

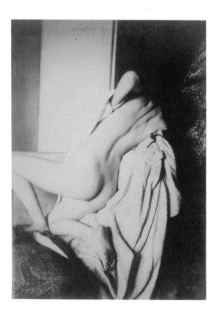

After the Bath, Woman Drying her Back, Edgar Degas, 1896, gelatin silver print, 16.5 x 12 cm (6½ x 4¹¹⁄₁₆ in), The J. Paul Getty Museum, Los Angeles, USA

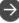
INGRES' VIOLIN **p.66** LUTZ & ALEX SITTING IN THE TREES **p.134** BEAUTY **p.158** THE SURREAL **p.162** CELEBRITY **p.167** GENDER **p.178**

Still Life

KEY PHOTOGRAPHERS: ROGER FENTON • LOUIS DUCOS DU HAURON • JAROMÍR FUNKE
ANDRÉ KERTÉSZ • EDWARD WESTON • ROBERT MAPPLETHORPE

Never merely a collection of objects, a still life could represent wealth or social status, while highlighting technological innovation and reflecting changing attitudes to form and representation.

Derived from the Dutch word *stilleven*, still life is recognized as the visual study of everyday objects, either from nature or from a domestic environment. Roger Fenton, who had been working on a photographic catalogue of the British Museum's collection, displayed his skill at lighting and composition in *Still Life with Fruit and Decanter* (see page 50). His work was matched by that of the Frenchmen Charles Aubry (1811–77), Adolphe Braun

(1812–77) and Louis Ducos du Hauron. Baron Adolph de Meyer (1868–1946) took a more painterly approach to his subjects, as in *Glass and Shadows* (1905), which soon contrasted with the emergence of new artistic movements. In Modernism, photographers explore form through abstraction. Jaromír Funke (1896–1945) embodied this aesthetic in works such as *The Spiral* (1924), while André Kertész's *The Fork* (see page 70) and Edward Weston's *Pepper (No. 30)* (see page 74) made familiar objects strange by viewing them from unfamiliar angles.

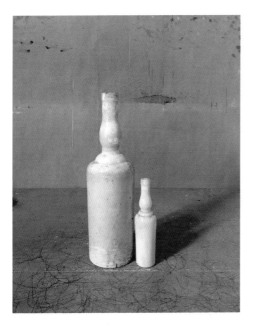

KEY DEVELOPMENTS
A fascinating comparison between still-life painting and photography can be found in the studies of the Bologna studio belonging to Giorgio Morandi (1890–1964) by the colour photography pioneer Joel Meyerowitz. The perfectionism of Morandi, who spent months working on each painting, is matched in Meyerowitz's images, the composition of which is rendered with attention to line, texture and shadow.

Morandi's Objects, White Bottles,
Joel Meyerowitz, 2015

THE FORK **p.70** PEPPER (NO. 30) **p.74** AMAZON **p.150** THE SURREAL **p.162** CONSUMERISM **p.169**
TEXTURE **p.177**

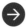

Self-Portraiture

KEY PHOTOGRAPHERS: NADAR • EL LISSITZKY • CLAUDE CAHUN • ANDY WARHOL
CINDY SHERMAN

Photographers, like painters before them, created self-portraits. Some helped to define the form, before the selfie made it an everyday activity.

Self-portraits run the gamut from the conventional and accidental to the playful and provocative. The first photographic portrait, a self-portrait of 1839 by Robert Cornelius, is conventional in comparison with the work of later photographers such as El Lissitzky (1890–1941), whose study from 1924 is a complex series of superimposed images that reflect the ethos of the Russian Constructivists. The finest exemplar of self-portraiture in the nineteenth century was Nadar, who photographed

himself countless times, sporting the fashions of the day, donning a series of guises, or portrayed against a variety of backdrops. His immense skill is evident throughout. Claude Cahun (1894–1954), often aided by her partner and fellow artist Marcel Moore (1892–1972), also adopted various roles in front of the camera. Her aim was to explore gender conventions and identity. Cindy Sherman took a similar approach (see page 122), while Andy Warhol explored his relationship with celebrity through two decades of self-portraiture.

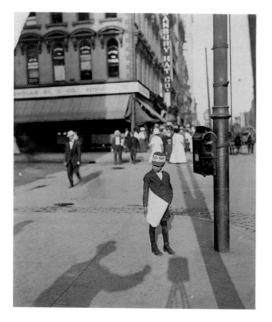

KEY DEVELOPMENTS
Some photographers are present in their work through a trick of the light or the use of a mirror. Man Ray, Diane Arbus, Nan Goldin, Lee Friedlander (b.1934), Eve Arnold and Weegee all appear in self-portraits through the use of mirrors. Shadows also allow photographers to be a presence in a shot. Lewis Hine featured in his photograph of a newsboy in 1908, while Claude Monet (1840–1926) just registered on the bottom of the frame in his *Shadow on a Lily Pond* (1920).

Self-Portrait with Newsboy, Lewis W. Hine, 1908, gelatin silver print, 13.8 x 11.8 cm (5⁷⁄₁₆ x 4⅝ in), The J. Paul Getty Museum, Los Angeles, USA

→ SELF-PORTRAIT **p.48** SELF-PORTRAIT IN DRAG **p.120** UNTITLED #96 **p.122** THE SURREAL **p.162** CELEBRITY **p.167** GENDER **p.178**

Abstraction

KEY PHOTOGRAPHERS: ALFRED STIEGLITZ • PAUL STRAND • ANDRÉ KERTÉSZ • MAN RAY
LÁSZLÓ MOHOLY-NAGY • EDWARD WESTON • JAN GROOVER

Coinciding with the emergence of Modernism, abstract photography emphasized form over the figurative and was a reaction against the Pictorialist trend.

The rapid changes that took place at the turn of the twentieth century resulted in a reappraisal of art and its role in society. Several key photographers who shifted away from realism towards art at the end of the nineteenth century returned to straight photography to explore form through abstraction. Early experiments with photomontage (see page 212) played with form, but in conventional photography abstraction took hold through works such as *Symmetrical Patterns from Natural Forms* (1914) by Erwin Quedenfeldt (1869–1948) and *Wall Street, New York* by Paul Strand. The latter image formed part of the exhibition 'Paul Strand, circa 1916', a milestone in

modernist photography. Artists as diverse as László Moholy-Nagy, André Kertész, Curtis Moffat (1887–1949) and Man Ray followed suit, while in the United States Alfred Stieglitz carried out a decade-long examination of cloud formations, and Edward Weston explored angularity and texture in his still-life and nude studies.

KEY DEVELOPMENTS

Key to the work of many photographers exploring abstraction was the use of juxtaposition. Photograms were effective for the way each object was laid out on light-sensitive paper, while André Kertész's *Mondrian's Eyeglasses and Pipe* (1926) became a series of lines contained within the sharp geometry of a table corner. The work of Jan Groover (1943–2012) went further, often denying the visual space to identify the objects within a frame.

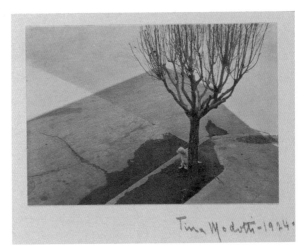

Tree with Dog, Tina Modotti, 1924, palladium print, 8.3 x 11.9 cm (3¼ x 4¹¹⁄₁₆ in), The J. Paul Getty Museum, Los Angeles, USA

PEPPER (NO. 30) **p.74** PHOTOGRAM **p.84** THE SURREAL **p.162** MODERNITY **p.176** CYANOTYPE **p.193** PHOTOGRAM **p.201**

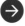

Avant-Garde

KEY PHOTOGRAPHERS: MAN RAY • LÁSZLÓ MOHOLY-NAGY • ALBERT RENGER-PATZSCH
ALEXANDER RODCHENKO • EL LISSITZKY • GUSTAV KLUTSIS

In the early decades of the twentieth cen-
tury photography splintered into different
movements, reflecting political and cultural
changes in the arts and society in general.

If photography's trajectory in the
nineteenth century was always at one
remove from the major art movements of
the era, it collided head on with them from
the beginning of the twentieth. Cubism's
engagement with mechanical form hinted
at the role photography would soon play
within the avant-garde, and both the Dada
and Surrealist movements saw the potential
of this youthful medium. In the Weimar
Republic, the Staatliches Bauhaus embraced
photography at the behest of László
Moholy-Nagy, who dominated the cultural
landscape with his photograms and angular
shots of landscapes. In the Soviet Union,
photography was in the vanguard of a
movement that pushed for radical societal
change. Alexander Rodchenko gave up
painting to develop a photographic style
that, like Moholy-Nagy's, embraced oblique
perspectives, often from above. But his
work, along with that of El Lissitzky, Gustav
Klutsis (1895–1938) and Max Penson
(1893–1959), which aimed to capture the
momentum of modern life, was compro-
mised by Stalin's brutal regime.

KEY DEVELOPMENTS
'Film und Foto' is regarded as the first great
exhibition of European and American photography
and was curated by László Moholy-Nagy and
Sigfried Giedion (1888–1968). The iconic poster
for the event was designed by Jan Tschichold
(1902–74), who became the leading advocate of
Modernist design. Inspired by an exhibition of
1923 by the Weimar Bauhaus, his work was hugely
influential in the development of typography.

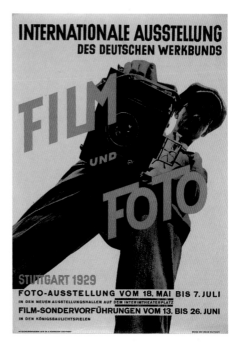

Film und Foto (International Exhibition
of the German Industrial Confederation,
Stuttgart), Willi Ruge, 1929, offset
lithograph, 84 x 58.5 cm (33 x 23⅛ in),
Museum of Modern Art, New York, USA

→ INGRES' VIOLIN **p.66** PORTRAIT OF MOTHER **p.68** PHOTOGRAM **p.84** THE SURREAL **p.162**
MODERNITY **p.176** PHOTOMONTAGE **p.212**

War

KEY PHOTOGRAPHERS: ROGER FENTON • MATHEW BRADY • TIMOTHY H. O'SULLIVAN
ROBERT CAPA • GERDA TARO • MARGARET BOURKE-WHITE • NICK UT • TIM HETHERINGTON

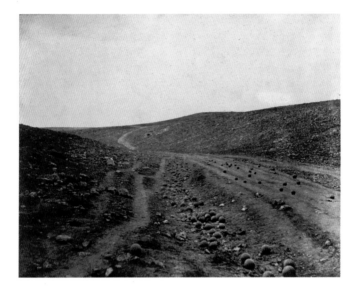

Valley of the Shadow of Death, Roger Fenton, 1855, salted paper print, 27.6 x 34.9 cm (10⅞ x 13¾ in), The J. Paul Getty Museum, Los Angeles, USA

Photojournalism brought conflict into people's homes, at first just reporting on battles and their outcome. Over time, it questioned the motives for going to war.

The first major coverage of a conflict was that of the Crimean War, and Roger Fenton proved himself one of the most experienced photographers on the ground. However, lengthy exposure times limited him to recording the detritus of battle. Mathew Brady (1822–96) and his team, particularly Timothy H. O'Sullivan, focused more on the human cost of battle during the American Civil War (see page 52), as well as on the military figures and politicians representing both sides. By the time of World War I, technology allowed for aerial surveys of battlefields and a greater

presence in the trenches, thus highlighting the terrible conditions soldiers faced. If coverage of World War II generally fitted traditional lines, of fighting the good fight, during the Spanish Civil War the role of the photojournalist shifted from documentation to questioning the reasons for it. This increased later in the twentieth century, particularly in Vietnam (see page 116).

KEY DEVELOPMENTS

Roger Fenton narrowly missed being killed by cannon fire before taking *Valley of the Shadow of Death* (1855). Although the image features no dead, it is a chilling portrait of conflict, its power lying in the viewer conjuring up the horror that evidently took place there.

A HARVEST OF DEATH **p.52** AMERICAN SOLDIERS LANDING ON OMAHA BEACH **p.92**
PHAN THỊ KIM PHÚC **p.116** POLITICS **p.172** POWER **p.180**

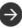

Propaganda

KEY PHOTOGRAPHERS: ALEXANDER RODCHENKO • EL LISSITZKY • HEINRICH HOFFMANN
HUGO JAEGER • ALBERTO KORDA • NICK UT

Derived from a seventeenth-century term for the methods used by the Vatican to reach out to non-Catholic countries, the word 'propaganda' acquired its modern, secular usage in the 1790s; it was not until 1914 that it was applied to photography.

World War I brought the first large-scale use of propaganda by governments, and photography became an essential tool to win over the masses. By the 1920s it had become a sophisticated device, as evinced by Stalin's regime. The Russian avant-garde had initially embraced a revolution that promised to end the country's feudal order, but in the years after Lenin's death in 1924 photography increasingly became part of a brutal method of coercion. In this it was incredibly effective, and it was taken up by the Nazis in the 1930s. At the same time, the US government's Farm Security

Administration realized the importance of documenting the plight of the less fortunate in the country's rural states to promote President Franklin D. Roosevelt's plans for national reconstruction. The work of Walker Evans, Dorothea Lange, Gordon Parks (1912–2006) and their colleagues helped this campaign (see pages 80–83). In World War II, photography ranked with film as one of the key tools of propaganda.

KEY DEVELOPMENTS

This photograph by Yevgeny Khaldei (1917–97) of soldiers atop Berlin's Reichstag building was taken a few days after the city fell in 1945. The flag was stitched together from separate pieces of cloth; effects were used to add more smoke in the background and to remove one of two watches from a soldier's wrist, which were probably looted.

The Red Flag on the Reichstag, Berlin, Yevgeny Khaldei, 1945

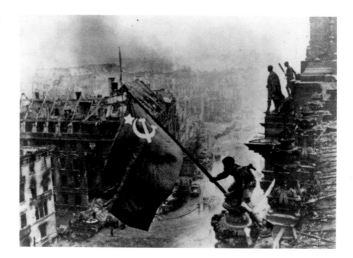

MIGRANT MOTHER, NIPOMO, CALIFORNIA **p.80** AMERICAN SOLDIERS LANDING ON OMAHA BEACH **p.92**
CHE GUEVARA **p.104** ICONOGRAPHY **p.166** POWER **p.180** PHOTOMONTAGE **p.212**

Ethnography

KEY PHOTOGRAPHERS: LOUIS-AUGUSTE BISSON • WILLIAM HENRY JACKSON
FRANK MEADOW SUTCLIFFE • EDWARD S. CURTIS • DORIS ULMANN

Ethnic-minority and marginalized communities have preoccupied photographers since the early days of the daguerreotype.

Étienne Serres (1786–1868), a professor at the Musée d'histoire naturelle in Paris, was one of the first to see the value of photography for ethnographic studies, and in the early 1840s he created a team to use the medium, including Louis-Auguste Bisson (1814–76) and Henri Jacquart (1809–87). The next few decades brought a significant increase in the number of photographic studies of peoples around the world, from Frank Meadow Sutcliffe's record of English coastal life to the Hungarian folk portraits of Carol Szathmari (1812–87). But few studies were as comprehensive or as technically accomplished as *600 Portraits of American Indians* (1877). By 1900, different approaches to the representation of

societies were employed, with photographers increasingly recording people in an everyday environment rather than in carefully choreographed portraits. Representation of the working classes edged towards social documentary, while the study of communities around the world became more nuanced and sensitive to those being photographed.

KEY DEVELOPMENTS
William Henry Jackson (1843–1942) had photographed tribes in the Omaha area for almost a decade by the time he contributed to *600 Portraits*. His work was continued by Edward S. Curtis (1868–1952), who spent the first two decades of the twentieth century amassing a vast library of images, recordings and personal testimonies representing Native American life.

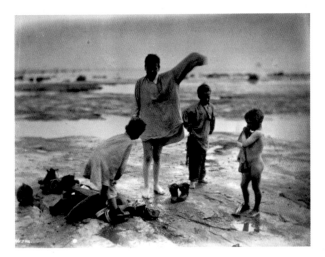

Mudlarks in Whitby, Frank Meadow Sutcliffe, c.1880, albumen print

THE MUDLARKS **p.58** THE STEERAGE **p.60** MIGRANT MOTHER, NIPOMO, CALIFORNIA **p.80** SUNDAY AFTERNOON, WHITBY, ENGLAND **p.118** NEW BRIGHTON, ENGLAND **p.126** RELIGION **p.160** PEOPLE **p.173**

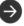

Photojournalism

KEY PHOTOGRAPHERS: HENRI CARTIER-BRESSON • WEEGEE • ROBERT CAPA • GERDA TARO
MARGARET BOURKE-WHITE • NICK UT • RICHARD DREW • TIM HETHERINGTON

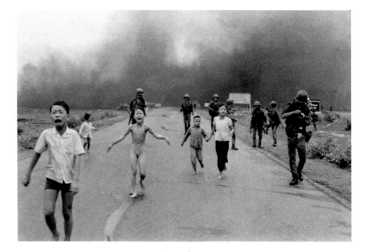

Phan Thị Kim Phúc,
Nick Ut, 1972,
silver print

From war, politics and society to sports, culture and the entertainment industry, photojournalism rapidly progressed to play a major role in everyday life.

The coverage of the Crimean War in *The Illustrated London News* was the first significant role played by photography in mass media. The following decade, photographic coverage of the American Civil War on both sides of the conflict revealed the true potential of the medium. After the introduction of halftone in the printing of New York's *The Daily Graphic* in 1880, photographs gradually became a staple of news reporting. The development of flash photography and the increased portability of cameras increased coverage, but costs still meant that engravings played an equal role until the 1920s. With the arrival of the wirephoto in 1921, syndicated

photographers could send through their images with speed. The golden age that followed spanned three decades, from the 1930s through to the end of the 1950s. This period brought extraordinary developments in sports, social and crime photography, while photojournalists covering the major conflicts of this era got closer to the action than ever before.

KEY DEVELOPMENTS
Embedded journalism, wherein reporters and photographers are attached to military units during armed conflicts, was first used in the invasion of Iraq in 2003 and thereafter became standard practice. It allowed the news media closer access to the front line. However, it also led to concerns that journalists were limited by what the military wanted them to see, and made them targets for opposing forces.

COP KILLER **p.86** THE LIBERATION OF BUCHENWALD **p.94** PHAN THỊ KIM PHÚC **p.116** THE FALLING MAN **p.144**
POLITICS **p.172** THE DECISIVE MOMENT **p.174** SLR **p.208** FLASH PHOTOGRAPHY **p.210**

Documentary

KEY PHOTOGRAPHERS: MATHEW BRADY • JACOB RIIS • IAN BERRY • DON MCCULLIN
ROBERT FRANK • MARY ELLEN MARK • JOSEF KOUDELKA • SEBASTIÃO SALGADO

From ethnography and war to changes in social conditions and the natural world, documentary photography explores subjects with greater depth than the daily headlines can ever achieve.

In the work of photographers covering the Crimean and American Civil wars in the mid nineteenth century, some of the most fascinating images, such as Mathew Brady's *Yorktown, Virginia* (1862), were less news items than documentary portraits away from the battlefield. Perhaps unsurprisingly, these photographers later took part in geological and topographical studies. Inspired by the work of social activists such as Henry Mayhew (1812–87), urban photographers documented the lives of

the poor and the dispossessed. Their work edged towards activism, and is echoed in the role photographers played in the Farm Security Administration in 1930s America. The rise of McCarthyism in the late 1940s halted such practices, but they continued in Britain through the work of Ian Berry, Don McCullin (b.1935) and Martin Parr. From *The Americans* by Robert Frank to the study of gypsies by Josef Koudelka (b.1938) and the epic surveys of Sebastião Salgado (b.1944), the photographic documentary tradition is best represented today in monographs and exhibitions.

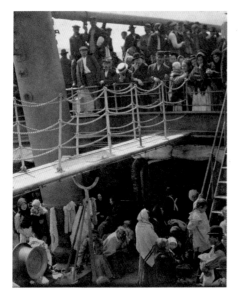

The Steerage, Alfred Stieglitz, photogravure, 33.5 x 26.4 cm (13¹³⁄₁₆ x 10⅜ in), The J. Paul Getty Museum, Los Angeles, USA

KEY DEVELOPMENTS

Traditional documentary came under attack in the 1970s and 1980s by photographers, critics and academics who regarded it as too simplistic a portrayal of life and insufficiently engaged with political structures. One of the most outspoken members of this group was the photographer and essayist Allan Sekula (1951–2013). His collection 'Photography Against the Grain' (1984) featured images that inspired a more left-leaning approach to documentary.

THE STEERAGE **p.60** MIGRANT MOTHER, NIPOMO, CALIFORNIA **p.80** WASHROOM IN THE DOG RUN OF THE
BURROUGHS HOME, HALE COUNTY, ALABAMA **p.82** PARADE, HOBOKEN, NEW JERSEY **p.98**
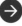

Humanism

KEY PHOTOGRAPHERS: AUGUST SANDER • ANDRÉ KERTÉSZ • BRASSAÏ
HENRI CARTIER-BRESSON • ROBERT DOISNEAU • ELLIOTT ERWITT • W. EUGENE SMITH

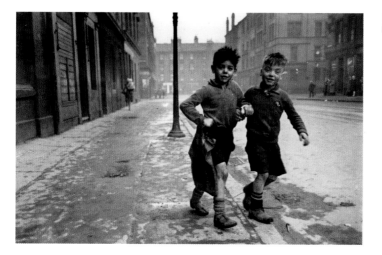

Gorbals Boys, Bert Hardy, 1948

Although present in the work of earlier photographers, the notion of humanism took root amid the ashes of a war-torn world and espoused a desire to depict sympathetically the human condition.

Originating with the political left wing in 1930s France, then coalescing as a loose movement unified in its mission to counter the immense human toll of World War II, humanist photography recorded the everyday – life as it unfolded on streets, in cafés and bars and between ordinary people. The seeming ordinariness of the best images to emerge is what made them so memorable. The photographs captured feelings experienced by all but which nevertheless remained personal to their subjects. The images recalled the work of André Kertész, August Sander (1876–1964) and Brassaï, but the charge here was led by Henri Cartier-Bresson, whose images first appeared in magazines but, like those of many of his contemporaries in this movement, soon found their way into galleries. That many of the photographs were staged did not matter. What was essential to these photographers was capturing the 'decisive moment', as Cartier-Bresson described it – the perfect snapshot of human feeling or action.

KEY DEVELOPMENTS
In 1955 Edward Steichen curated 'The Family of Man' at New York's Museum of Modern Art. It was a vast exhibition of humanist photography, representing the work of the key figures involved. Among the collection were three images by Bert Hardy (1913–95), including *Gorbals Boys* (pictured). The exhibition travelled the world and was seen by approximately nine million visitors.

THE KISS AT THE HOTEL DE VILLE **p.96** USA, CALIFORNIA **p.100** LOVE **p.159** PEOPLE **p.173**
THE DECISIVE MOMENT **p.174** FAMILY **p.182** SLR **p.208**

Science

KEY PHOTOGRAPHERS: JOHN W. DRAPER • ANNA ATKINS • EADWEARD MUYBRIDGE
ÉTIENNE-JULES MAREY • HAROLD EUGENE EDGERTON • WILLIAM ANDERS

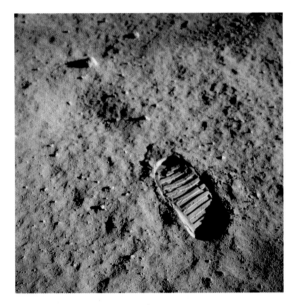

KEY DEVELOPMENTS
Photography was employed in the fields of eugenics and criminality. The first was an extension of anthropological studies and linked to the desire of some scientists to catalogue all racial characteristics. Some scientists were also under the impression that criminality could be identified in physical appearance, and that photography could aid their research.

Moon Footprint, Buzz Aldrin, 1969, NASA, USA

Photography became a tool for scientists; it was employed in progressive research and in supporting theories that have subsequently been dismissed.

The botanical photograms developed by Anna Atkins (1799–1871), shortly after John Herschel (1792–1871) created the cyanotype process, hinted at the scientific possibilities of photography, which were borne out over the course of the next 150 years. In 1895 the X-ray was developed by the physicist Wilhelm Röntgen (1845–1923) while he was experimenting with a cathode-ray tube. Within a year X-ray equipment began to appear in hospitals. This was soon followed by infrared and ultraviolet photography, both of which

were developed by the American inventor Robert W. Ford (1868–1955). Around the same time, the experiments that Eadweard Muybridge (1830–1904) and Étienne-Jules Marey (1830–1904) were conducting into movement were the start of research that would eventually lead to Harold Eugene Edgerton (1903–90) photographing the first millisecond of a nuclear explosion in 1952. The first photograph of the Moon was a daguerreotype by John W. Drapern in 1840. Just over a century later, astronaut William Anders used a Hasselblad 500 EL to photograph the Earth while he was orbiting the Moon.

PHOTOGRAM **p.84** EARTHRISE **p.110** NATURE **p.163** TECHNOLOGY **p.175** CYANOTYPE **p.193**
PHOTOGRAM **p.201** STOP TIME **p.206**

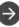

Art

KEY PHOTOGRAPHERS: GUSTAVE LE GRAY • JULIA MARGARET CAMERON
OSCAR GUSTAVE REJLANDER • GERTRUDE KÄSEBIER • EDWARD STEICHEN • ALFRED STIEGLITZ

Photography's relationship with art has ranged between mutually beneficial alliance and open hostility.

Photography was initially embraced by many artists. Delacroix, Gustave Courbet (1819–77), Édouard Manet (1832–83), Degas, Paul Cézanne (1839–1906) and Paul Gauguin (1848–1903) engaged with the medium, either as photographers or by using photography in their working process. Gustave Le Gray, who initially trained as a painter, embraced photography and not only sought to exploit its more painterly qualities, but also experimented with the form. His seascapes, taken off the Normandy coast in summer 1856 and spring 1857, display extraordinary technical prowess, often printing an image from two negatives. Julia Margaret Cameron lacked Le Gray's perfectionism, but drew heavily on fine art and presaged the emergence of the Pictorialist movement, which rejected the precepts of nascent institutions such as the Photographic Society of Great Britain, which held that photography was soley a means of documenting reality and not an adjunct to painting.

KEY DEVELOPMENTS
The Brotherhood of the Linked Ring was one of the most significant organizations in the Pictorialist tradition. The Brotherhood was founded in London in 1892 by Henry Peach Robinson, author of *Pictorial Effect in Photography* (1869), and at the height of its fame boasted 74 'links' – like-minded photographers from across Europe. It inspired similar organizations to sprout up across the continent over the next two decades, as well as the American Photo-Secession, which was active until 1910.

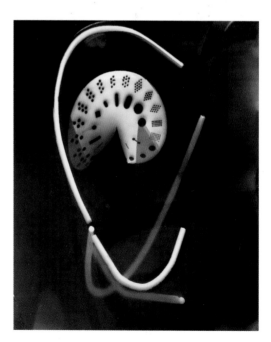

Photogram, László Moholy-Nagy, 1939, gelatin silver print, 49.53 cm x 40.32 (19½ x 15⁹⁄₁₀ in)

BEATRICE **p.56** THE MUDLARKS **p.58** WEATHER **p.156** BEAUTY **p.158** NATURE **p.163**
PLATINUM PRINTS **p.197**

Glamour

KEY PHOTOGRAPHERS: EDWARD STEICHEN • CECIL BEATON • CLARENCE SINCLAIR BULL
RUTH HARRIET LOUISE • SLIM AARONS • EVE ARNOLD • RICHARD AVEDON • ANNIE LEIBOVITZ

KEY DEVELOPMENTS

There are similarities between Nadar's Bernhardt portrait and Alfred Eisenstaedt's photo-shoot with Marilyn Monroe in 1953. Like Bernhardt, Monroe was on the brink of success. Eisenstaedt (1898–1995), who took the famous V-J Day photograph of a sailor kissing a young woman in Times Square, captured the young star's beauty, sexuality and sense of fun. But beyond her radiance the images also hinted at Monroe's mystique, which, like Bernhardt's, captivated audiences.

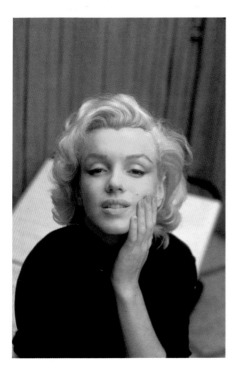

Marilyn Monroe on the Patio Outside of her Home, Alfred Eisenstaedt, 1953

Print publishing and cinema sparked an industry in glamour photography that depicted beauty, sex, sensuality and lifestyles that few people could dream of.

Nadar's portrait of the aspiring actress Sarah Bernhardt in 1864 is an early example of photography's engagement with glamour, albeit in a subtle register. The launch of *Vanity Fair* in 1913 and the rise of Hollywood over the course of the next two decades edged glamour photography into the limelight. ('Glamour' would also be the byword for a more explicit line of nude and pornographic photography from the late nineteenth to the mid-twentieth century.) The public wanted to see images of their favourite stars and celebrities, and the worlds of fashion and cinema sought to profit from that desire. Edward Steichen was an early pioneer of the Hollywood photo-shoot, balancing his more personal abstract work with portraits of Hollywood legends, including his evocative shot of Gloria Swanson (1924). He was joined by Clarence Sinclair Bull (1896–1979), Cecil Beaton (1904–80), George Hurrell (1904–92) and Ruth Harriet Louise (1903–40), the first female photographer in Hollywood. Later, Slim Aarons and Eve Arnold created a more relaxed approach to Hollywood glamour.

KINGS OF HOLLYWOOD **p.102** BEAUTY **p.158** ICONOGRAPHY **p.166** CELEBRITY **p.167** FLASH PHOTOGRAPHY **p.210** SOFT FOCUS **p.214**

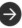

Pop

KEY PHOTOGRAPHERS: RICHARD HAMILTON • ROBERT RAUSCHENBERG • ANDY WARHOL
SIGMAR POLKE • PETER BLAKE

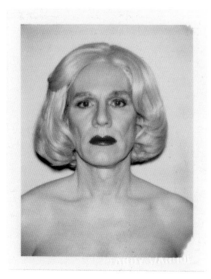

Self-portrait in Drag (Platinum Pageboy Wig), Andy Warhol, 1981, Polaroid, 10.8 x 8.5 cm (4¼ x 3½ in), Kunsthalle Hamburg, Hamburg, Germany

KEY DEVELOPMENTS

Pop Art's importance in the history of photography, as in that of painting and other disciplines, was to eradicate previous categorizations. Works such as Warhol's *Mao* (1972), which used as its basis the cover photo from the publication *The Thoughts of Chairman Mao Tse-Tung* (1966), might have been playful. But they were also provocations to purists on both sides of the debate that had raged since the nineteenth century, between those who saw photography as art and those who viewed it as documentary.

Blending photomontage and appropriation, Pop Art used photography to emphasize the production-line nature of the modern consumerist culture and the blurring of the line between high and low art.

Inspired as much by advertising as by the ideas surrounding Marcel Duchamp's 'ready-mades', Pop artists mostly took existing photographs and exploited them in their work. *Just What Is It That Makes Today's Homes So Different, So Appealing?*, a collage from 1956 by Richard Hamilton (1922–2011), comprised images from American magazines in its examination of the everyday. Hamilton was in the vanguard of what became known as the Independent Group, the British precursor to American Pop Art, of which the de facto figurehead was Andy Warhol. Warhol's silkscreens – with their focus on popular icons such as Marilyn Monroe and Elvis Presley, politicians such as Mao and Richard M. Nixon, and artefacts such as the electric chair – radically altered familiar images, visually and contextually. Warhol also became his own artwork in a series of self-portraits. The silkscreens of Robert Rauschenberg (1925–2008) collided global events with the everyday, while Ed Ruscha (b.1937) created photobooks that detailed continuous stretches of Californian roadsides, sometimes rendering everyday buildings, such as an archetypal gas station, in paint.

SELF-PORTRAIT IN DRAG **p.120** ICONOGRAPHY **p.166** CELEBRITY **p.167** CONSUMERISM **p.169** APPROPRIATION **p.187** PHOTOMONTAGE **p.212**

Society

KEY PHOTOGRAPHERS: JACOB RIIS • LEWIS HINE • WALKER EVANS • BERENICE ABBOTT
BILL BRANDT • CECIL BEATON • ROBERT FRANK • SEBASTIÃO SALGADO • MARTIN PARR

From street photography and crowded bars to the glamour of Hollywood and city life, photography presents a record of societies in a constant state of transition.

For almost a century, photographs of society tended to focus on opposite ends of the spectrum. The work of Nadar, Cecil Beaton and Norman Parkinson (1913–90) indulged the privileged, while Jacob Riis, Walker Evans and Bill Brandt documented the lives of the poor and the working class. Alfred Stieglitz's *The Steerage* (see page 60) is a key image from the early twentieth century for the way it presents both a symbolic and a literal portrait of class division. Following World War II, previously marginalized communities came into focus more frequently. Robert Frank's book *The Americans* was a seismic shift in representation, highlighting the disparity between the image of his adopted country and how it really looked. It inspired the portraits of Harlem and the New York subway system in the 1960s and 1970s by Bruce Davidson (b.1933), Ian Berry's *The English* and Martin Parr's photo-essay series that reflected on the middle classes, mass tourism and global consumerism.

KEY DEVELOPMENTS

If earlier portraits representing the working class and poverty tended to be limited to specific cities or areas, more recent documentary photographers have presented projects from a global perspective. Outstanding among these is Sebastião Salgado, whose *Workers* (1997) is a vast overview of labour conditions at their most challenging and exploitative all over the world.

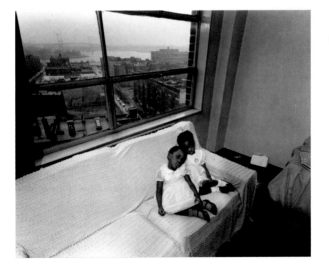

Twin Girls Sitting on a Couch Together, Harlem, New York City, USA, Bruce Davidson, 1966

PARADE, HOBOKEN, NEW JERSEY **p.98** NEW BRIGHTON, ENGLAND **p.126** CLASS **p.170** POVERTY **p.171** PEOPLE **p.173** THE DECISIVE MOMENT **p.174** AGE **p.179** YOUTH CULTURE **p.186** →

Topography

KEY PHOTOGRAPHERS: CHARLES SHEELER • BERND AND HILLA BECHER • ROBERT ADAMS
STEPHEN SHORE • RICHARD LONG • EDWARD BURTYNSKY

An exhibition in 1975 defined a photography style that developed in the postwar years and detailed the industrialization of urban and rural spaces.

The exhibition 'New Topographics: Photographs of a Man-Altered Landscape', which took place in 1975 at the International Museum of Photography at the George Eastman House in Rochester, New York, presented the works of eight young American photographers whose focus was the human impact on landscapes. The locations ranged from industrial sites to suburban sprawl, and the images suggested that landscape has never been 'natural'. The new topographers, who included Robert

Adams (b.1937), Lewis Baltz (1945–2014) and Stephen Shore (b.1947), were critical of these developments. The exhibition also featured the pivotal work of Bernd Becher (1931–2007) and his wife, Hilla (1934–2015). The Bechers began photographing Germany's industrial Ruhr Valley in 1959. More than capturing the mechanics, as Charles Sheeler had done in his portraits of American factories, they employed a systematic approach to the cataloguing of buildings. This focus on the relationship between industry and landscape has been continued by Edward Burtynsky with his global environmental surveys (see page 152).

KEY DEVELOPMENTS
In addition to their ground-breaking photography, Bernd and Hilla Becher were instrumental in setting up the photography department at the Kunstakademie Düsseldorf. Their approach became known as the Düsseldorf School, and photographers influenced by their work and Bernd Becher's teachings include Andreas Gursky (see page 150), Thomas Ruff (b.1958), Thomas Struth (see page 132) and Candida Höfer (b.1944).

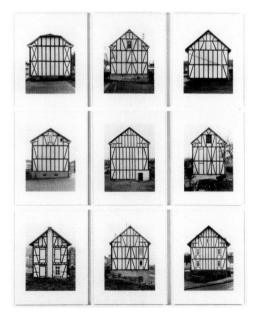

Framework Houses, Siegen Area, Germany, 1959–89, Bernd and Hilla Becher, 1989, 9 black and white photographs, overall dimensions 173 x 142 cm (68 x 56 in), BHB-128 (9)

NEW YORK, NIGHT VIEW **p.78** LOUVRE 1, PARIS, 1989 **p.132** OVERPASS **p.146** SALT PANS #13 **p.152** ARCHITECTURE **p.157** CITYSCAPE **p.168** MODERNITY **p.176**

Fashion

KEY PHOTOGRAPHERS: MAN RAY • GEORGE HOYNINGEN-HUENE • HORST P. HORST
CECIL BEATON • DAVID BAILEY • TERENCE DONOVAN • DIANE ARBUS • BRUCE WEBER

The emergence of illustrated magazines at the beginning of the twentieth century increased the demand for photographers skilled in capturing the nuances of fashion. *Harper's Bazaar* had been in operation since 1867, but the arrival of photography and developments in halftone printing transformed the magazine into a burgeoning industry. In 1911 Condé Nast took over *Vogue*, and thereafter rivalry between the publications intensified. The same year, the French magazine *Art et Décoration* commissioned Edward Steichen to shoot designs by the avant-garde couturier Paul Poiret. Steichen claimed that these were the earliest fashion photographs,

although the look he adopted owed much to illustrations by Paul Iribe and Georges Lepape. His move prompted career changes by other photographers, including Baron Adolph de Meyer, one of the prominent Pictorialists, who became *Vogue*'s first contract photographer. By the 1920s, fashion photography was flourishing and the likes of George Hoyningen-Huene took their shoots outside the studio. Hoyningen-Huene also popularized the use of male models, such as Horst P. Horst (1906–99), who himself became a major photographer (see image below).

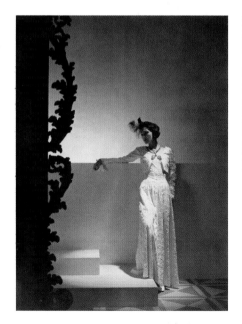

KEY DEVELOPMENTS
During World War II countries had struggled under occupation or extreme austerity. Although black-and-white photography remained the more 'artistic' form of expression, fashion magazine editors recognised in colour the opportunity to set an aspirational tone in their publications. The exotic was employed, either in the choice of location for a shoot or in the design of clothes. Diana Vreeland, editor of *Harper's Bazaar* from 1936 to 1952, led the charge, her vision moulding fashion for a changed world.

Vogue 1937, Fashion Designer Coco Chanel, Horst P. Horst, 1937

DIVERS **p.72** BEAUTY **p.158** CELEBRITY **p.167** CONSUMERISM **p.169** MODERNITY **p.176** YOUTH CULTURE **p.186** COLOUR **p.199** KODACHROME **p.207**

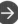

Advertising

KEY PHOTOGRAPHERS: EDWARD STEICHEN • ALFRED STIEGLITZ • IRVING PENN
BRUCE WEBER • HELMUT NEWTON • GUY BOURDIN • JUERGEN TELLER

Beetle Sedan, Anon, c.1961

Print advertising had existed since the 1830s, but the opportunities afforded by photography at the start of the twentieth century made this form of promotion increasingly attractive.

Rotogravure printing, which produced higher-quality images, caused the profits accrued through magazine and newspaper sales to be overtaken by advertising revenues. Fashion led the way. Edward Steichen, the most successful fashion photographer of the 1930s, branched out to oversee campaigns for other products, but with little impact on his artistic integrity. His shots for Woodbury Soap ads in 1935 are reminiscent of his more abstract work. A beautifully lit shot features a nude with her back to the camera. Soapy water runs down her body, while her face is in shadow and her limbs are pulled in close. The image equated the product with glamour and sex.

By the end of World War II, photographic advertising was rapidly becoming the norm. Its use ranged from sophisticated to crude; a relaxation of moral attitudes enabled the depiction of sexuality to shift from the coyly suggestive to the openly provocative. The use of photographers better known for their gallery work also blurred the line between art and commerce.

KEY DEVELOPMENTS
In the early 1960s, Volkswagen was keen to break into the US car market with its Beetle. However, the design seemed anathema to the style and look of American automobiles. Instead of highlighting its virtues, the ad campaign for the car was playful, self-deprecating and effective. In going up against the behemoth US car industry, Volkswagen emphasized how small it and its car were. It worked, and the campaign was a watershed moment for alternative advertising methods.

BEAUTY **p.158** ICONOGRAPHY **p.166** CELEBRITY **p.167** CONSUMERISM **p.169** MODERNITY **p.176**
YOUTH CULTURE **p.186** APPROPRIATION **p.187**

Paparazzi

KEY PHOTOGRAPHERS: WEEGEE • MARCELLO GEPPETTI • RINO BARILLARI
RON GALELLA • MEL BOUZAD

The name came originally from a film, but in the years since it has defined a style of photography that aims to capture images of public figures in their private lives.

In Federico Fellini's celebrated movie portrait of Rome, *La Dolce Vita* (1960), the actor Walter Santesso played a press photographer named Paparazzo, a variation on the Italian dialect word that suggests an annoying sound. During that era real-life versions of Paparazzo, Marcello Geppetti (1933–98) and Rino Barillari (b.1945), stalked celebrities who were visiting the Italian capital. These photographers' behaviour was replicated in most European countries and America, although the British press attracted the most ire for their intrusion into the lives of the rich

and famous. The paparazzis' defence has generally been to argue that they are merely responding to public demand for greater access, and that celebrities need paparazzi to ensure that they remain in the public eye. Many countries have since introduced privacy laws to curb the worst excesses of the paparazzi, particularly in the light of high-profile events such as the hounding of Princess Diana, which some people believe contributed to the Paris road accident in which she was killed in 1997.

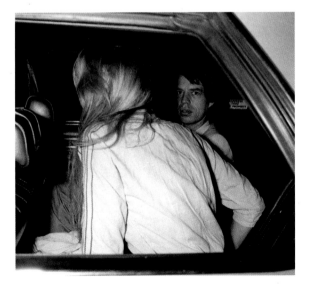

KEY DEVELOPMENTS
A landmark legal case to curb the activities of paparazzi in the United States took place in 1972. Ron Galella (b.1931), who had been photographing Jacqueline Kennedy Onassis in New York, sued her after her security guard destroyed his camera and film. She counter-sued on grounds of harassment. She won the case and Gallela was served with a restraining order.

Jerry Hall and Mick Jagger Sighted on July 6, 1981 at Gibbon Restaurant in New York City, Ron Galella, 1981

COP KILLER **p.86** CELEBRITY **p.167** MUSIC **p.185** SLR **p.208**

Conceptual

KEY PHOTOGRAPHERS: HIPPOLYTE BAYARD • CINDY SHERMAN • GILLIAN WEARING
JOHN HILLIARD • MARTHA ROSLER

Although conceptual photography has become increasingly prevalent since the 1960s, its antecedents date back to the medium's infancy.

As its name suggests, it is a movement that explores ideas more than form or representation. Photography's relationship with conceptual art is twofold. One aspect lies in the documentation of an event or activity – an artist uses a photograph as the record of what took place. The other employs the photograph as the artwork itself. An early example of the latter is *Self Portrait of a Drowned Man* (1840) by Hippolyte Bayard (1801–87). His play with identity presages the work of photographers such as Claude Cahun and Cindy Sherman, who use alter egos to explore gender roles. Gillian Wearing's work also explored identity and questioned the veracity of the image (see page 136). A similar theme was explored by John Hilliard (b.1945) in *Cause of Death* (1974), which asks a question that has become increasingly relevant in the digital age: is what we are looking at real?

KEY DEVELOPMENTS
Land artists initially used photography as a record of their work. Artists such as Walter De Maria (1935–2013), Hans Haacke (b.1936), Richard Long (b.1945), Robert Morris (b.1931), Dennis Oppenheim (1938–2011) and Robert Smithson (1938–73) carved into landscapes or used natural materials to create immense structures that were then photographed, often from elevated or aerial perspectives. Smithson's *Yucatán Mirror Displacements* (1969) went further, involving photography more directly in his creative process.

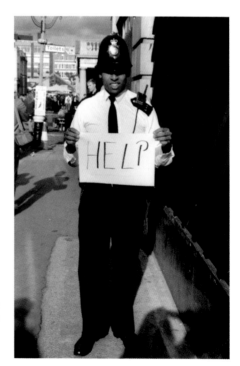

HELP, from the series *Signs that say what you want them to say and not Signs that say what someone else wants you to say*, Gillian Wearing, 1992–93, c-type print mounted on aluminium, 44.5 x 29.7 cm (17½ x 11¾ in)

WORK TOWARDS WORLD PEACE **p.136** APPROPRIATION **p.187** PHOTOMONTAGE **p.212**

Staged

KEY PHOTOGRAPHERS: HENRY PEACH ROBINSON • BRASSAÏ • YEVGENY KHALDEI
ROBERT DOISNEAU • CINDY SHERMAN • GREGORY CREWDSON

From intentionally fictional scenarios to subjects choreographed against real backdrops, staged photography prompts many questions about the truth of the images set before the viewer – can we believe our eyes?

Beyond portraiture, photographers have often organized situations to suit the composition of their images. One early image actually highlights the work of photographers, with William Henry Fox Talbot (1800–77) and colleagues seemingly preparing a shot in *The Reading Establishment* (1845). Many of Brassaï's shots of 1930s Paris at night were staged so that the photographer could achieve the tone he was looking for (see page 76).

Robert Doisneau's *The Kiss at the Hotel de Ville* (below) was a staged re-creation of a moment that had taken place off-camera just instants before. More recently, Gregory Crewdson's elaborate scenarios resemble film sets. Staged photography becomes more problematic when the context is real, such as Alexander Gardner moving a body he had shot in a previous photograph some 40 yards in order to take *The Home of a Rebel Sharpshooter* (1865), or Yevgeny Khaldei's *The Red Flag on the Reichstag, Berlin* (see page 25).

KEY DEVELOPMENTS
Jeff Wall's images appear to capture life as it is happening (see page 146). Like Robert Doisneau's *The Kiss at the Hotel de Ville*, his work appears to have caught people in one moment of their life. But unlike Doisneau's image, in which only the main couple are actors, everything in Wall's images is staged.

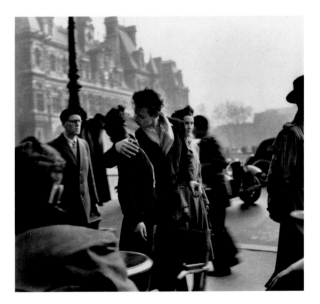

The Kiss at the Hotel de Ville, Robert Doisneau, c.1950, silver print, Gamma-Rapho Agency, Paris, France

LOVERS IN A PARIS CAFÉ **p.76** THE KISS AT THE HOTEL DE VILLE **p.96** UNTITLED #96 **p.122**
BENEATH THE ROSES **p.148** ICONOGRAPHY **p.166** THE DECISIVE MOMENT **p.174**

Performance

KEY PHOTOGRAPHERS: CINDY SHERMAN • SOPHIE CALLE • GILLIAN WEARING
GREGORY CREWDSON • GOHAR DASHTI • ZHANG HUAN

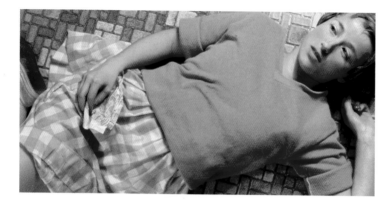

Untitled #96, Cindy
Sherman, 1981,
chromogenic colour
print, 71 x 122 cm
(24 x 48 in)

Closely linked to conceptual and staged photography, performance photography places the subject within a specific environment to explore issues that range from politics and gender to personal identity and social space.

Cindy Sherman's self-portraiture questions cultural stereotypes and assumptions, particularly in terms of female representation. Sophie Calle (b.1953) also challenges gender classification, but her images blur real-life and constructed scenarios. Individuals encountered on the street take an even more participatory role in Gillian Wearing's work, which engages with the way we perceive images. Eschewing the individual, Spencer Tunick (b.1967) photographs thousands of nudes, creating a landscape that juxtaposes the organic and the mechanical. Gregory Crewdson's meticulously crafted scenarios deconstruct American suburbia, while the work of Gohar Dashti (b.1980) from Iran and

Zhang Huan (b.1965) from China tackles current social issues from a cultural and historical perspective.

KEY DEVELOPMENTS

Cindy Sherman first attracted critical attention as part of a collection of artists known as the Pictures Generation, whose work was shown together at a New York gallery in 1977. The group included Barbara Kruger (b.1945), Louise Lawler (b.1947), Robert Longo (b.1953), David Salle (b.1952), Richard Prince (b.1949), Jack Goldstein (1945–2003) and Sherrie Levine (b.1947). Their work employed appropriation and played with cultural icons and stereotypes, and became a huge influence on the contemporary art landscape in the 1980s.

SELF-PORTRAIT **p.48** BEATRICE **p.56** UNTITLED #96 **p.122** WORK TOWARDS WORLD PEACE **p.136**
BENEATH THE ROSES **p.148** CONSUMERISM **p.169** APPROPRIATION **p.187**

Contemporary Art

KEY PHOTOGRAPHERS: GERHARD RICHTER • WOLFGANG TILLMANS • RICHARD BILLINGHAM
GILLIAN WEARING • PIERPAOLO FERRARI

The prevalence of photography at art awards points to the critical establishment's embrace of the medium as an art form and artists' ongoing engagement with the recorded image.

In 2000 Wolfgang Tillmans became the first photographer to win the Turner Prize, Britain's most prestigious and controversial art award. His body of work encompassed both figurative and abstract images, often questioning the role of photography in art and contemporary life. It is a question asked by many contemporary artists who employ photography, dating back to Gerhard Richter (b.1932), whose body of work eschews any adherence to a particular style, and who has used photography both

as part of an artwork and as an end in itself. Tracey Emin (b.1963), like Claude Cahun and Cindy Sherman before her, has used photography to explore subjectivity and personal history. Richard Billingham (b.1970) played with the conventions of the family photograph to produce a shocking portrait of family dysfunction. Along with Gillian Wearing, Emin and Billingham were part of the Young British Artists group that emerged in the 1990s and whose work, like that of Tillmans and Richter, questions our perception of everyday life and photography's capacity to record it.

KEY DEVELOPMENTS
With their cult magazine *Toiletpaper*, Maurizio Cattelan (b.1960) and Pierpaolo Ferrari (b.1971) purport to create a periodical that features appropriated images. But each image has been specially created by the artist and the photographer. Playful, humorous and often deliriously colourful, the images channel Sigmund Freud's notion of the uncanny, seeming both strange and familiar, linking surrealism with fashion, advertising and contemporary mores.

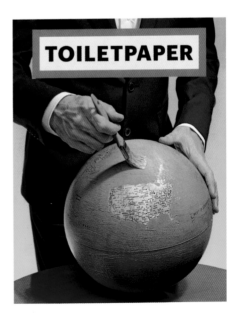

Front Cover of *Toiletpaper magazine 12*, Maurizio Cattelan & Pierpaolo Ferrari, 2016, offset printed magazine in high-density colour inks, 29 x 22.5 cm (11½ x 9 in)

UNTITLED #96 **p.122** LUTZ & ALEX SITTING IN THE TREES **p.134** WORK TOWARDS WORLD PEACE **p.136** THE SURREAL **p.162** CONSUMERISM **p.169** APPROPRIATION **p.187** →

The Selfie

KEY PHOTOGRAPHERS: MARTIN PARR • GILLIAN WEARING • KIM KARDASHIAN • ALEC SOTH
OROMA ELEWA • MOLLY SODA • THE ART HOE MOVEMENT

The term 'selfie' was first used on an Australian Internet forum in 2002 and has since come to represent the most ubiquitous form of self-portrait.

The selfie's popularity grew with the increasing sophistication of smartphone technology and the widespread use of social network sites. Earlier examples include the shot Buzz Aldrin (b.1930) took of himself while spacewalking outside *Gemini 12* in 1966. Discussion of selfies soon broaches the topic of narcissism, best exemplified by *Selfish* (2015), a book by Kim Kardashian (b.1980) that features 325 pages of self-portraits. Younger artists have embraced the form. The Art Hoe Movement is a collective of women who use the selfie to

challenge mainstream representations of black people. In 2017 London's Saatchi Gallery held an exhibition of selfies, drawing a line between painters' self-portraits and selfies taken by celebrities and members of the general public. In everyday use, selfies rarely involve any engagement with form, often being little more than updates on one's current activity. If conventional photography is, as Paul Strand described it, 'a record of your living', the selfie can be regarded as both a record of and a replacement for actual experience.

KEY DEVELOPMENTS
Alec Soth (b.1969) has been regarded as his generation's Walker Evans, his work a world away from the average selfie portrait. After joining Instagram in 2013, he began to produce what he called 'unselfies', self-portraits in which his face is partially or wholly obscured. Often humorous and beautifully staged, the images question the very act of self-portraiture.

The Unselfie, Alec Soth, 2015

SELF-PORTRAIT **p.48** SELF-PORTRAIT IN DRAG **p.120** UNTITLED #96 **p.122** BEAUTY **p.158** YOUTH CULTURE **p.186** POLAROID **p.211**

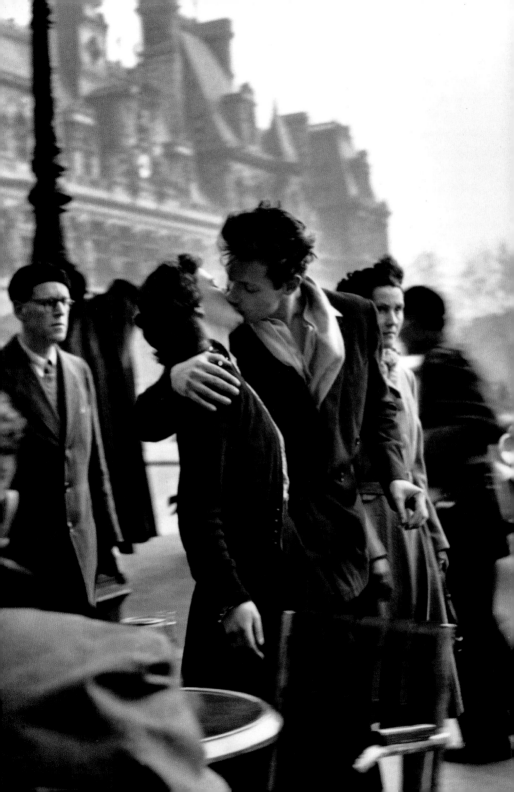

WORKS

View from the Window at Le Gras

NICÉPHORE NIÉPCE: HELIOGRAPH • 16.5 x 20 CM (6⅝ x 7⅞ IN)

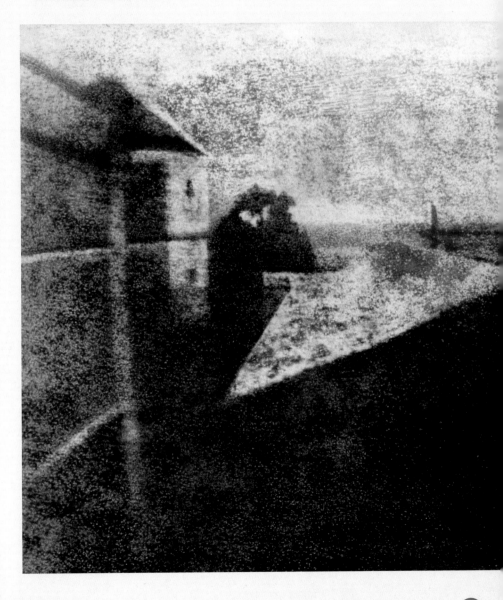

Inventor and scientific pioneer Nicéphore Niépce (1765–1833) developed his interest in lithography and experiments with a camera obscura into one of the first major breakthroughs in photography.

The earliest surviving photographic image was believed lost for over 50 years, until a print was uncovered in a trunk in 1952 by the photography historian Helmut Gernsheim. To produce it, Niépce took a pewter plate and coated it with a thin layer of bitumen of Judea, a naturally occurring asphalt. The compound's light-sensitive qualities enabled him to develop a process he called Heliography. The coating became hardened in its exposure to light, and when it was washed with the solvent oil of lavender, only the hardened elements remained – the image having literally been etched by the sun's rays. Niépce's first attempt at capturing this view from one of the rooms in his family home was made on the surface of a lithographic plate, but it was eventually erased. This later photograph was originally believed to have been the result of an eight- or nine-hour exposure to the sun's light on facing walls. But one researcher, using Niépce's notes and the same photographic process, placed the exposure time at a few days.

NICÉPHORE NIÉPCE

Nicéphore Niépce set up a laboratory for scientific research at his family home in Chalon-sur-Saône, Burgundy. He followed his heliographic process with the physautotype, which he developed in tandem with Louis Daguerre. He also invented the Pyréolophore, the world's first internal combustion engine, but his brother's profligate spending in promoting it left them both poverty-stricken.

ARCHITECTURE **p.157** CAMERA OBSCURA **p.190**

Self-Portrait

C.1855

NADAR: SALTED PAPER PRINT FROM GLASS NEGATIVE
20.5 x 17 CM (8¹⁄₁₆ x 6¹¹⁄₁₆ IN) • THE J. PAUL GETTY MUSEUM, LOS ANGELES, USA

Other works by Nadar
Charles Baudelaire (1855)
Sarah Bernhardt (1864)
Edouard Manet (1870)

Breaking away from the conventions of photographic portraiture, Nadar (1820–1910) became the exemplar of instantaneity, capturing his subjects as active participants rather than passive sitters.

Very much a product of the Romantic Age, the colourful Nadar was an editor, novelist and caricaturist (and a sometime debtor, subversive and spy) whose skill in mimicking people on paper was matched by his ability to capture their essence in his studio. His portraits were exemplary in their use of the available technology, including artificial light. In discussing his work, Nadar referred to 'the moral grasp' of his subject, emphasizing 'that instant understanding which puts you in touch with the model'. In comparison with the portraits taken by many of his contemporaries, Nadar's subjects look more engaged, even jovial or apparently in conversation with him. His most outstanding work was produced between 1854 and 1870, during which time he took many self-portraits. The example shown here highlights what made him so great. His hands are perfectly poised. And his hair, wispy as it catches the light, hints at flamboyance, while his expression – partly shrouded in shadow – is a combination of seriousness and mischief.

NADAR
The son of a printer and bookseller, Paris-born Gaspard-Félix Tournachon was known as Tournadar, which was eventually shortened to Nadar. His first photographic studio was opened in 1854; by the 1890s he was more interested in the development of flying machines and became the first aerial photographer.

PORTRAITURE **p.15** SELF-PORTRAITURE **p.21** SOCIETY **p.34**

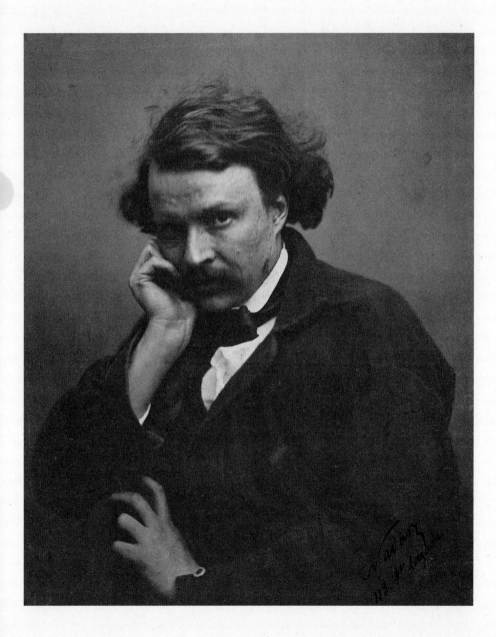

Still Life with Fruit and Decanter

1860

ROGER FENTON: ALBUMEN SILVER PRINT • 35.4 x 43.2 CM (13¹⁵⁄₁₆ x 17 IN)
THE J. PAUL GETTY MUSEUM, LOS ANGELES, USA

Other works by Roger Fenton
Valley of the Shadow of Death
(1855)

*Westminster Abbey and the
Palace of Westminster Under
Construction* (1857)

The Sanitary Commission (1855)

An acclaimed war photographer whose emphasis on action as well as place helped to define photojournalism in its nascent years, Roger Fenton (1819–69) also produced an extraordinary series of still lifes that highlighted his technical prowess.

This study, a detailed demonstration of the capacity of photography to match the textural and compositional achievement of painting, was one of 40 still-life portraits of fruit and flowers that Fenton produced in 1860. The objects were arranged on marble and fabric within a tight timeframe, hence the recurrence of certain fruit, and their ripeness is indicated by the presence of wine glasses and decanters. Fenton used gold-toned albumen prints that gave the image a richer purple-brownish shade.

The previous decade, Fenton had captured the scale and senseless depravity of the Crimean War, presenting a chilling record of inhumanity. The still-life portraits also deal with the tenuousness of life – it is possible to see the fruit gradually decaying across the series. They underpin the notion that we are born of the earth and eventually return to it. But the choice of fruit also hints at the growing wealth of the Victorian middle class, as well as the reach of the British Empire in obtaining it.

ROGER FENTON
Born in Rochdale, Lancashire, Roger Fenton studied art under the French Romantic painter Paul Delaroche, but changed to photography in 1851. In addition to his still-life portraits and images from the front line of the Crimean War, he was instrumental in founding the Photographic Society.

MONOCHROME **p.12** STILL LIFE **p.20** ART **p.31**

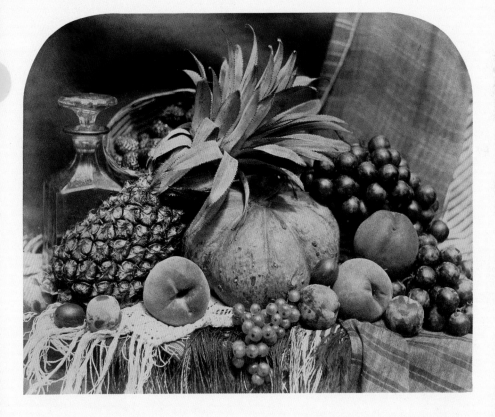

A Harvest of Death

TIMOTHY H. O'SULLIVAN: ALBUMEN SILVER PRINT • 17.8 x 22.1 CM
(7 x 8¹¹⁄₁₆ IN) • THE J. PAUL GETTY MUSEUM, LOS ANGELES, USA

An apprentice in his teens to Mathew Brady, Timothy
H. O'Sullivan (c.1840–82) became one of the most
important chroniclers of the American Civil War.

The images captured during the conflict represent a
seismic shift in the role of photojournalism in the United
States. O'Sullivan was one of ten photographers Brady
commissioned to record the war, photographing key
figures and military encampments, and getting as close to
the battlefield as safety would allow. The resulting images,
Brady noted, presented audiences with 'the eye of history'.

Gettysburg was the most brutal battle of the war,
resulting in the deaths of approximately 50,000 soldiers
over three days, from 1 to 3 July 1863. O'Sullivan
chillingly captured the bleak, deathly landscape in its
immediate aftermath, while bodies lay strewn across the
field of conflict. The photograph's title was supplied by
Alexander Gardner in his book *Gardner's Photographic*

Below: The images of the bodies would
have shocked contemporary viewers,
so O'Sullivan refrained from approaching
the dead too closely, but the line of
bodies in the foreground emphasizes the
horror that took place.

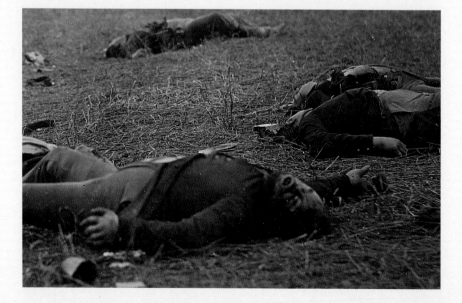

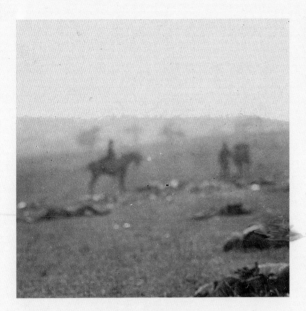

Other works by Timothy H. O'Sullivan

Pontoon Bridge Across the Rappahannock. Virginia (1863)

Ancient Ruins in the Cañon de Chelle, New Mexico (1873)

Aboriginal Life Among the Navajo Indians Near Old Fort Defiance, New Mexico (1873)

Left: Almost spectral in appearance, the two horsemen give a sense of scale to the battle and reassurance that there is life after the carnage.

Sketchbook of the War, which featured many of the conflict's most important images. Although Gardner described the scene as featuring rebel dead, subsequent scholars have noted that it mainly features Union soldiers. Most of the bodies in the photograph are missing their shoes, which were routinely removed owing to the scarcity of footwear. Stark and direct, the image is made more unsettling by the mist – a death shroud – in the distance. Unlike modern wars, which typically devastate the earth, the landscape here looks unaffected by the conflict; were it not for the bodies strewn across the field, this scene might be a pastoral idyll.

TIMOTHY O'SULLIVAN

Towards the end of the Civil War, O'Sullivan was attached to General Ulysses S. Grant's division, with which he witnessed the sieges of Petersburg and Fort Fisher, and was present at the surrender of Robert E. Lee at Appomattox Court House in April 1865. O'Sullivan went on to become a pioneer in the field of geophotography.

→ DEATH **p.165**

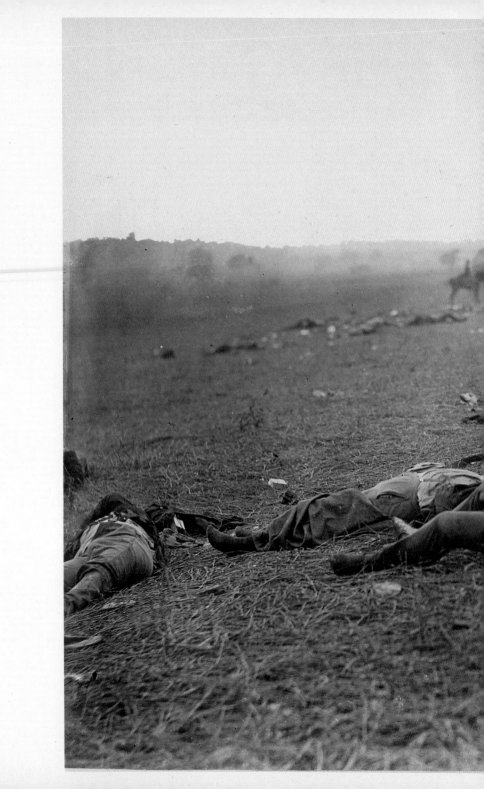

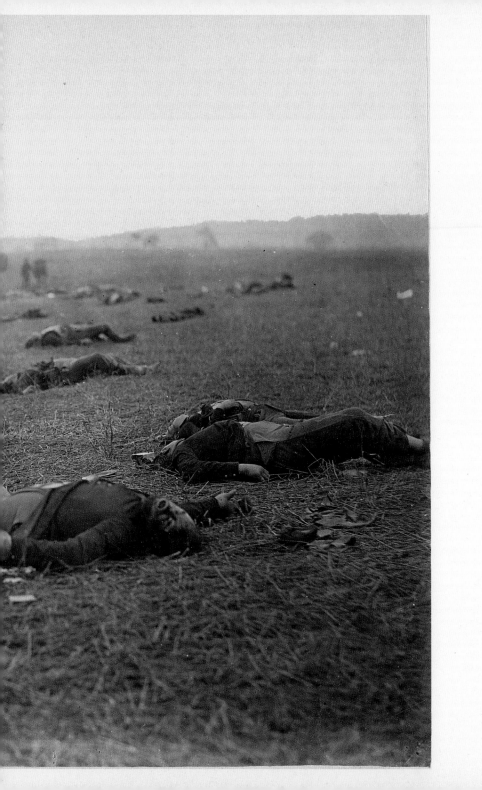

Beatrice

1866

JULIA MARGARET CAMERON: ALBUMEN SILVER PRINT
33.8 x 26.4 CM (13⁵⁄₁₆ x 10⅜ IN) • THE J. PAUL GETTY MUSEUM,
LOS ANGELES, USA

**Other works by
Julia Margaret Cameron**
Hosanna (1865)
Whisper of the Muse (1865)
Julia Jackson (1867)

An early champion of photography as an art form,
Julia Margaret Cameron (1815–79) produced beguiling
portraits that prioritized artistry and the spiritual essence
of an image over technical perfection.

Ethereal and mournful, Cameron's visualization of
Beatrice Cenci, immortalized by Percy Bysshe Shelley's
verse drama of 1819, best exemplifies the photographer's
desire to move away from the instantaneous towards art.
Inspired by Guido Reni's portrait of c.1600 of the Italian
noblewoman executed for conspiring to murder her
brutal father, Cameron wanted to tap into the spirituality
of her subject – to reach beyond the physical and into a
realm of pure emotion. Although dismissed by many of
her peers, Cameron's work has gained currency over time.
Her images employ light and soft focus to startling effect.

Beatrice was taken with a large camera that Cameron
had recently acquired, which held a 38 x 30.5 cm (15 x 12
in) negative. In addition to producing grander tableaux,
Cameron used the larger scale to move even closer to
her subject. Like so many of her images, *Beatrice* finds
its subject's gaze fixed away from the lens. If Reni's
portrait suggests the faintest hint of plea in her
expression, Cameron's photograph records resignation,
acceptance of the fate that lies in store.

JULIA MARGARET CAMERON
Cameron's career as a photographer spanned just 11 years, starting
in 1864. Born in Calcutta and educated in France, she then returned
to India and remained there until 1848, when she moved to London,
where her career was established. She moved in 1875 to Ceylon (now
Sri Lanka); there her output declined because of her lack of access to
photographic materials.

PICTORIALISM **p.13** PORTRAITURE **p.15** STAGED **p.40**

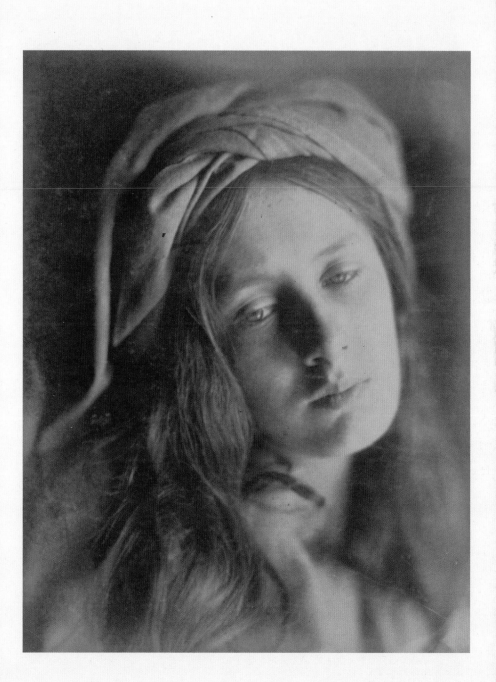

The Mudlarks

c.1880

FRANK MEADOW SUTCLIFFE: ALBUMEN SILVER PRINT

A founder member of the Brotherhood of the Linked Ring, which sought to raise photography to the level of art, Frank Meadow Sutcliffe (1853–1941) evocatively recorded English coastal life at a time when tradition was being eclipsed by modernization.

The Yorkshire coast that Sutcliffe knew was, in his eyes, a disappearing one. Portraiture provided his main income, but documentary pictorialism was his passion – capturing the daily life of Whitby's indigenous population, whose traditional way of life as fisherpeople and boatbuilders was being eroded by tourism. Though often staged – the art of pictorialism lay in balancing the appearance of nature against the requirements of art – Sutcliffe's photographs captured the spirit of the townspeople at work and play. *The Mudlarks* finds four youths on a break from their search at low tide for objects of value in the sea bed. Their dress informs us of their economic circumstances, but their demeanour and expressions suggest that riches would be unlikely to make them happier than they are in this moment. This was one of Sutcliffe's many portraits of children, which culminated in the controversial *The Water Rats*, a photograph from 1886 that featured naked boys playing in water and whose notoriety led to the photographer being excommunicated by his local clergy.

FRANK MEADOW SUTCLIFFE
The son of a celebrated landscape painter, Sutcliffe was born in Leeds. Initially settling in Kent, he moved back north to Whitby and then to Sleights, Yorkshire. In addition to recording northern English coastal and rural life, he wrote prolifically on photographic subjects and was a columnist for the *Yorkshire Weekly Post*.

LANDSCAPE **p.16** ETHNOGRAPHY **p.26** DOCUMENTARY **p.28** STAGED **p.40**

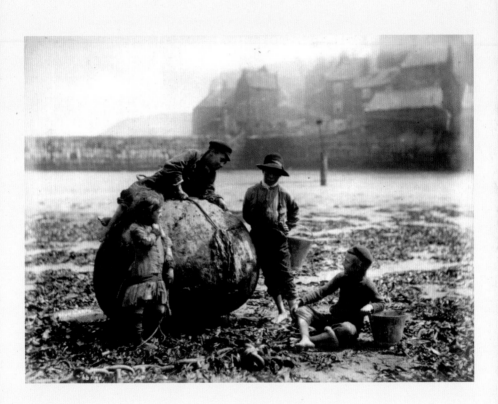

Other works by Frank Meadow Sutcliffe
The Water Rats (1886)
Girl on the Shore (1889)
Stern Realities (1890)

CLASS **p.170** POVERTY **p.171** PEOPLE **p.173** ALBUMEN PAPER **p.195**

The Steerage

1907

ALFRED STIEGLITZ: PHOTOGRAVURE • 35.5 x 26.4 CM (13³/₁₆ x 10⅜ IN)
THE J. PAUL GETTY MUSEUM, LOS ANGELES, USA

ALFRED STIEGLITZ
Born in Hoboken, New Jersey, Stieglitz studied in Europe, where he forged his reputation before returning to the United States in 1900. He revolutionized the landscape of American photography with a secession movement that, like its European counterpart, sought to elevate photography to an art form.

One of the most important photographers in the history of the medium, Alfred Stieglitz (1864–1946) moved from pictorialism to modernism and set the course for the way American photography would develop in the twentieth century.

Stieglitz took this image with a 10.1 x 12.7 cm (4 x 5 in) Auto-Graflex on the last prepared glass plate he had with him. The result marked a shift away from a sparse, painterly approach towards documentary. The sharp geometric lines highlight the class divisions between decks, while the tight framing accentuates the sense of claustrophobia felt by those of limited means. Some have misread the photograph as representing the dawn of a new age for many of the passengers. However, these were not poverty-stricken aspirants for US citizenship, but people likely to have been denied entry into the country and facing a long journey eastwards, back to their homeland. As such, it exudes a tone of despair rather than hope.

Although Stieglitz remarked in later life that 'If all my photographs were lost, and I were represented only by *The Steerage*, that would be quite all right,' he waited four years before he published this image. And it was another two years before he exhibited it at his celebrated Gallery 291 in New York.

Other works by Alfred Stieglitz
Winter, Fifth Avenue (1892)
From the Back Window – 291 (1915)
Georgia O'Keeffe – Torso (1918–19)
Equivalent (1930)

STRAIGHT PHOTOGRAPHY **p.14** ETHNOGRAPHY **p.26** SOCIETY **p.34** DOCUMENTARY **p.28**

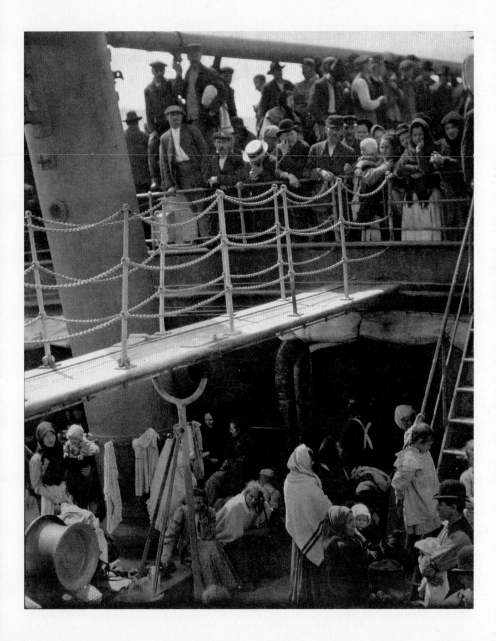

CLASS **p.170** POVERTY **p.171** PEOPLE **p.173**

The Entrance to the Pyramid of Menkaure

1913

FRIEDRICH ADOLF PANETH: AUTOCHROME • ROYAL PHOTOGRAPHIC SOCIETY, UK

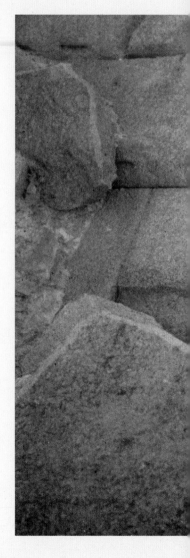

A chemist and an authority in his time on volatile hydrides and the composition of the stratosphere, Friedrich Adolf Paneth (1887–1958) was also an amateur photographer whose vast collection of photographs from his family's various holidays are extraordinary early colour portraits of a bygone era.

Shortly after graduating from the University of Vienna, Paneth met and married Else Hartmann. On his honeymoon to Cairo, he took a camera loaded with Autochrome plates, which became the first in a collection of over 2,000 images taken between 1913 and the mid 1930s spanning Europe, Russia and the Middle East. They were remarkable for their use of colour at a time when the majority of images viewed around the world were in black and white. This portrait of Else and an Egyptian in front of the Menkaure Pyramid, the smallest of the three main pyramids of Giza on the southwestern outskirts of Cairo, is subtly framed. It gives equal importance to both subjects, who are positioned in alignment with the rocks around them. In contrast to the earlier, monolithic portraits of Egypt's monuments by Francis Frith and James S. Virtue, Paneth's image is personal. Other photographs taken on family excursions are divided between intimate moments and more conventional shots of local people and landmarks. Few are as enigmatic as this image.

Other works by Friedrich Adolf Paneth
Snowy Mountains (1915)
Heinz and Eva on the Hillside (1925)
Quay Market (1934)

LANDSCAPE **p.16** COLOUR **p.18** ETHNOGRAPHY **p.26**

FRIEDRICH ADOLF PANETH
An Austrian refugee from the Nazis, Paneth remained in Britain from 1933 until the end of World War II, after which he moved to Germany to lead the Max Planck Institute for Chemistry in Mainz, where he remained until his death.

Mechanic and Steam Pump

1921

LEWIS HINE: GELATIN SILVER PRINT • 24.4 X 19.4 CM (9⅝ X 7⅝ IN)
THE J. PAUL GETTY MUSEUM, LOS ANGELES, USA

Other works by Lewis Hine
Self-Portait with Newsboy
(1908)
Oyster Shuckers in Dunbar Cannery, Louisiana (1911)
Raising the Mast, Empire State Building (1932)

Lewis Hine's (1874–1940) early work prompted changes in US child labour laws, while his approach to documentary photography in the 1920s presented a portrait of urban industrialization that contrasted sharply with the rural images produced a decade later by photographers commissioned by the Food Standards Agency (FSA).

After his groundbreaking work with the National Child Labor Committee, Hine widened his focus to document all aspects of an expanding industrial workforce. However, his enthusiasm for the mechanization of contemporary American society was tempered by the conditions in which he witnessed countless people working.

Mechanic and Steam Pump first appeared in the December 1921 edition of the sociological journal *The Survey Graphic*. It was one of many photographs taken throughout the decade by Hine inside the country's vast power plants. Accentuating the lines of every pivot and joint, the image highlights the photographer's awe at the scale of industry, yet remains committed to his notion that the vast machinery could function effectively only through the intense labour of the US workforce. It presents a symbiotic relationship between man and machine, the spanner a channel between metal and flesh. In this meticulously constructed shot, Hine transforms a lone worker into a symbol of human industry.

LEWIS HINE

A sociologist who employed a camera to advance social reform, Lewis Hine produced shocking portraits of child labour that were instrumental in changing US labour laws. His epiphany regarding the power of the photographic image came from four years – between 1904 and 1909 – of documenting the immigrant experience at Ellis Island. Hine would later document the work of the Red Cross during World War I and the construction of the Empire State Building; he also mentored a new generation of photographers, including Paul Strand.

STREET PHOTOGRAPHY **p.17** SELF-PORTRAITURE **p.21** SOCIETY **p.34**

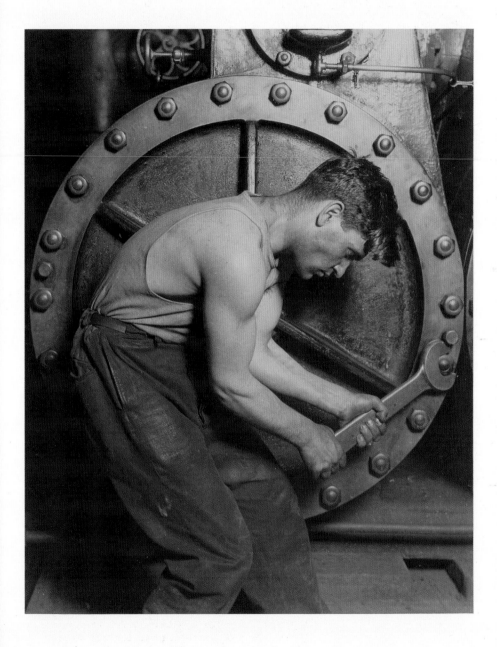

MOVEMENT **p.161** TECHNOLOGY **p.175** MODERNITY **p.176**

Ingres' Violin

1924

MAN RAY: SILVER PRINT RETOUCHED WITH PENCIL AND INDIAN INK
29.6 x 22.7 CM (11⅝ x 8¹⁵⁄₁₆ IN)

Other works by Man Ray
Untitled Rayograph (1922)
Solarized Portrait of Lee Miller (1929)
Glass Tears (1932)

American-born Man Ray (1890–1976) made Paris his home, became the photographic face of both the Dadaist and the Surrealist movements, blurred the line between fashion and art to rapturous effect, and brought dreams to life through his work.

For this portrait of the nightclub singer, actress, painter and artist's model Kiki de Montparnasse, Man Ray painted the *f*-holes of a stringed instrument on to a photographic print and then re-photographed the print. The image appeared in the thirteenth issue of André Breton's *Littérature* magazine in June 1924 and practically heralded the arrival of the Surrealist movement. It references one of Man Ray's inspirations, the French Neoclassical painter Jean-Auguste-Dominique Ingres, who also played the violin. With Kiki's body transformed into a musical instrument, there is a hint that she is something to be played. (She and Man Ray were lovers when this image was created, which further complicates any interpretation.) Her apparent lack of limbs also emphasizes her vulnerability. The title is a French idiom that means 'hobby', which further hints at the ambivalence of the image, between objectification and an appreciation of beauty, albeit with more than a dash of humour.

MAN RAY
Moving to Paris in 1921, Man Ray made Montparnasse his home. A vibrant district frequented by rich and poor alike, it became his base, where he produced portraits of esteemed artists and writers. With his assistant and sometime lover Lee Miller, he developed solarization and created a form of photogram he referred to as the *rayograph*.

PORTRAITURE **p.15** AVANT-GARDE **p.23** ART **p.31**

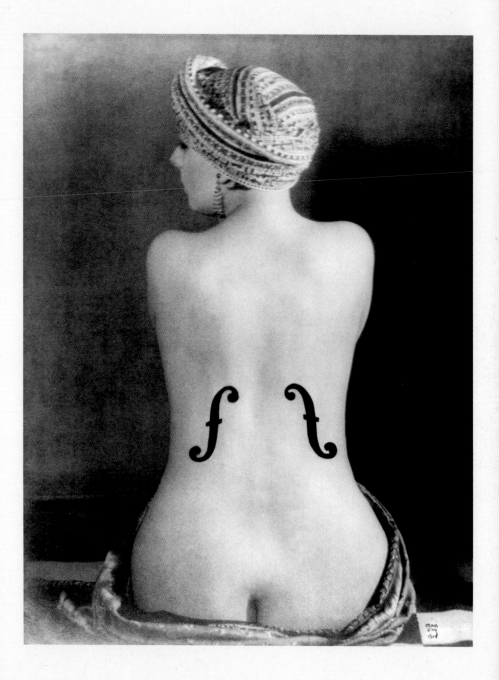

Portrait of Mother

1924

ALEXANDER RODCHENKO: GELATIN SILVER PRINT
22.9 x 15.9 CM (9 x 6¼ IN)

ALEXANDER RODCHENKO
Turning to photography at the age of 33, Alexander Mikhailovich Rodchenko emerged from the Russian Revolution as one of the Soviet Union's pre-eminent artists and one of the few to survive the wrath of Stalin. Photography and photomontage dominated his work in this period before he turned his back on them in the late 1930s, returning to painting and his own form of abstract expressionism.

Inspired by Cubism and Futurism, as well as the Suprematist paintings of Kazimir Malevich, Alexander Rodchenko (1891–1956) became a leading force in the Constructivist movement and a photographer whose impact on graphic design is unparalleled.

Rodchenko's early images comprised a series of photographs of his family and close friends. Outstanding among these is the portrait of his 59-year-old mother. He cropped his negative so closely that it is impossible to see any of the objects that originally featured. Instead we are forced to look at his mother's actions and thus become aware of our own act of seeing. There is admiration, perhaps more than sentiment, in the way Rodchenko has shot his mother as she struggles to read through one lens, her concentration mirrored in the way he has closed off the outside world to focus solely on her. She is dressed simply but nobly, a look that would subsequently become heroic in Soviet propaganda. In the same year, Rodchenko took another photograph of a subject wearing glasses, his friend the literary critic Osip Brik, with one eye obscured by the reflection of text on a lens. It signalled Rodchenko's shift into a different, more radically creative gear.

Other works by Alexander Rodchenko
Shukhov Transmission Tower (1919)
Osip Brik (1924)
The Stairs (1930)

MONOCHROME **p.12** PORTRAITURE **p.15** AVANT-GARDE **p.23**

ICONOGRAPHY **p.166** FAMILY **p.182** PHOTOMONTAGE **p.212**

The Fork

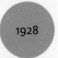

1928

ANDRÉ KERTÉSZ: GELATIN SILVER PRINT • 19.2 x 24.7 CM (7⁹⁄₁₆ x 3⅝ IN)
MUSÉE NATIONAL D'ART MODERNE, CENTRE POMPIDOU, PARIS, FRANCE

Other works by André Kertész
Satiric Dancer, Paris (1926)
Distortion #40 (1933)
The Lost Cloud, New York (1937)

From his early experiments with unorthodox camera angles and style, André Kertész (1894–1985) mastered the art of balancing form and content, taking photographs whose compositional excellence was matched by a capacity to capture the nuances of human behaviour and the beauty of abstraction.

Kertész described the photographer's art as 'a continuous discovery which requires patience and time'. Only through determination and focus is a photographer likely to grasp the meaning of an image, and Kertész regarded the use of tricks as a betrayal of the truth. Everything in this photograph is texture, from the table and dish to the fork and its shadow, interrupted by the rim of the dish and then magnified as it curves over the lip of the receptacle. The thin line where the table ends, stretching over half of the image, contrasts with the streamlined curve of the bowl and fork. Taken at a time when many artists were engaged as much with an object's function as with its form, *The Fork* achieves a beautiful design without obscuring the simple basic role of the utensil. Initially shown in galleries, this photograph was also used in an advert for the silversmith Bruckmann-Besteck.

ANDRÉ KERTÉSZ
Hungarian-born Kertész Andor emigrated to Paris in 1925, changed his name and began to attract attention for his portraits and abstract images. Increasingly in demand, in 1928 he also changed camera format, preferring the smaller Leica to plate-glass cameras. After World War II he moved to the United States, where his reputation grew, although he felt that he deserved even more acclaim than he received.

GELATIN SILVER PRINTS **p.196**

Divers

1930

GEORGE HOYNINGEN-HUENE: SILVER PRINT

A pioneering fashion photographer, George Hoyningen-Huene (1900–68) moved his profession out of the studio and on to location; he also helped to popularize shooting models from elevated perspectives.

This photograph first appeared in the July 1930 edition of US *Vogue* with the caption: 'Two-piece swimming suit with garnet-red trunks and mixed red-and-white top of machine-knit alpaca wool, resembling a sweater weave.' The description of colour was essential for any prospective consumer. What it fails to convey is the beauty of the image. The symmetry of the shot, from the use of the diving board and the subjects' position on it, as well as the light of the summer sun, accentuates the lines of the models' bodies. And although we don't see their faces, there is a sense of longing in their looking out to sea (an imaginary vista: the photograph was taken against a painted backdrop on the roof of *Vogue*'s Paris studio, high above the Champs-Elysées).

Hoyningen-Huene was one of the first fashion photographers to employ male models frequently in his shoots. For many of the shoots, including this one, it was Horst P. Horst. Hoyningen-Huene's protégé and lover, Horst also became a celebrated fashion photographer.

GEORGE HOYNINGEN-HUENE
Born into Russian aristocracy, Hoyningen-Huene fled with his family at the start of the Communist Revolution, first to London and then to Paris. After moving to the United States in 1935, he was contracted to *Harper's Bazaar,* for which he excelled at studio compositions that accentuated shadow, and at outdoor fashion shoots.

PORTRAITURE **p.15** GLAMOUR **p.32** FASHION **p.36** STAGED **p.40**

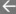

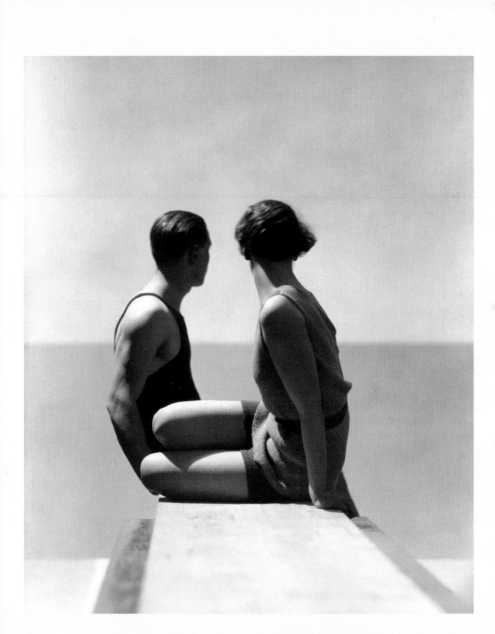

Other works by George Hoyningen-Huene
Dancer Alanova (1930)
Satin Pump (facing left) from Perugia (1929)
Toni Hollingsworth and Loty Salon (1941)

BEAUTY **p.158** GELATIN SILVER PRINTS **p.196**

Pepper (No. 30)

1930

EDWARD WESTON: GELATIN SILVER PRINT • 24 x 19.1 CM (9½ x 7½ IN)
MUSEUM OF FINE ARTS, HOUSTON, TEXAS, USA

Other works by Edward Weston
Shells (1927)
Nude (1936)
'Hot Coffee', Mojave Desert (1937)

One of the most influential American photographers, Edward Weston (1886–1958) is renowned for his attention to detail, his unique view of the world and his ability to capture the essence of his subject.

Weston's desire 'to make the commonplace unusual' was achieved with his still life of a pepper. It was the last of 30 studies shot over four days. He placed the pepper inside a large tin funnel lying on its side and moved in close so that it filled the frame of a 20.3 x 30.5 cm (8 x 10 in) negative. The funnel provides a slight curve and rough texture in the lower foreground, while darkening the backdrop to accentuate the pepper's convoluted shape and the light reflecting off it. The fruit was just beginning to turn, but the slight signs of decay marking the otherwise smooth skin add to its strangeness in close-up.

Weston's entry in his journal highlights his great satisfaction with the shot. The extreme proximity of the camera confers an abstract quality on the pepper, which, with its strange shape and leathery texture, here resembles the work of abstract sculptors such as Henry Moore, especially his experiments with walnut wood.

EDWARD WESTON
A native of Chicago, Weston initially adopted the soft-focus pictorialist style but soon abandoned it in favour of a more radical approach to image – something that Terence Pitts, director of the Center for Creative Photography, described as a 'quintessentially American, and specially Californian, approach to modern photography'. Weston's body of work is remarkable for its range of subjects.

STILL LIFE **p.20** ABSTRACTION **p.22** AVANT-GARDE **p.23** ART **p.31**

TEXTURE **p.177** GELATIN SILVER PRINTS **p.196**

Lovers in a Paris Café

BRASSAÏ: GELATIN SILVER PRINT • 24.9 x 19.8 CM (9¹³⁄₁₆ x 7¹³⁄₁₆ IN)
MUSÉE NATIONAL D'ART MODERNE, CENTRE POMPIDOU, PARIS, FRANCE

1932

BRASSAÏ

Gyula Halasz took the name Brassaï in memory of Brasso, his hometown in Transylvania, Hungary. Arriving in Paris aged 25, he was soon drawn to the city's nightlife. His book *Paris by Night* (1933), described as 'the eye of Paris' by Henry Miller, made his name and enabled him to document life in the city's more prosperous enclaves.

With his collection from 1931 of images capturing Paris at night, Brassaï (1899–1984) became recognized as one of the finest street photographers. Although many of his images were staged, they encapsulate the spirit of the French capital after dark.

Brassaï's most popular photograph captures the ardour of two lovers in a café near the Place d'Italie. It appears to be an impromptu shot of a couple who are about to kiss, but the framing is perhaps a little too perfect for it to be a chance photograph. We see the look of desire in the woman's face from two perspectives courtesy of one mirror, and the camera is high enough to capture the expression in the man's eyes in the other mirror. The lighter top third of the photograph is balanced by the darker lower section, where the two bodies merge into one, accentuating the couple's closeness. The contents of the table sit perfectly within the frame, populating the lower half of it just enough to add depth to the shot and draw a line between the lovers and the world around them. It is a perfect set-up. 'The meaning of art is not authenticity', wrote Brassaï, 'but the expression of authenticity.'

Other works by Brassaï
Fat Claude and her Girlfriend at Le Monocle (1932)
Streetwalker near Place d'Italie, Paris (1932)
Balloon Seller, Montsouris Park, Paris (1934)

PORTRAITURE **p.15** SOCIETY **p.34** STAGED **p.40**

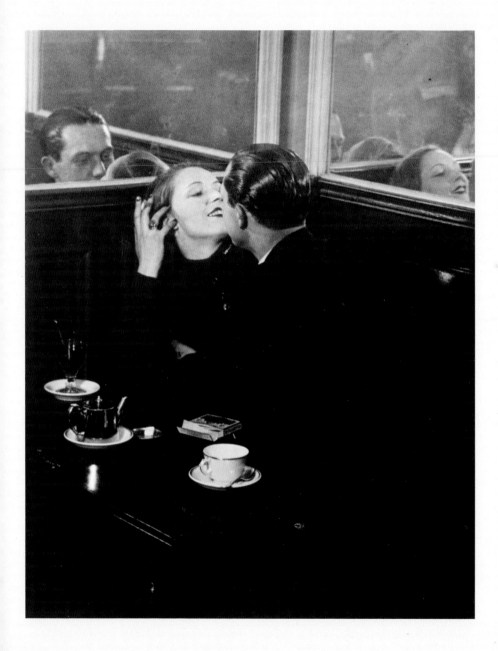

New York, Night View

1932

BERENICE ABBOTT: GELATIN SILVER PRINT • 34.1 x 27 CM (13⁷⁄₁₆ x 10⅝ IN)

Other works by Berenice Abbott
Under the El at the Battery, New York (1936)
Manhattan Bridge, Lower East Side, New York (1937)
Happy's Refreshment Stand with Two Men, Florida (1954)

One-time assistant to Man Ray and champion of the work of Eugène Atget, Berenice Abbott (1898–1991) became a vital chronicler of America's urban transformation.

Abbott's photographs of New York were inspired by the writings of Lewis Mumford, with whom she shared a desire for a more humane approach to urban planning and architectural design. This shot, taken from the Empire State Building between 4:30 and 5 pm on 20 December 1932, was a 15-minute exposure with a Kurt-Bentzin large-format camera that produced a 20.3 x 25.4 cm (8 x 10 in) negative. It records midtown Manhattan as day gradually turns to night. By shooting at dusk, Abbott captures many of the details on the façades of the buildings adjacent to the Empire State, while structures in the background become a mosaic of square lights against the descending blackness. This view of the city veers towards abstraction through the grid-like network of roads, buildings and lights. It is exhilarating and otherworldly, no less a paean to the New York that came to define mid-to-late twentieth-century metropolitan life than Edgard Varèse's cacophonous orchestral homage *Amériques* (1927). Both are in thrall to a vast city rooted to a rock and whose detail is as impressive as its scale.

BERENICE ABBOTT
In 1959, two decades after the publication of her book *Changing New York*, Abbott travelled along US Highway 1 from Florida to Maine, recording the growth of small towns and automobile-related architecture. She eventually settled in Maine, which she continued to photograph until her death.

MONOCHROME **p.12** ABSTRACTION **p.22** TOPOGRAPHY **p.35**

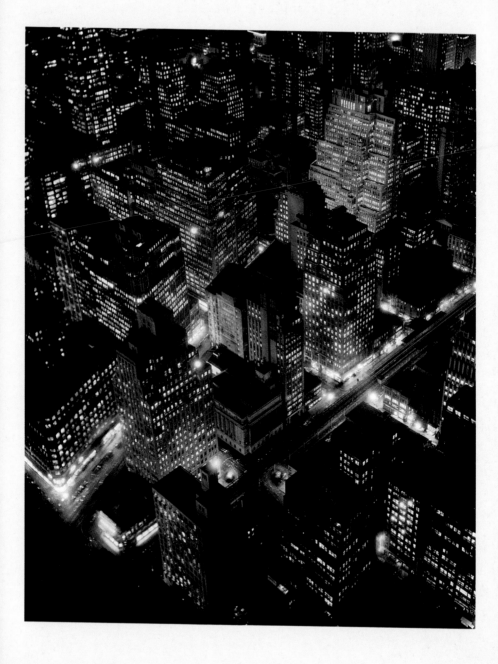

Migrant Mother, Nipomo, California

1936

DOROTHEA LANGE: GELATIN SILVER PRINT • 28.3 x 21.8 CM (11⅛ x 8⁹⁄₁₆ IN)
LIBRARY OF CONGRESS, WASHINGTON D.C., USA

Other works by Dorothea Lange
Broke, baby sick and car trouble! (1937)
Abandoned Farm in the Dust Bowl, Coldwater District, near Dalhart, Texas, June (1938)
Migratory Cotton Picker, Eloy, Arizona (1940)

DOROTHEA LANGE
Born Dorothea Nutzhorn, Lange studied under Clarence H. White then opened a studio in San Francisco. After her work across America's farm belt in the 1930s, she documented the detainees in US internment camps during World War II. When the conflict ended, she took up teaching and in 1952 co-founded the photographic journal *Aperture*.

With the onset of the Great Depression, Dorothea Lange (1895–1965) abandoned her studio for the outside world and became one of the most compassionate chroniclers of American working-class life.

The power of Lange's photograph *White Angel Breadline* (1933), featuring a homeless man queuing for food, attracted the attention of the Farm Security Administration (FSA). They invited Lange to become one of a group of photographers, led by Walker Evans, who would record life in America's rural states. She travelled the country for five years, photographing people as they searched for work. These images, like those of Lange's colleagues, contrast significantly with earlier movements. If photographers such as Lewis Hine had previously emphasized an increasingly mechanized society, the FSA photographers edged towards a more pastoral documentary form.

Migrant Mother is perhaps the most famous image to have come out of the FSA project. Lange met Florence Owens Thompson and her family among thousands of migrant workers inside a pea-pickers' camp in Nipomo Mesa, California. She took just a handful of shots. The family's poverty can be seen not only in the clothes Thompson and her children wear, but also in the backdrop. The seam running from the top right corner makes clear that this is canvas – a tent of some kind – but it appears more patchwork than anything sturdy. The children, unkempt cherubs, face away from the camera, drawing our attention to the Madonna-like figure in the centre. Thompson's expression and pose – hands were a regular focus of Lange's attention – are those of a mother worried about the future, and made her a symbol of America's economic plight in the 1930s.

PORTRAITURE **p.15** DOCUMENTARY **p.28**

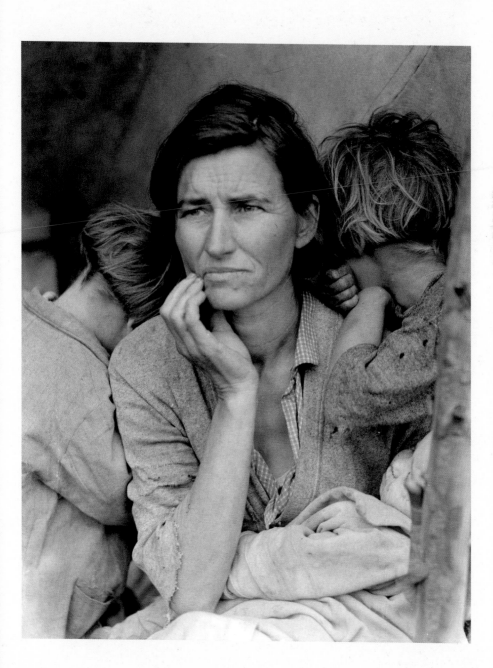

CLASS **p.170** POVERTY **p.171** FAMILY **p.182**

Washroom in the Dog Run of the Burroughs Home, Hale County, Alabama

1936

WALKER EVANS: GELATIN SILVER PRINT • 23.5 x 16.7 CM (9¼ x 6⁹⁄₁₆ IN)
J. PAUL GETTY MUSEUM, LOS ANGELES, USA

WALKER EVANS
His photographs first appeared as illustrations for *The Bridge* (1930), an epic poem by his friend Hart Crane. He followed this with a short commission to cover life in Havana, Cuba, before embarking on the body of work that cemented his reputation. It was not until 1971 that he received a definitive retrospective of his work, at New York's Museum of Modern Art.

America's renowned chronicler of the lives of the country's poverty-stricken, Walker Evans (1903–75) produced a body of work that was direct, unfettered in style and profoundly humane.

In 1936 Evans took a leave of absence from the government agencies that employed him to document rural life. The writer and critic James Agee had been commissioned by *Fortune* magazine to cover cotton tenantry in the United States, and Evans was asked to shoot the accompanying images. The commission was subsequently cancelled, but Agee and Evans then collaborated on a more ambitious project. In 1941 they published *Let Us Now Praise Famous Men*, an account of life for three families in Alabama. While Agee's prose raged at the injustice he witnessed, Evans's photographs were often elegiac, reflecting his desire to produce images that were 'literate, authoritative, transcendent'. Alongside single and group portraits were shots of the families' homes. The washroom in the Burroughs house gives a stark illustration of the level of poverty some families endured. The image is beautifully framed, but the basic resources shared by the family and the emptiness of the house, as glimpsed through the doorway, offer a bleak indictment of neglected societies in rural America.

Other works by Walker Evans
Alabama Tenant Farmer Wife (1936)
Bud Fields and his Family, Hale County, Alabama (1936)
Prairie Ave., 21st Street, South Side, Chicago (1946)

STRAIGHT PHOTOGRAPHY **p.14** PORTRAITURE **p.15** ETHNOGRAPHY **p.26** PHOTOJOURNALISM **p.27**
DOCUMENTARY **p.28**

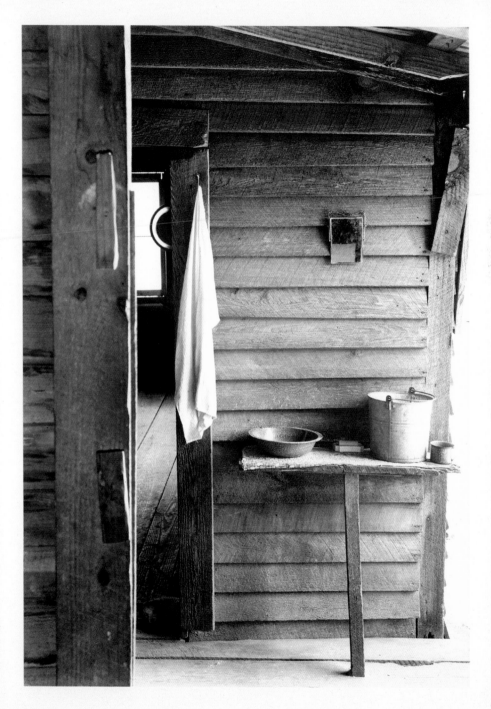

CLASS **p.170** POVERTY **p.171** FAMILY **p.182**

Photogram

LÁSZLÓ MOHOLY-NAGY: GELATIN SILVER PRINT
49.53 x 40.32 CM (19½ x 15⁹⁄₁₀ IN)

1939

One of the key figures at the Bauhaus school in the 1920s, László Moholy-Nagy (1895–1946) championed the integration of technology and industry into all areas of the arts.

A photograph created without the aid of a camera, this oblique image is nevertheless imbued with intersections that fascinated Moholy-Nagy in his more conventional work, such as his elevated shots of streets. Light is passed through a variety of fluids and various objects to create the shapes in each image. Daylight papers were initially used – Moholy-Nagy began experimenting with them in 1923 – but were subsequently replaced by gaslight papers, which react more quickly.

The practice was employed by photographic pioneers and was an amusement for children in the late nineteenth century. But here the result feels radical. An initial instinct is to find order in the form – something identifiable. But the play with light challenges the sense of any normal photographic perspective, including depth of field. Not so much a single image as a series of layers, there are fragments of images, placed one on top of another. With this and the many other photograms he produced, Moholy-Nagy hinted at photography's potential as a viable artistic alternative to painting.

LÁSZLÓ MOHOLY-NAGY
Shortly after leaving the Bauhaus, Moholy-Nagy constructed the kinetic sculpture *Light Prop for an Electric Stage*, his most celebrated achievement. After moving to Britain in 1935, he designed the special effects for Alexander Korda's science-fiction film *Things to Come* (1936). He spent his last years in the United States as head of the Institute of Design at the Illinois Institute of Technology.

MONOCHROME **p.12** STILL LIFE **p.20** ABSTRACTION **p.22** AVANT-GARDE **p.23** ART **p.31**
CONCEPTUAL **p.39**

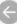

Other works by László Moholy-Nagy
Boxen (1924)
Lyon, France (1929)
From the Radio Tower, Berlin (1926)

PHOTOGRAM **p.201**

Cop Killer

1941

WEEGEE: SILVER PRINT • 23.5 x 30.5 CM (9¼ x 12 IN)
INTERNATIONAL CENTER OF PHOTOGRAPHY, NEW YORK, USA

Other works by Weegee
Body of Dominick Didato (1936)
Under the Third Avenue Elevated (1938)
Untitled (Simply Add Boiling Water) (1943)

With stark images that are as sensational as they are factual, Weegee (1899–1968) remains the most famous and, thanks to his methodology, the most notorious press photographer in the history of American photojournalism.

Here, Anthony Esposito is being booked by two police officers after having been arrested with his injured brother on suspicion of murdering a businessman during a robbery and then, as they attempted to escape, patrolman Edward Maher. The incident became known as the 'Battle of Fifth Avenue'. Weegee later summed up the prisoner's situation: 'In the Line-Up Room. This guy killed a cop. First he got a black eye then the electric chair at Sing Sing prison.' This matter-of-fact description perfectly encapsulates Weegee's style of photojournalism.

In Weegee's unorthodox mugshot, lighting takes on the moody tone that would be replicated in the noir thrillers that became increasingly popular throughout

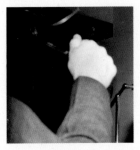

Above: Weegee includes the official police photographer in the shot. It tightens our focus on the activity to the right of the frame, but also reinforces Weegee's photograph as anything but a formal record of the events.

Right: The seriousness of Esposito's crime is emphasized by the fact that even though he is cuffed to one officer, the other still maintains a tight grip on him.

STRAIGHT PHOTOGRAPHY **p.14** PHOTOJOURNALISM **p.27** DOCUMENTARY **p.28**

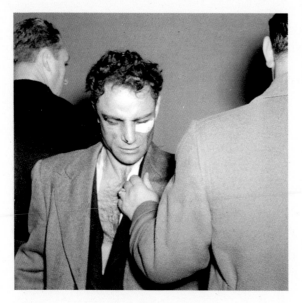

Left: From Weegee's description we know that Esposito's injuries were probably caused by the police, but the expression captured could be read as that of a man resigned to his fate or perhaps even preparing for it.

the 1940s and 1950s. Critics have suggested that Weegee's images directly influenced their visual style. The use of flash underpins the immediacy of the image. As in all his best-known work, Weegee used a 4 x 5 Speed Graphic camera, which was pre-set at f/16 at 1/200 of a second. The focal distance is short, which suited him since most of his crime photography was in medium-to-extreme close-up. Disturbing though many of his images are in recording crime and carnage on the streets of New York at a time when organized gang activity was rife, their impact lies in Weegee's modus operandi of shooting straight, with little flourish, to capture the drama of the moment.

WEEGEE
The pseudonym of Ukraine-born Usher Fellig was derived from 'Ouija', as in board – the number of times he reached crime scenes before the police fuelled the myth that he had supernatural contacts. Weegee was the first journalist to own a police radio, and the respect accorded to him gave him access other photojournalists could only wish for.

POWER **p.180** CRIME **p.181**

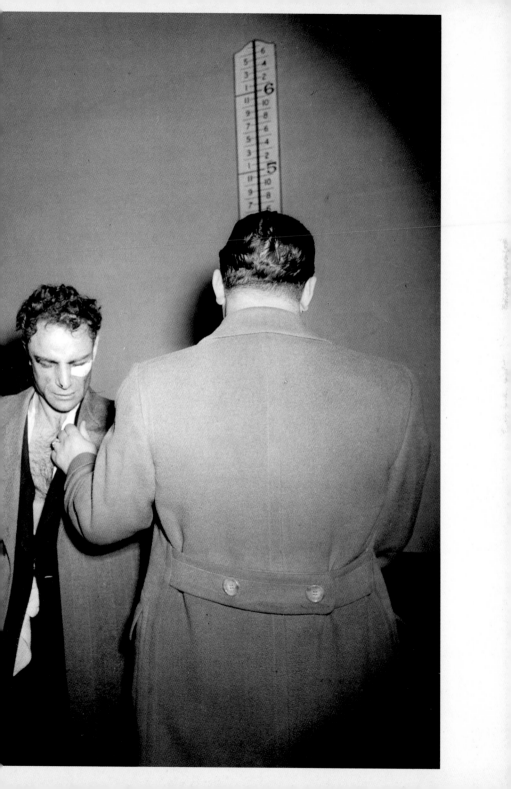

Transmission Lines in Mojave Desert

1941

ANSEL ADAMS: NATIONAL ARCHIVES, WASHINGTON D.C., USA

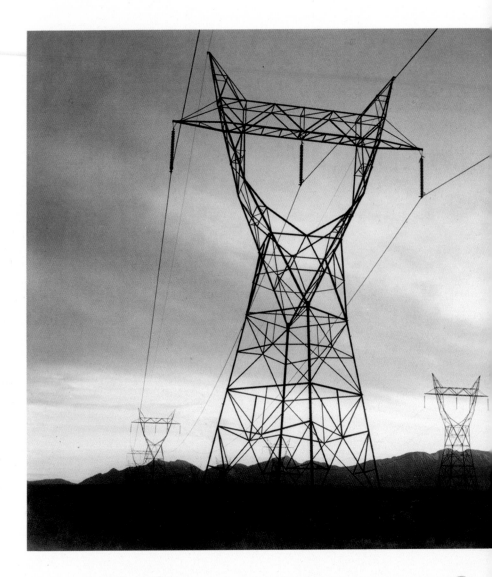

Other works by Ansel Adams
Moonrise, Hernandez, New Mexico (1941)

Mount Williamson, Sierra Nevada, from Manzanar, California (1944)

Moon and Half Dome, Yosemite National Park, California (1960)

The greatest photographer of America's landscapes and national parks, Ansel Adams (1902–84) also pioneered the Zone System technique for determining optimal film exposure and development.

When Adams saw an exhibition of Paul Strand's photographs, he rejected the soft-focus pictorialist style that had dominated his own previous work in favour of a more direct representation of the natural world. His subsequent photographs of America's landscapes, particularly its National Parks, have made him one of the most admired American photographers.

There are human traces in Adams's best-known work, such as the building in the foreground of *Moonrise, Hernandez, New Mexico.* But the photographs that feature human-built structures as their main focus are less well known. However, these works can take on a fascinating, abstract appearance. *Transmission Lines* was part of Adams's coverage of the vast structures built close to America's great rivers. With the sun on the horizon, almost dipping behind a mountain range, the landscape loses much of its detail. Instead, our attention is drawn to the scale of the metal structures that rise up out of it. This image prefigures the work of environmental photographers such as Edward Burtynsky, who detail the profound impact of industry on the natural world.

ANSEL ADAMS
Born on the outskirts of San Francisco and a witness to the devastation wrought by the earthquake of 1906, Adams spent much of his youth in California's National Parks. He became a photographer in his mid twenties and became an environmental advocate who campaigned for the preservation and protection of the American wilderness.

WEATHER **p.156** NATURE **p.163** TECHNOLOGY **p.175**

American Soldiers Landing on Omaha Beach, D-Day, Normandy, France June 6, 1944

1944

ROBERT CAPA: GELATIN SILVER PRINT • 22.5 x 34 CM (8¾ x 13½ IN)
INTERNATIONAL CENTER OF PHOTOGRAPHY, NEW YORK, USA

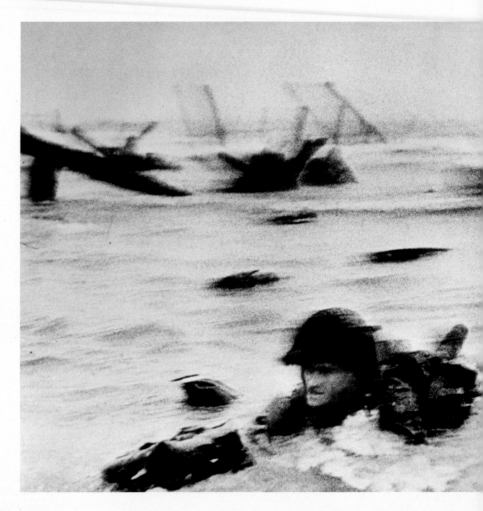

WAR **p.24** PROPAGANDA **p.25** PHOTOJOURNALISM **p.27**

The most renowned work of the celebrated war photographer Robert Capa (1913–54) captured the brutal immediacy of armed conflict.

This image, one of a series of 11, was almost lost. Capa joined American troops who landed in France at the start of Operation Overlord, the code-name for the mission to liberate Western Europe from Nazi occupation. He made his way to the shore with members of Company E of the 16th Regiment of the US 1st Infantry Division. Using two Contax II cameras mounted with 50 mm lenses and several extra rolls of film, he took 106 pictures. However, a mistake in the lab at *Life* magazine's London base is believed to have destroyed many of the negatives.

This image, the only one to feature a single soldier, highlights the rapid movement required to survive the barrage of gunfire from the German forces stationed along the coastline. The landing craft and obstructions behind the soldier create a strange backdrop, while in the distance smoke from a damaged ship rises into the sky. It is a terrifying picture of war, but to audiences around the world it proved that the Allies were making headway against the Nazis.

Other works by Robert Capa
The Falling Soldier (1936)
Pablo Picasso and Françoise Gilot, Golfe-Juan, France (1948)
Absorption Camp Sha'ar Ha'aliya, Haifa, Israel (1950)

ROBERT CAPA
Hungarian-born Capa cemented his reputation with his photographs of the Spanish Civil War. After World War II he co-founded the Magnum Photographic Agency. In the 1950s he spoke of a desire to move away from conflict, but he was killed when he stepped on a landmine while covering the escalating conflict in Indochina.

DEATH **p.165** GELATIN SILVER PRINTS **p.196**

The Liberation of Buchenwald

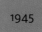
1945

MARGARET BOURKE-WHITE: SILVER PRINT

A celebrated documentary photographer by the time of the outbreak of World War II, Margaret Bourke-White (1904–71) became the first female war correspondent and the first woman to be allowed to work in combat zones.

Bourke-White's photograph from Buchenwald concentration camp shows a group of political prisoners who had narrowly escaped death, but had been witnesses to horrific barbarity. The Allied countries were aware of the Third Reich's policy of ethnic cleansing, but the sheer scale of the operation became clear only as countries were liberated. The press was an essential component in recording these crimes, although their coverage was often tempered owing to the shocking nature of what they witnessed. This image wasn't seen until a special '25 Years of *Life*' magazine was published in December 1960.

Other photographs documenting the Holocaust emphasize the scale of the atrocities, with victims viewed in terms of numbers. This image is extraordinary for the way in which Bourke-White emphasizes the individuality of each man, the barbed-wire fence no longer constraining them. She later wrote that her role as photographer provided some distance from the horrors that she saw, but it was never at the cost of communicating the anguish and humanity of her subjects.

Other works by Margaret Bourke-White
Chrysler Building, New York (1930–31)
The Louisville Flood (1937)
Gandhi and the Spinning Wheel (1946)

WAR **p.24** PHOTOJOURNALISM **p.27** DOCUMENTARY **p.28** HUMANISM **p.29**

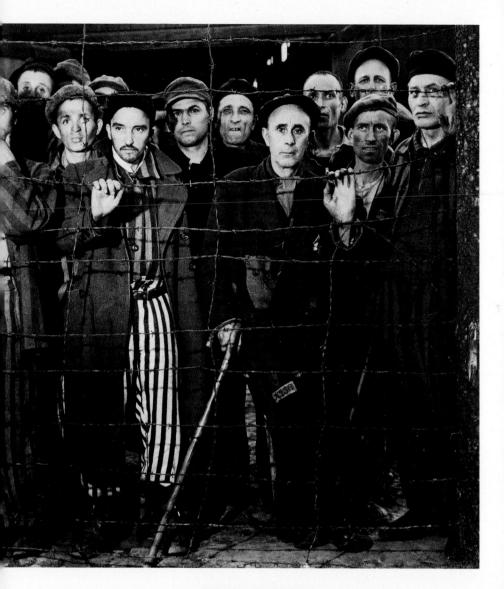

MARGARET BOURKE-WHITE
Bourke-White's skill as a photographer was matched by her sheer force of will. She recorded American life in the 1930s, was the first foreign journalist to be permitted to photograph the impact in the Soviet Union of Stalin's five-year plans, and captured the events leading up to the partition of India in 1947.

DEATH **p.165**

The Kiss at the Hotel de Ville

c.1950

ROBERT DOISNEAU: SILVER PRINT

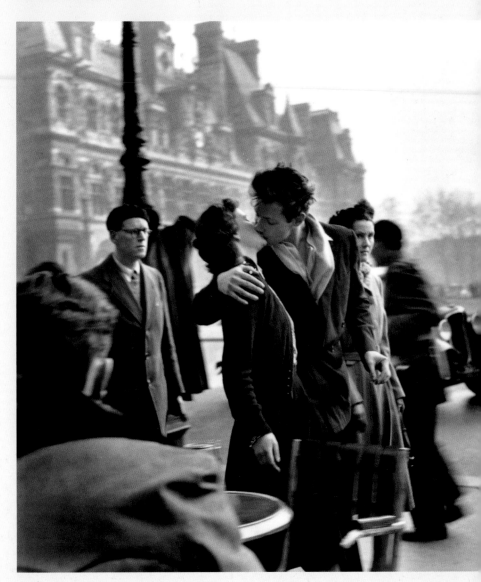

Other works by Robert Doisneau
Les Concierges Rue du Dragon (1946)
Picasso (1950)
Le Muguet du Métro (1953)

Roaming the streets of Paris with his Leica, Robert Doisneau (1912–94) brought compassion and humour, often with a hint of pathos, to his candid portraits of everyday life.

This iconic photograph presents viewers with the old, the modern and the timeless. One of Paris's most recognizable landmarks provides the backdrop to a bustling street and a couple oblivious to the world around them. It appeared in the June edition of *Life* magazine and was initially thought to have been captured in the moment. However, it was staged. Not that that bothered Doisneau, who once commented, 'I don't photograph life as it is, but life as I would like it to be.'

Françoise Delbart and Jacques Carteaud were the subjects. Doisneau had seen them kissing and asked if they would kiss once again, but this time in front of his camera. Carteaud fits the role of the bohemian – his unbuttoned shirt and scarf a contrast to the stern-looking man walking behind or the woman to his right. Delbart is relaxed, her right hand perfectly poised. The blurring of cars and pedestrians suggests that time has stopped for the couple while for the rest of the world it whizzes by.

ROBERT DOISNEAU
Originally an assistant to André Vigneau, Doisneau was inspired by André Kertész and Henri Cartier-Bresson and began to have his own work published in the early 1930s. He was a forger for the French Resistance, and after World War II spent a short time working for *Vogue*. But the Paris streets inspired his best work.

LOVE **p.159** GELATIN SILVER PRINTS **p.196**

Parade, Hoboken, New Jersey

1955

ROBERT FRANK: GELATIN SILVER PRINT

Few photographic projects have had an impact comparable to the work Robert Frank (b.1924) produced in the mid 1950s when he recorded daily life in America.

In his book *The Americans* (1958), Frank aimed to capture what naturalized citizens might choose to photograph were they to journey around their adopted country. He envisioned a collection of images that are 'anywhere and everywhere – easily found, not easily selected and interpreted'. Between 1955 and 1957 Frank travelled the length and breadth of the country. The resulting 83 images were divided into four sections, with each image linked thematically or conceptually. With images that convey the tapestry of American rural and urban life, Frank helped to transform photographic practice.

Parade, Hoboken, New Jersey is the first image to appear in *The Americans*. The message conveyed here is a far cry from the Rockwellian portraits that adorned the covers of *The Saturday Evening Post* in the 1950s, featuring a casual style that appeared radical at the time. The views from the two windows on this summer day are obscured, one by dirty glass, while in the other a woman is 'blinded' by an American flag. Patriotism, Frank suggests, veers towards the myopic if it is unchecked.

Other works by Robert Frank
Fourth of July – Jay, New York (1954)
Trolley – New Orleans (1955)
Drive-In Movie, Detroit (1955)

STRAIGHT PHOTOGRAPHY **p.14** ETHNOGRAPHY **p.26** DOCUMENTARY **p.28**

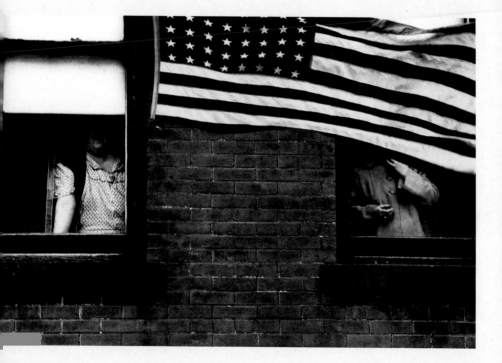

ROBERT FRANK
Born in Switzerland, Frank emigrated to the United States in 1947. In 1959, after the publication of *The Americans*, he started making films. These include his debut, *Pull My Daisy*, written and narrated by Jack Kerouac, and the infamous film about The Rolling Stones, *Cocksucker Blues* (1972).

CLASS **p.170** PEOPLE **p.173** GELATIN SILVER PRINTS **p.196**

USA, California

1955

ELLIOTT ERWITT: SILVER PRINT

Echoing Henri Cartier-Bresson's notion of the 'decisive moment', the most celebrated photographs of Elliott Erwitt (b.1928) capture moments that speak universally of the humanist tendency towards compassion.

Playful, intimate and occasionally ironic, Erwitt's photographs were particularly welcome in the period following the end of World War II, and reflected a new age of optimism. In this image, a couple kiss in a car that faces out to sea. The tide is calm and the sun is setting. We see them via the vehicle's wing mirror – the focal point of the image. From what we see of their clothing, they are well-to-do. From the absence of any obstruction above the woman's head we can guess that the car is a convertible. The scene is picture-postcard perfect.

The 1950s was the era of the automobile, and the car's role in society was more than functional. The journey was often as important as any destination. Cars were even viewed as an extension of the entertainment industry, and drive-ins increased in number across the United States. The fact that the couple appear in the mirror of a car denotes the importance of the vehicle in their lives – something as natural on the American landscape as a rolling tide or the setting sun.

Other works by Elliott Erwitt
View from a Car, Wyoming, USA (1954)
Spain. 1964 (1964)
Marilyn Monroe, New York City (1956)

LANDSCAPE **p.16** GLAMOUR **p.32**

ELLIOTT ERWITT

Born Elio Romano Erwitt in Paris to Jewish-Russian parents, he moved to Los Angeles when he was aged 10 and became a photographer's assistant while serving in the US army. Of his eclectic oeuvre, which encompasses his earlier humanist photography and directing films, Erwitt's most renowned work since the 1970s has focused on dogs.

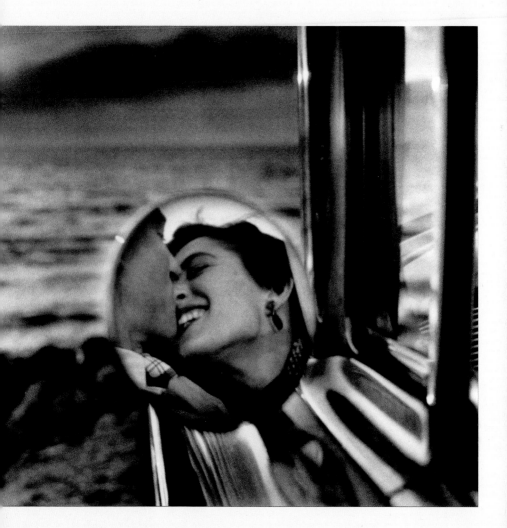

Kings of Hollywood

SLIM AARONS: SILVER PRINT

1957

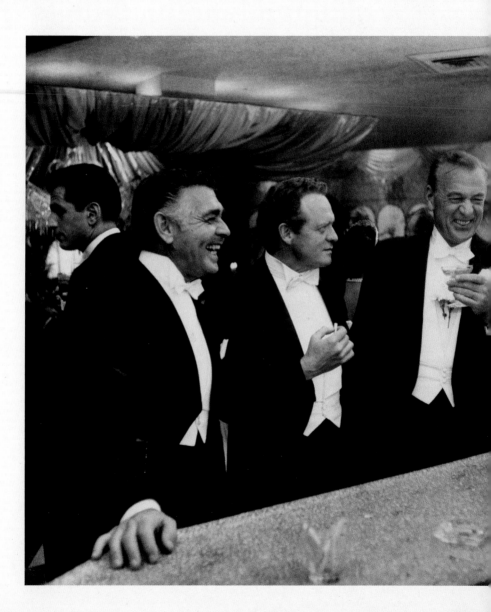

PORTRAITURE **p.15** COLOUR **p.18** GLAMOUR **p.32** PAPARAZZI **p.38**

Other works by Slim Aarons
Pink Accessory (1955)
Kirk Douglas (1967)
Laguna Beach (1970)

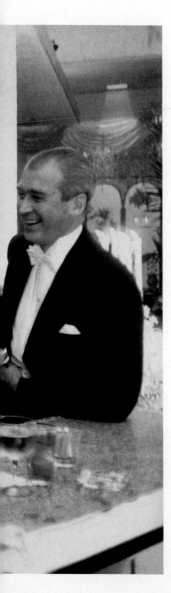

Not only a photographer but also a Hollywood insider, Slim Aarons (1916–2006) shot the rich and famous at their most relaxed.

'I knew everyone,' Aarons once told an interviewer. 'They would invite me to one of their parties because they knew I wouldn't hurt them. I was one of them.' Upon arriving in Hollywood after World War II, Aarons quickly learned that a well-cultivated image was everything. What he gave audiences was a sense of intimacy – a view into a world beyond the roll-call of premières and movie-star portraits.

Described by *Smithsonian* magazine as 'a Mount Rushmore of stardom', *Kings of Hollywood* features the actors Clark Gable, Van Heflin, Gary Cooper and James Stewart. It was taken at a New Year's Eve party in Romanoff's restaurant in Beverly Hills. The men look relaxed; their laughter – apparently brought on by a joke at Aaron's expense – appears genuine. The skilful framing creates a sense of proximity between subject and viewer. Gable's right hand reaches towards us. The empty glass in the foreground might be the photographer's, but its position makes the viewer one of the group.

SLIM AARONS
George Allen Aarons was awarded a Purple Heart for his work as a combat photographer in World War II. He described his later work as photographing 'attractive people, doing attractive things in attractive places'. His apartment inspired that of James Stewart's character in *Rear Window* (1954).

→ ICONOGRAPHY **p.166** CELEBRITY **p.167** GELATIN SILVER PRINTS **p.196**

Che Guevara

ALBERTO KORDA: SILVER PRINT

1960

Other works by Alberto Korda
New York (1959)
Don Quixote of the Lamp Post (1959)
Militia Woman (1962)

Alberto Korda (1928–2001) found international recognition for this portrait of Che Guevara.

The photograph, known in Spanish as *Guerrillero Heroico* ('Heroic Guerrilla'), was taken at a memorial service for the 136 people who died when a French vessel carrying munitions exploded in Havana harbour. Che appeared only for a moment, but something about his expression caught the attention of Korda, who took two shots with his Leica M2, using a 90 mm lens. The height of the stage above Korda enabled him to shoot Che with enough elevation to give a sense of gravitas but not so much as to deify. The subject's expression is one of strength and defiance.

In October 1967, after Che was executed by the Bolivian army, the Italian publisher who had purchased this image produced posters to commemorate the revolutionary hero. It made Korda's photograph one of the key images of the twentieth century. Modest about his achievement, Korda said throughout his life that his success had involved a great deal of luck. His advice to aspiring photographers was always the same: 'Forget the camera, forget the lens, forget all of that. With any four-dollar camera you can capture the best picture.'

ALBERTO KORDA
Born in Havana, Alberto Díaz Gutiérrez opened his first studio in 1953 and quickly became Cuba's pre-eminent fashion photographer. The Cuban Revolution changed his life; he became Fidel Castro's personal photographer, and remained in post until 1970. He was also an accomplished underwater photographer, and in later years exhibited his work around the world.

PORTRAITURE **p.15** PROPAGANDA **p.25** DOCUMENTARY **p.28**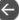

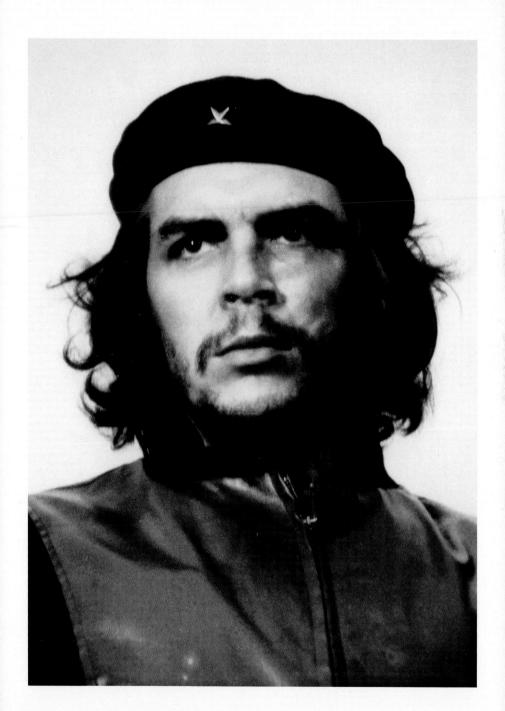

→ ICONOGRAPHY **p.166** POLITICS **p.172**

Malcolm X

EVE ARNOLD: SILVER PRINT

EVE ARNOLD
Born Eve Cohen, Eve Arnold photographed world leaders, celebrities and film stars, as well as the poor and rootless. 'I don't see anybody as either ordinary or extraordinary,' she commented, 'I see them simply as people in front of my lens.' She was the first woman to join the Magnum Photos agency, and continued to take photographs into her nineties.

Egalitarian in her choice of subject and unintimidated by power, Eve Arnold (1912–2012) photographed royalty and poverty with the same discerning eye.

In 1960 *Life* magazine commissioned Arnold to document a year in the life of Malcolm X, the outspoken Nation of Islam representative who had attracted admiration and ire in equal measure. In all her projects – including her most famous, a photo-shoot with Marilyn Monroe on the set of John Huston's movie *The Misfits* – Arnold's tenacity cemented a relationship with her subjects, giving her a greater understanding of what drove them and helping to define how she shot them.

This informal photograph was taken in a moment of solitude. Malcolm X's expression, only partially revealed, is inscrutable. The watch hints at precision, suggesting an organized man, while the presence of the Nation of Islam ring so close to the centre of the shot reminds us of what defines him. It is no conventional portrait of a political figure, and yet it possesses a stateliness and conveys the gravitas of the man. 'He was a really clever showman,' Arnold said of Malcolm X, 'apparently knowledgeable about how he could use pictures and the press to tell his story.'

Other works by Eve Arnold
Haiti. The American drug companies tested Milltown, an early tranquilizer experiment at this asylum (1954)

Marilyn Monroe resting (1955)

China. Inner Mongolia. Horse training for the militia (1979)

PORTRAITURE **p.15** SOCIETY **p.34**

Jack Ruby Killing Lee Harvey Oswald

1963

ROBERT H. JACKSON: GELATIN SILVER PRINT

After missing the moment President John F. Kennedy was assassinated because he was changing film in his camera, Robert H. Jackson (b.1934) was perfectly positioned to capture the moment Kennedy's killer was shot dead.

Two days after Kennedy's death, Jackson was in the basement of the Dallas Police Headquarters when Lee Harvey Oswald was being transferred by armoured car to the nearby county jail. As the prisoner was led out, surrounded by an entourage of law-enforcement officers, he was shot once in the abdomen by nightclub owner Jack Ruby. Jackson not only had a clear view of Oswald the moment he was shot, he also caught the reactions of the people around him. Homicide detective Jim Leavelle leans back, reeling in shock at what just happened. Another man, still smoking his cigar, attempts to reach out and grab Ruby. Behind him, a broadcast journalist, microphone in hand, has yet to register what has just happened. We see Ruby only from behind, but his body appears tense as the shot is fired, while the pain of the bullet's impact registers on Oswald's face. The blurred figure accentuates our role as witness, adding to the power of this extraordinary photograph.

ROBERT H. JACKSON
A staff photographer on the *Dallas Times Herald*, Robert Hill Jackson won a Pulitzer Prize for this shot of Jack Ruby's killing of Lee Harvey Oswald. He later moved to the *Colorado Springs Gazette-Telegraph*; he retired in 1999.

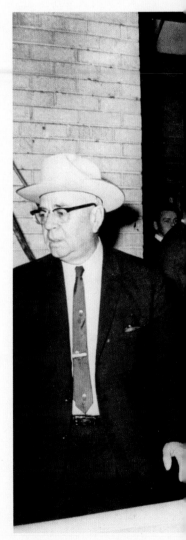

PHOTOJOURNALISM **p.27**

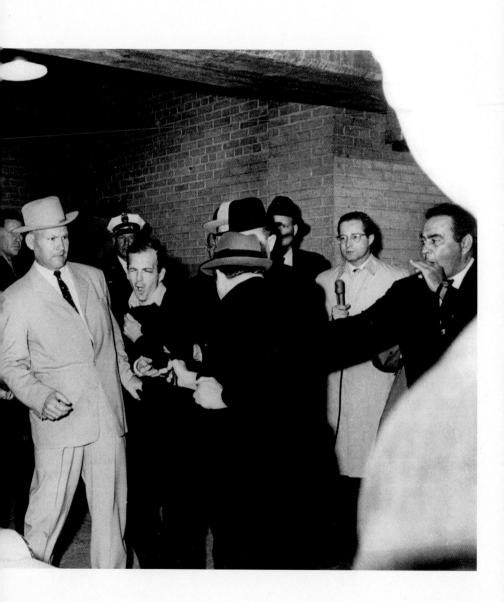

Earthrise

WILLIAM ANDERS: COLOUR EKTACHROME • NASA, USA

As he orbited the Moon, the astronaut William Anders (b.1933) took this photograph, which transformed the way we viewed our planet.

Earthrise has done more to promote the environmental movement than any other photograph. *Apollo 8* was the second human spaceflight mission in the Apollo programme and the first crewed spacecraft to leave the Earth's orbit and circle the Moon. On 24 December 1968, as the Command Module was completing one of its ten lunar orbits, the Earth came into view, appearing extraordinarily vivid against the blackness of space. Mission commander Frank Borman (b.1928) took a

Below: The cliff-edge rim of the Moon emphasizes its barrenness – no less appealing than the blackness that surrounds it.

WILLIAM ANDERS
Born into a Navy family, Anders
entered the US Naval Academy
after high school, became a
pilot and in 1963 was selected
by NASA to be part of its third
group of astronauts. He was
the back-up pilot for *Gemini 11*
before being assigned Lunar
Module Pilot for *Apollo 8*.
With Commander Borman and
Command Module Pilot James
Lovell, Anders was one of the
first humans to travel out of
Low Earth Orbit.

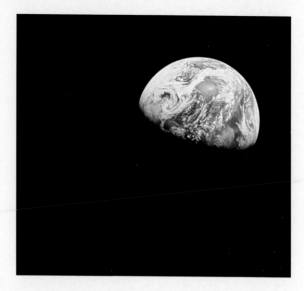

black-and-white photograph. Then Lunar Module Pilot
Anders took this shot using a highly modified Hasselblad
500 EL with an electric drive that was loaded with a
70 mm magazine of customized Kodak Ektachrome film.

Above: That the Earth doesn't appear
as a fully visible globe, the remainder is
cloaked in the darkness of night, only
emphasises the planet's fragility.

The Earth, a lonely planet in the night sky, had
previously been imagined this way only by science-fiction
writers and filmmakers. Anders's shot, one of 11 he took
in rapid succession, highlighted Earth's beauty but also
its fragility. The South Pole can be seen at 10 o'clock,
with the Equator running in a near-vertical diagonal
line towards the top right corner. Nightfall is just passing
across the African continent. 'We came all this way to
explore the Moon,' Anders later noted, 'and the most
important thing is that we discovered the Earth.'

→ WEATHER **p.156** NATURE **p.163**

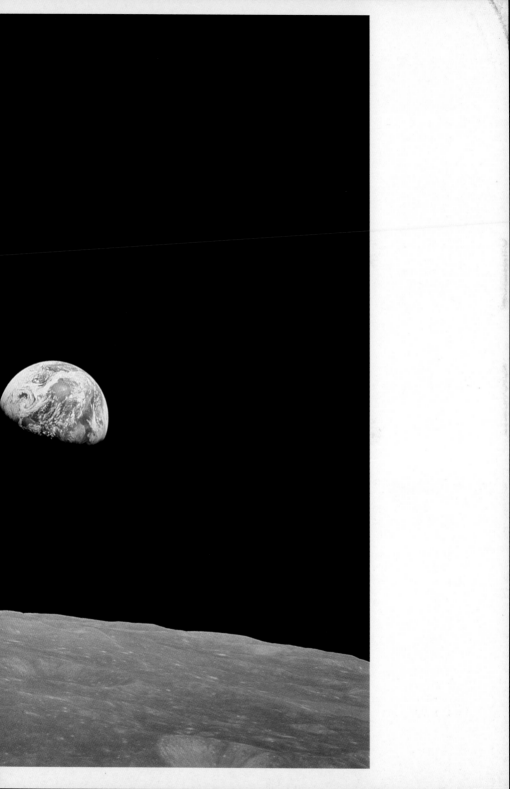

Algiers, Louisiana

WILLIAM EGGLESTON

C.1972

WILLIAM EGGLESTON
Although he developed
an interest in photography
at college, it wasn't until the
1970s that Eggleston achieved
widespread recognition. His
show at MoMA in 1976 was a
watershed moment, forever
dispelling the notion that
monochrome was the only
appropriate medium for a
serious photographer.

Through his images of everyday American life, William Eggleston (b.1939) transformed opinions within the art world regarding the value of colour photography.

Eggleston started using colour film in the mid 1960s. After witnessing the stark effect that dye-transfer printing had on advertising, he used it in his own work, with startling results. 'Every photograph I subsequently printed with the process', he noted, 'seemed fantastic and each one seemed better than the previous one.' Dye-transfer printing gave Eggleston's photographs of ordinary American life a strange, otherworldly quality. The image might be of a light fitting on a blood-red ceiling, a deteriorating sign above the awning of a shop or a supermarket employee returning trolleys from a car park to the store, but the nature of the process often produced unusual or heightened colouring. This image, first published in *William Eggleston's Guide*, features a strong tinge of yellow and orange in the foreground, from the colour of the dog's coat to the puddle of water and the ground surrounding it. It contrasts starkly with the white of the house and the roof of the car in the background. It's a compelling image in which the banal becomes fascinating.

Other works by William Eggleston
Greenwood, Mississippi (1973)
Untitled (Neon Confederate Flag) (1973)
Untitled (Marcia Hare in Memphis Tennessee) (1975)

PORTRAITURE **p.15** COLOUR **p.18** ART **p.31** SOCIETY **p.34**

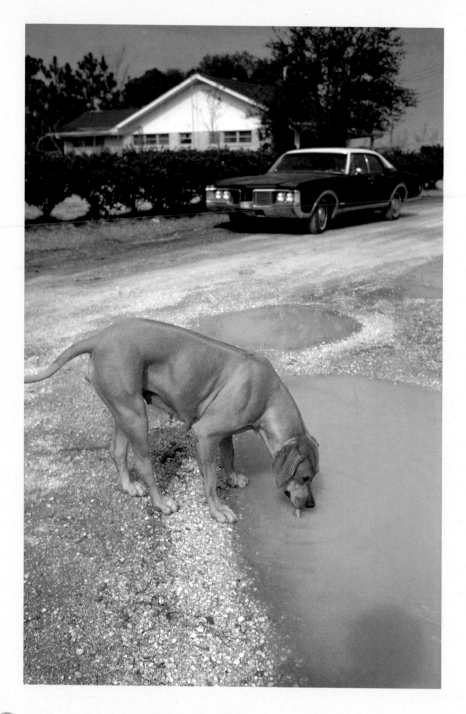

Phan Thị Kim Phúc

NICK UT: SILVER PRINT

1972

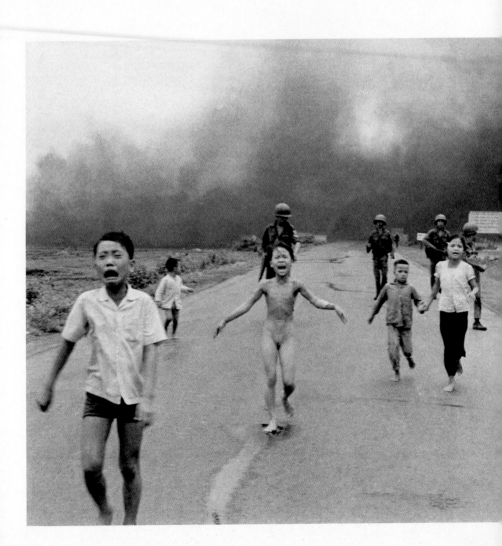

NICK UT

Born in Long An, Vietnam, Ut began photographing for Associated Press (AP) when he was just 16. He sustained three injuries during the Vietnamese conflict, but continued working for the agency. He has since represented AP in Tokyo, South Korea and Hanoi, and now lives in Canada.

Trained as a photojournalist on the battlefields of Vietnam, Nick Ut (b.1951) captured the senseless depravity of war with this horrific image.

On 8 June 1972 Ut was on the outskirts of Trang Bang, a village 40 km (25 miles) northwest of Saigon. The South Vietnamese air force had mistakenly dropped napalm bombs on the village. As he made his way towards the settlement, he saw a group of children running in the opposite direction. One child had no clothes and was screaming and crying. He took this photograph and then realized that Pan Thị Kim Phúc had lost them because of fire, which had burned 30 per cent of her body. He took her to a civilian hospital, where doctors told him they didn't expect her to live. She was transferred to a US military hospital, which saved her life.

The image is disturbing for the apparent indifference of the soldiers and for the shock and pain registering on the children's faces. News outlets were initially reluctant to print an image of a naked child, but eventually decided to make an exception. It became a defining image of the antiwar movement and contributed to the American public's desire for the conflict to end.

Other works by Nick Ut

A Refugee clutching a baby is carried by a government helicopter gunship from Tuy Hòa, north-east of Saigon (1975)

Muhammad Ali throws a punch at a sandbag during a workout at a gym in Tokyo (1976)

A Japanese snow monkey relaxes in a hot spring in the Jigokudani valley in northern Nagano prefecture in Japan (2012)

DEATH **p.165** POLITICS **p.172**

A Sunny Sunday Afternoon, Whitby, England

1974

IAN BERRY: GELATIN SILVER PRINT

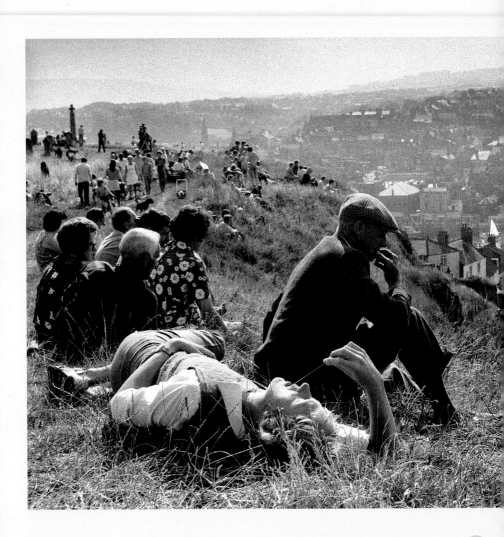

IAN BERRY
Originally from Preston, Lancashire, Berry learned photography in 1952, when he moved to South Africa. In 1960 he recorded the Sharpeville massacre, in which 69 people were killed. His photographs were entered into the court proceedings and led to the exoneration of the protestors. Their publication caused outrage around the world.

A documentary photographer and photojournalist, Ian Berry (b.1934) captured a nation at work and play with his pivotal book *The English* (1978).

In 1974 Berry was awarded the British Arts Council's first major photographic bursary. The result, inspired by Robert Frank's *The Americans*, was a comprehensive study of all walks of English life. One of the most famous shots Berry took for the project is this portrait of people enjoying their day off. They are seen relaxing on a hill overlooking the northern coastal town of Whitby. The denser numbers in the distance mirror the crowded housing below. A group nearer to Berry converse and watch a clutch of yachts making their way along the river, In the foreground the younger man, lying down and playing with a blade of grass, looks relaxed. The older man, by contrast, appears pensive. Still wearing his cap and jacket, he looks down to the town but his mind seems elsewhere. They represent two different generations, while the wild grass around them adds texture and divides the image, contrasting the pastoral with the urban.

Other works by Ian Berry
Sharpeville, South Africa (1960)

Having captured ringleaders, the soldiers then move in on the mob with batons and rubber bullets, Londonderry, Northern Ireland (1971)

Evangelical Church (1983)

CLASS **p.170** GELATIN SILVER PRINTS **p.196**

Self-Portrait in Drag (Platinum Pageboy Wig)

1981

ANDY WARHOL: DYE DIFFUSION TRANSFER PRINT (POLAROID) • 10.8 x 8.5 CM (4¼ x 3½ IN), POLAROID, KUNSTHALLE HAMBURG, HAMBURG, GERMANY

Other works by Andy Warhol
Self-Portrait (1966)
Muhammad Ali (1977)
Self-Portrait with Fright Wig (1986)

Leading the Pop Art vanguard, Andy Warhol (1928–87) embraced the limitations of the Polaroid camera, producing thousands of portraits.

Photography had always been central to Warhol's work, albeit via his screen prints. An artist for whom identity remained a moveable feast, the self-portraits he shot between 1962 and 1986 are fascinating for the way he presents himself. With each series, his face appears more like a mask. He started using Polaroid in the 1970s, initially as the basis for more complex works, but many never progressed beyond simple, often crudely shot portraits.

Warhol's self-portraits in drag recall Man Ray's photographs of Marcel Duchamp in female dress. Drag queens fascinated Warhol, and this series blurs the line between genders. His expression remains blank, yet there is a hint of vulnerability, which could be read as a desire both to be looked at and for the viewer to turn away. Those contradictions lay at the heart of Warhol's celebrity, which he both embraced and shunned. The use of Polaroid flattens the image and the light is harsh, but Warhol uses subtle shadows to soften his outline. The red of his lipstick and blusher adds a playful touch of élan.

ANDY WARHOL
A key figure in the American modern art movement, Warhol saw parallels between consumerism and the art market, and highlighted them in his iconic Campbell's Soup Can prints. Throughout the 1960s he diversified his artistic practice, taking in photography and filmmaking as well as creating a community of diverse artists through The Factory, his New York studio.

SELF-PORTRAITURE **p.21** ART **p.31**

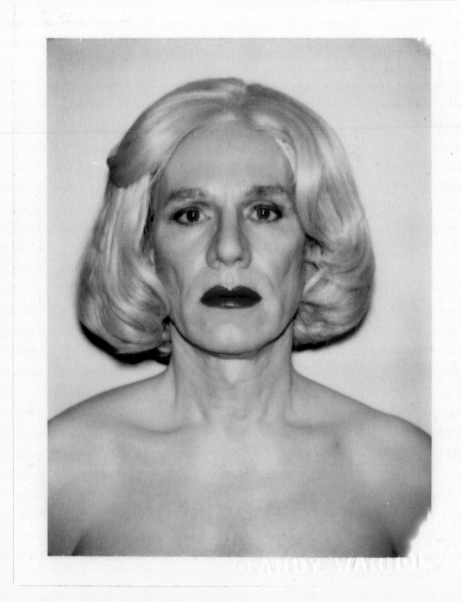

Untitled #96

1981

CINDY SHERMAN: CHROMOGENIC COLOUR PRINT • 61 x 121.9 CM (24 x 48 IN)

No photographer has crafted such a complex negotiation between viewer and subject, societal attitudes to gender and questions of identity through self-portraiture as Cindy Sherman (b.1954).

This image comes from the second series of Sherman's foray into colour. If the first series, which depicted her against rear-screen projections, evokes a bygone era of film and television, this series explores the way women are presented in pornographic magazines. Commissioned for *Artforum*, each photograph was to appear across a

Other works by Cindy Sherman
Untitled A (1975)
Untitled Film Still #21 (1978)
Untitled #228 (1990)

double-page spread in the style of *Playboy* centrefolds. Shot in close-up, an approach she would continue to employ in subsequent projects, Sherman is always seen looking off to the side. The vantage point of the viewer accentuates the vulnerability of the subject.

In this image, Sherman uses orange to almost kitsch effect, with her skirt raised to expose part of her thigh, hinting at violation. Her expression could be read as pensiveness; the personal ad in her hand suggests that she has just made or is about to make a call. The photograph goes beyond mere parody of the form, with Sherman questioning both the representation and the reception of such imagery.

CINDY SHERMAN

After studying as a painter, Cynthia Morris Sherman turned to photography, set up a studio with Robert Longo, Charles Clough and Nancy Dwyer, and became part of the Pictures Generation, which appropriated material from the consumer and media culture in which they had grown up.

ICONOGRAPHY **p.166**

Cookie at Tin Pan Alley

1983

NAN GOLDIN: CIBACHROME PRINT

With her images of friends, lovers and strangers from New York's underground, Nan Goldin (b.1953) brought a rawness to portrait photography.

By the time she moved to New York in 1978, Goldin was shooting mainly in colour, but her focus still centred on the questioning of identity where an alternative third gender 'made more sense than either of the other two'. Her images from this period were a blend of styles that reflected the times, anarchic and rebelling against the straightjacketing of 'conventional' behaviour. Blurring the lines between art, fashion, anthropology and photojournalism, she created an aesthetic that has inspired subsequent photographers.

Goldin shot friends at parties, enjoying one another's company and in down times – those periods of quiet introspection. *Cookie at Tin Pan Alley* is such a moment. In her stillness, Cookie resembles one of the busts on the background wall. Her complexion and the light top she wears are a stark contrast to the wood panelling and low-lit surroundings. A sense of loneliness might have been offset by two glasses on the table. But she hardly looks happy with the company that might be there. Or both drinks are hers and she is lost in her own thoughts.

Other works by Nan Goldin
The Hug, New York City (1980)
Nan and Brian in Bed, New York City (1983)
Nan one month after being battered (1984)

NAN GOLDIN

A key chronicler of American subculture and a photographer whose work was punk before the movement had even taken root, Goldin first attracted attention with a show in 1973 detailing Boston's gay and transsexual communities. Her slideshow 'The Ballad of Sexual Dependency', comprising photographs taken between 1979 and 1986 and detailing New York's No Wave music and art scene, remains her defining work.

→ PEOPLE **p.173**

New Brighton, England

1983–85

MARTIN PARR: CHROMOGENIC COLOUR PRINT

Blurring the lines between art and entertainment and between high and low culture, Martin Parr (b.1952) transformed British attitudes to photography with his saturated colour portraits.

Parr's first series of colour photographs was inspired mainly by the work of Joel Meyerowitz, as well as by John Hinde's postcards of the Butlins holiday camps in Britain during the 1960s and early 1970s. The series 'The Last Resort: Photographs of New Brighton' was shot over the course of three summers, from 1983 to 1985. Parr recorded working-class life at the seaside not far from his home in Wallasey, on the mouth of the River Mersey. The impact of the series on the British photography landscape was no less seismic than the work of William Eggleston had been in the United States a decade earlier.

The image on the following pages is one of the best known from the series, whose representation of the

Below: Unlike the other children waiting to be served, this young girl acknowledges the presence of Parr's camera. Her position is aligned with the vertical shadow along the table and is a counterpoint to the young woman.

MARTIN PARR

Away from his work, Parr is an avid collector of postcards, which have frequently been shown in exhibitions, and of photobooks. In collaboration with the critic Gerry Badger he has published three volumes on the history of photobooks from the nineteenth century to the present day.

working class was derided by critics as condescending when first exhibited at a gallery in London. The photographs have since been acknowledged as a more accurate reflection than many of the 'noble' black-and-white portraits that came before them. The image is divided in two, between the disorderly backdrop of children and the sole employee behind the counter in the foreground. The image is striking for the young woman's gaze into the camera. It is direct, almost confrontational. Her lips are slightly pursed, suggesting annoyance, either with Parr distracting her or the cacophony of young voices she is having to contend with. Parr's use of saturated colours comes through in the green of the mint chocolate chip ice cream and the skin of the children, which has been exposed to varying degrees of sunlight.

Above: Parr's images take the form of vernacular photography, not perfectly framed portraits. The presence of two arms intruding into the frame hints at the larger world outside.

Other works by Martin Parr
Clifton College Public School, Bristol, England (1988)
The Leaning Tower of Pisa, Italy (1990)
Common Sense, Benidorm, Spain (1997)

CLASS **p.170** VERNACULAR **p.183**

Piss Christ

1987

ANDRES SERRANO: CIBACHROME COLOUR PRINT

Other works by Andres Serrano
Blood (1987)
Donald Trump (America) (2004)
Dead Sea Tree (Jerusalem) (2014)

The quality of his images notwithstanding, Andres Serrano (b.1950) is a controversial figure whose photographs confront societal attitudes to race, gender and articles of religious faith.

The striking image of a crucifix encased in a translucent yellow-orange substance prompted significant public outrage thanks to its title. It became one of the more controversial artworks of the 1980s. Moreover, the revelation that Serrano had received a $15,000 grant from the National Endowment for the Arts caused a furore in the US Congress during which one senator ripped up a copy of the image.

The response to Serrano's image has too often eclipsed his reasons for creating the work. Despondent at the way religious icons were peddled for profit, he intended *Piss Christ* to argue that the true value of faith was greater than any commercial gain. However, such products, even when immersed in urine – in this case, the artist's own – have an intrinsic value if they can offer spiritual strength. And Serrano's image is rapturously beautiful. It is lit so that the blood of Christ is seen to surround the image, while the stark yellow at the top of the crucifix represents the light of God shining upon Christ.

ANDRES SERRANO
New Yorker Serrano explores the link between the spiritual and the corporeal, as well as the lives of the dispossessed in contemporary society. Frequently using bodily fluids and faeces in his photographs, Serrano attracts controversy for the way he grapples with his ambivalence to the establishment.

PORTRAITURE **p.15** COLOUR **p.18** STILL LIFE **p.20** AVANT-GARDE **p.23** ART **p.31** CONCEPTUAL **p.39**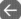

RELIGION **p.160**

Louvre 1, Paris 1989

1989

THOMAS STRUTH: CHROMOGENIC PRINT, 183 x 234 CM (72 x 92 IN)

A key member of the Düsseldorf School, Thomas Struth (b.1954) explores the way we interact with one another in social spaces.

Struth's series 'Museum Photographs' explores his 'interest in the fate of art in museums' and his desire to end the deification of art – to find a way to appreciate a painting as it would have been perceived before greatness was conferred upon it. In these large-scale images, artworks come alive through the process of vicarious viewing. We not only see the painting, but also witness it through the eyes of the museum's visitors. The focus here is Jacques-Louis David's vast painting *The Coronation of Napoleon* (1807), hanging in the Louvre in Paris. In the distance is a large group on a guided tour, behind individuals viewing the picture alone. In the foreground, other people engaged in conversation form a painterly tableau within the frame. Behind them, a museum attendant listens to a radio message and a couple are engaged in conversation. Struth's photograph echoes Louis-Léopold Boilly's painting *The Public Viewing David's 'Coronation' at the Louvre* (1810). Almost 200 years separate the two works, but the audiences differ little in their behaviour.

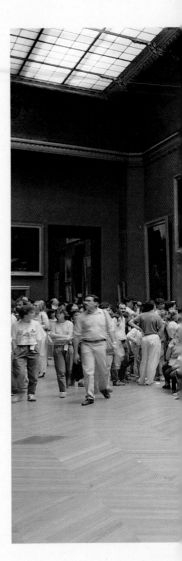

Other works by Thomas Struth
Shinju-ku, Tokyo (1986)
The Smith Family, Fife (1989)
Queen Elizabeth II and The Duke of Edinburgh, Windsor Castle (2011)

PORTRAITURE **p.15** DOCUMENTARY **p.28** ART **p.31** SOCIETY **p.34**

THOMAS STRUTH

Initially trained at Kunstakademie Düsseldorf in Germany, Struth first came to public attention in 1976 with grid photographs of his native Düsseldorf. He has also explored the psychological and social dynamic within families through a series of portraits, including one of Queen Elizabeth II and the Duke of Edinburgh.

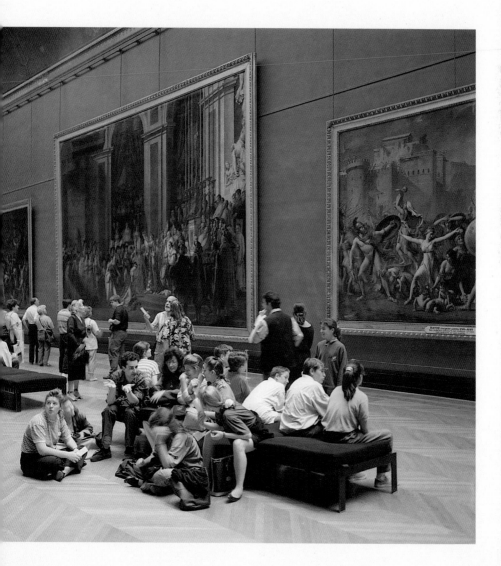

→ PEOPLE **p.173**

Lutz & Alex sitting in the trees

1992

WOLFGANG TILLMANS: CHROMOGENIC COLOUR PRINT

Other works by Wolfgang Tillmans
grey jeans over stair post (1991)
Concorde L449-11 (1997)
paper drop (haze) (2011)

Blurring the traditional lines between fashion, art and photojournalism, Wolfgang Tillmans (b.1968) was one of the key chroniclers of youth culture in the 1990s and is an astute observer of contemporary mores and attitudes.

Lutz & Alex sitting in the trees was part of a series of portraits featuring two of the photographer's childhood friends. It was first published in *i-D*, the influential British fashion, art, music and culture magazine, which then fell foul of newsagent chains, which refused to stock copies featuring such provocative images.

The tailored prelapsarian world depicted here by Tillmans is both frank and playful. Like so much of his work from this period, his photography skirts fashion without ever fully immersing itself in it. The coats draw attention to the models' nakedness but also help to reinforce their androgyny. Shot from an elevated position with a 50 mm Contax SLR camera, Alex is seen looking directly at the camera, unabashed and more headstrong, perhaps because she has climbed further up the tree. There is an intimacy in the way she leans towards the camera. Lutz is more rigid in his pose. He looks away from the camera, his expression hinting at unease.

WOLFGANG TILLMANS
The first photographer to be awarded the Turner Prize for art, Tillmans has worked across a variety of genres, most recently engaging with abstraction. However, as his photographs from Haiti following the earthquake of 2010 reveal, he is principally engaged with the way people exist in the world.

PORTRAITURE **p.15** COLOUR **p.18** NUDE **p.19** ART **p.31** FASHION **p.36**

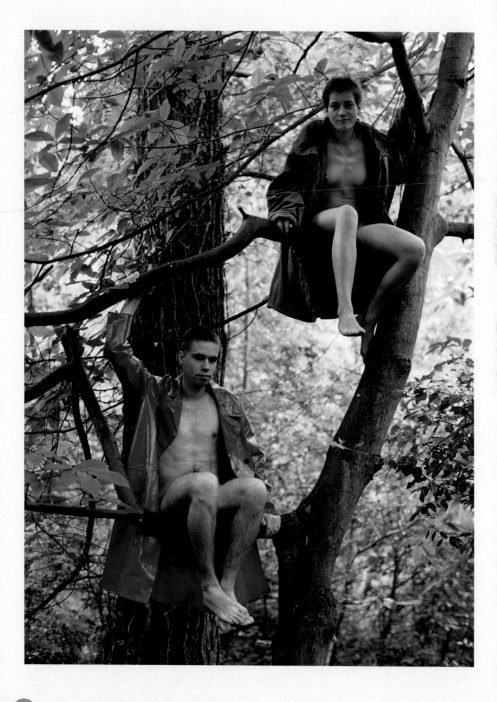

→ YOUTH CULTURE **p.186**

WORK TOWARDS WORLD PEACE, *from the series* Signs that say what you want them to say and not Signs that say what someone else wants you to say

1992−93

GILLIAN WEARING: C-TYPE PRINT MOUNTED ON ALUMINIUM • 44.5 x 29.7 CM (17½ x 11¾ IN)

Other works by Gillian Wearing
Self Portrait at 17 Years Old
(2003)

Sleeping Mask (for Parkett no. 70) (2004)

Me as Cahun Holding a Mask of My Face (2012)

GILLIAN WEARING
One of the few members of the Young British Artists movement of the 1990s to work in photography and video, Wearing was awarded the 1997 Turner Prize for *60 Minutes of Silence*, in which she used video like a still camera for an extended pose that explored the relationship between photographer and subject.

Questions of representation dominate the work of Gillian Wearing (b.1963), as she gives voice to her subjects or explores identity through self-portraiture.

In challenging preconceptions about photographic subjects, with this series of street portraits Wearing hands power back to the people being photographed, allowing them to express what they think or how they feel. The idea for the series stemmed from the photographer's ambivalence towards the conventions of portraiture, and her feeling that she 'couldn't bear the idea of taking photographs of people without their knowing'. Approaching strangers on the street, Wearing asked them to write what they were thinking on a piece of white paper. From a black police officer exclaiming 'HELP' and an elderly man writing 'ME', to a young woman stating, 'MY GRIP ON LIFE IS RATHER LOOSE!', Wearing sought to capture the juxtaposition of thought, expression and interpretation.

This image was used in 2017 by London Mayor Sadiq Khan and the artist David Shrigley as part of a series of artworks entitled '#LondonIsOpen' that appeared in the city's 270 Underground stations, highlighting its openness to the world, despite the referendum that had just voted in favour of Britain leaving the European Union.

STREET PHOTOGRAPHY **p.17** DOCUMENTARY **p.28** ART **p.31** CONCEPTUAL **p.39**

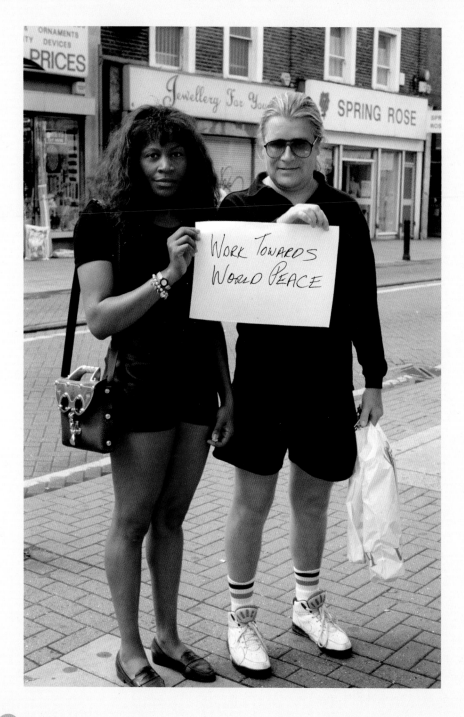

POLITICS **p.172**

Hilton Head Island, S.C., USA, June 24, 1992

1992

RINEKE DIJKSTRA: CHROMOGENIC PRINT • 117 x 94 CM (46 x 37 IN)
EDITION OF 6

Other works by Rineke Dijkstra
Julie, Den Haag, Netherlands,
February 29, 1994

Vondelpark, Amsterdam, June
10, 2005

Marianna and Sasha, Kingisepp,
Russia, November 2, 2014

Through her large-scale portraits, Rineke Dijkstra (b.1959) captures the awkwardness of adolescence.

A teenage girl stands on a beach, the tide rolling in behind her. Remnants of surf appear to pan out from where she stands, curved lines like tentacles spreading along the sand. With one hand, she holds her hair back as the wind blows. The other hand, marked by the presence of a ring with an aqua-blue stone, follows the line of her leg.

The image is part of Dijkstra's breakthrough series 'Beach Portraits'. Drawing on the intimacy of Diane Arbus and the rigorous formality of Thomas Struth, Dijkstra's images not only convey the personality of each subject, but also hint at the universal experience of adolescence and the torrent of emotions that stem from it.

This image references *The Birth of Venus*, but it differs in terms of the subject's expression. Botticelli's Venus appears placid, whereas the teenager in Dijkstra's portrait looks pensive. It may have been nervousness at being shot by a stranger, the temperature on the beach or something personal to her that we will never know. But it suggests that moment in youth when all is about to change.

RINEKE DIJKSTRA
Dutchwoman Dijkstra claims to have developed her distinctive photographic style from an accidental self-portrait taken as she emerged from a swimming pool in 1991. Showing her in a state of near-collapse – she was recovering from a cycling accident – the image revealed the richness of detail that can be obtained from a deceptively simple photograph.

PORTRAITURE **p.15** LANDSCAPE **p.16** COLOUR **p.18**

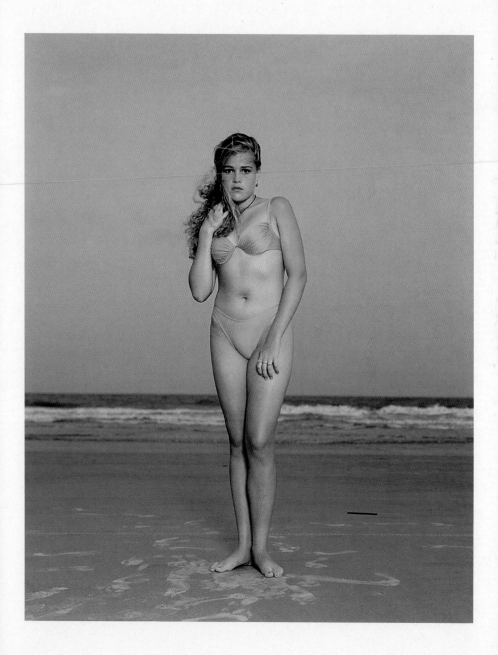

Baltic Sea, Rügen

HIROSHI SUGIMOTO: GELATIN SILVER PRINT

1996

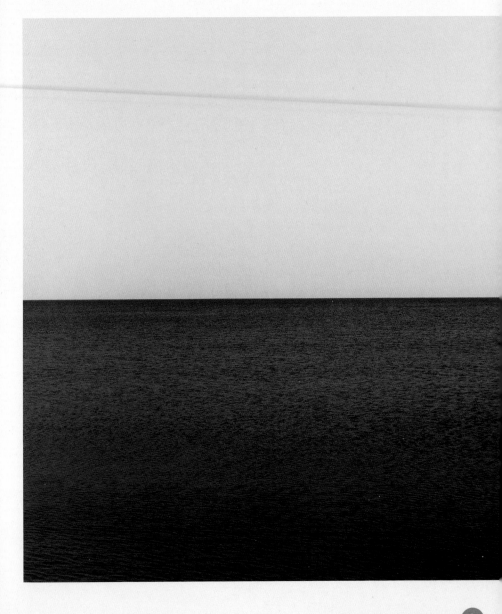

MONOCHROME **p.12** LANDSCAPE **p.16**

Hiroshi Sugimoto (b.1948) expresses the transience of existence through his large-scale photographs.

Perfect in its symmetry, divided horizontally by sea and sky, this photograph of the Baltic Sea is as beguiling as it is beautiful. The simplicity of the composition draws the viewer in to discover the complexity of the textures of the water and the seemingly inert sky.

Sugimoto began shooting the 'Seascapes' series, of which this is a part, in 1980. He employs a large-format view camera with 20.3 x 25.4 cm (8 x 10 in) black-and-white film, which he meticulously develops by hand (his prints appearing on double-weight gelatin silver paper). Unlike other images in the series where sky and sea meld into a band of whites and greys, or where the sun bounces off the sea creating a stark contrast between light and dark, this possesses the quality of late-period Mark Rothko, a mesmerizing pairing of two distinct blocks. In contrast to Sugimoto's similar *Caribbean Sea, Jamaica* (1980), there is no discernible pattern in the water, just ripples of calm that hint at the possibility of unease.

HIROSHI SUGIMOTO
Originally from Tokyo, Sugimoto moved to New York after studying fine art at the Art Center College of Design, Pasadena, California. A photographer renowned for his technical ability, he employs long exposures in much of his work, which has included theatres, buildings and the vast sculptures of Richard Serra.

Other works by Hiroshi Sugimoto
Hyena-Jackal-Vulture (1976)
Canton Palace, Ohio (1980)
Joe: 2029 (2005–06)

→ WEATHER **p.156** NATURE **p.163**

Flower Rondeau

1997

NOBUYOSHI ARAKI: RP-PRO CRYSTAL PRINT

From his erotic imagery through to his still lifes,
Nobuyoshi Araki (b.1940) explores our relationship
to sex, death and decay.

On the face of it, Araki's images of flowers appear
conservative compared to the erotic photographs
for which he is best known. For decades, Araki and
his wife, the essayist Yōko Aoki, cultivated a balcony
garden. The plants they grew there became the subject
of his book *Flowers in Paradise*, a double meaning that
encapsulates the flowers' beauty and also hints at the
importance to Araki of his small retreat. However,
these images will never grace the pages of mainstream
horticultural magazines, because Araki saw in them
an eroticism no less marked than that in his more
controversial work. For him, flowers represent the
female sex, their layers of petals resembling women's
genitalia. At the same time, they hint at the fragility of
life. Formally striking and often shot against a black or
neutral backdrop, the flower photographs occasionally
feature reptiles, both real and plastic. In this image,
he has used a dead lizard. Its decaying state is a stark
contrast to the beauty of the pink rose, but its presence
reminds us that beauty passes and decay follows.

Other works by Nobuyoshi Araki
Satchin and his Brother Mabo (1963–65)
Photo Maniac's Diary (1991)
Marvellous Tales of Black Ink (1994)

COLOUR **p.18** STILL LIFE **p.20** ART **p.31**

NOBUYOSHI ARAKI

A prodigiously industrious photographer who has produced more than 350 books of his work, Araki has attracted acclaim and ire in equal measure. The controversy surrounding the explicitness and tone of much of his work often overshadows his technical brilliance, as evinced in his still lifes.

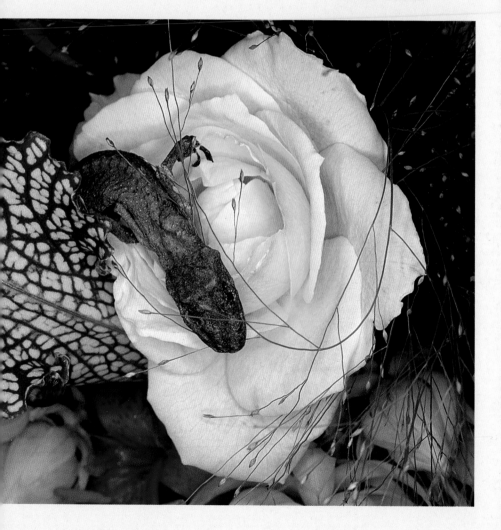

NATURE **p.163** DEATH **p.165** COLOUR **p.199**

The Falling Man

2001

RICHARD DREW: CIBACHROME PRINT

Amid the horror that unfolded on 11 September 2001, this image by Richard Drew (b.1946) of a lone man frozen in his rapid descent from one of the World Trade Center skyscrapers was chilling yet movingly human.

Subsequent media coverage of the terrorist attack focused mainly on two key moments: the planes flying into the twin towers and the buildings' subsequent collapse. In the intervening 102 minutes, people trapped in the buildings called their families, attempted to escape and, in many instances, were faced with the choice between incineration in the escalating heat and jumping to their death. One man, believed to be an employee of the North Tower's Windows on the World restaurant, was photographed by Drew as he fell to the ground.

Published in the immediate aftermath of the attack, the photograph was soon withdrawn. It was viewed as bad taste. But it gave a face, a face of dignity, to those who had perished. In an article in *Esquire* in 2003, Tom Junod named this victim 'The Falling Man'. Drew remembered him as being 'like an arrow, bisecting the two World Trade Centers'. To the left of him is the North Tower; everything to the right, the South. The exact time was 15 seconds past 09:41.

RICHARD DREW
An Associated Press photojournalist, Richard Drew was one of four photographers present in the kitchen of the Ambassador Hotel in Los Angeles when Robert F. Kennedy was assassinated.

PHOTOJOURNALISM **p.27** HUMANISM **p.29**

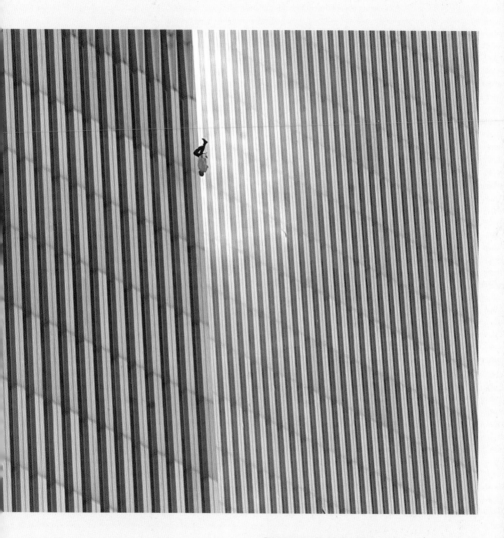

Other works by Richard Drew
Bobby Kennedy lying on the floor of the kitchen in the Ambassador Hotel, Los Angeles (1968)

Diana Ross Arrives (1977)

DEATH **p.165**

Overpass

2001

JEFF WALL: TRANSPARENCY IN LIGHTBOX • 214 x 237.5 CM (84³∕₁₀ x 93½ IN)

Bringing photography to the forefront of contemporary art, Jeff Wall (b.1946) draws on numerous influences to create moments that are open to multiple interpretations.

This photograph is a continuation of Wall's 'street pictures', all of which are staged and which began in 1982 with *Mimic*. Wall uses large-format cameras to produce images that are as painterly as they are photographic. His knowledge of art history often informs his work, and although his images possess the scale of a canvas, his use of a lightbox to exhibit them creates a very different and startling effect.

The palette of this constructed world – a long way from Cartier-Bresson's 'decisive moment' – is comprised of metallic greys and blues. The sky, dark with the threat of an imminent storm, blends with the sidewalk and road and some of the subjects' clothes. The lamppost and wires divide the far right of the image, separating the mechanized world from the pedestrians. And with the concrete wall they add depth. The impersonal nature of the shot – the travellers have their backs to the camera – contrasts with *Mimic's* directness, but also hints at the universal theme of the image – that modern life is in a permanently peripatetic state.

JEFF WALL
Wall is a Canadian art historian and a pioneer of the Vancouver School of photoconceptualism. In his own photography he balances popular culture references with the forms and styles of classical painting. From his breakthrough with *Picture for Women* in 1979, Wall's signature works, often large in scale, have been shown as transparencies in lightboxes.

STREET PHOTOGRAPHY **p.17** COLOUR **p.18** ART **p.31** SOCIETY **p.34** STAGED **p.40**

Other works by Jeff Wall
Picture for Women (1979)
Mimic (1982)
A Sudden Gust of Wind (after Hokusai) (1993)

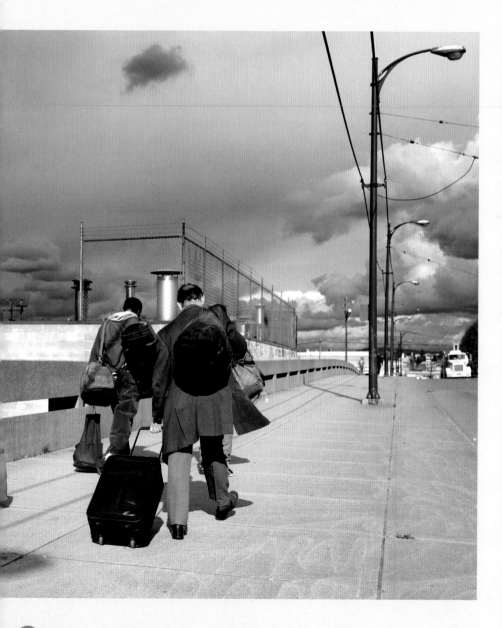

CONSUMERISM **p.169**

Beneath the Roses

2014

GREGORY CREWDSON: DIGITAL CHROMOGENIC PRINT
73.7 x 111.8 CM (29 x 44 IN)

Other works by Gregory Crewdson
Untitled (13–35) (1996)
Natural Wonder (1997)
Twilight (2001–02)

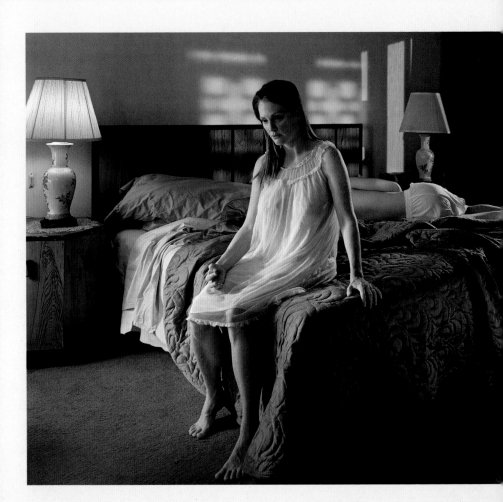

COLOUR **p.18** ART **p.31** STAGED **p.40**

With shoots resembling film productions, Gregory Crewdson (b.1962) deconstructs American suburban life through his lustrous domestic tableaux.

Crewdson's elaborately staged projects, often requiring a crew of dozens to realize, have established his reputation both critically and commercially. The series 'Beneath the Roses' took almost ten years to complete. In addition to referencing a wide range of cinematic influences, from Douglas Sirk and Todd Haynes to David Lynch and Steven Spielberg, it draws on the America of Edward Hopper and Norman Rockwell's *Saturday Evening Post* covers. Crewdson's re-imagining of the American small town is set in a permanent state of twilight, the penumbra hinting at secrets withheld or just out of view, and scenarios that appear familiar yet remain unexplained. Using a large-format camera and in this shot the actress Julianne Moore as his model, Crewdson creates a drama with no plot, motivation or resolution. Moore's near-blank expression recalls Cindy Sherman's self-portraits, inducing a variety of readings, and the entire scene can be read as a pastiche of cinematic representation (the actress's work with Haynes adds to the meta-narrative of the image) or a Baudrillardian commentary on the 'artificialness' of contemporary society.

GREGORY CREWDSON
A graduate of Yale University's Master of Fine Arts, Gregory Crewdson included in his senior thesis paintings of domestic life for the residents of Lee, Massachusetts. He would return to the town for his first photographic series, 'Natural Wonders'.

CONSUMERISM **p.169** MODERNITY **p.176** FAMILY **p.182**

Amazon

2016

ANDREAS GURSKY: CHROMOGENIC PRINT • 207 x 407 x 6.2 CM
(81½ x 160¼ x 2½ IN)

An alumnus of the Düsseldorf School, Andreas Gursky
(b.1955) uses digitally manipulated images to capture a
hyperreal world of globalization and mass consumerism.

Like Thomas Struth, Gursky creates vast images that
detail his fascination with the way the world works,
finding form in the repetitiousness of a technologized
society and the scale of modern commerce. This
shot of a vast, million-square-foot Amazon storage
facility is the reverse of a pointillist painting. Whereas

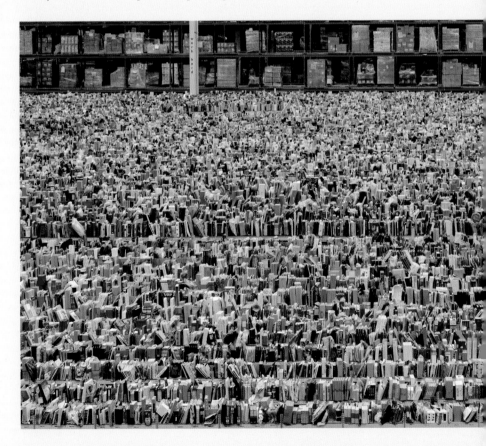

Georges Seurat's *A Sunday Afternoon on the Island of La Grande Jatte* (1884–86) transformed painted dots into a coherent image of calm, *Amazon* is pure chaos – hyper-distribution on an unfathomable scale – that gains familiarity only when viewed up close. In the distance, pillars are emblazoned with the mantras 'work hard', 'have fun' and 'make history'. It's the perfect image for a photographer whose work often questions the direction contemporary society has taken. His previous images have featured people, albeit never as individuals. Here, however, any sense of humanity is absent. This is an environment devised by an algorithm, bereft of the logic of Gursky's earlier work.

ANDREAS GURSKY
Of all Gursky's images, his serene *The Rhine II* (1999) has attracted the greatest media attention. The second in a series of six shots of the River Rhine and its green banks under an overcast sky, it became the most expensive photograph ever sold when it was auctioned at Christie's in 2011 for $4.3 million.

Other works by Andreas Gursky
Hong Kong, Shanghai Bank (1994)
The Rhine II (1999)
Kuwait Stock Exchange (2007)

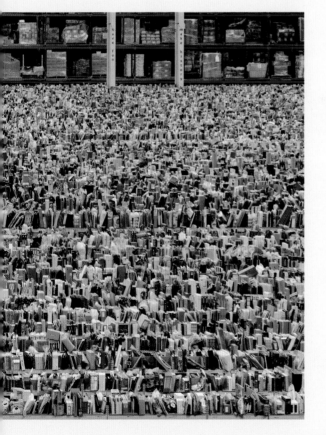

CONSUMERISM **p.169** MODERNITY **p.176**

Salt Pans #13

2016

EDWARD BURTYNSKY: CHROMOGENIC PRINT
148.6 x 198.1 CM (58½ x 78 IN)

The environmental impact of human industry is central
to the immense landscape portraits by the Canadian
photographer Edward Burtynsky (b.1955).

At once abstract and specific, Burtynsky's 'Salt Pans'
series is both striking and alarming. When considered
out of context, his use of colour, the geometrical
patterning heightened by the way the shot is framed, and
the sheer scale of the images are technically impressive.

Shot from approximately 150 to 200 m (500–800
feet) above the ground, this image has a formal quality
that places it beyond reportage or conventional aerial
photography. In its totality, it captures what Burtynsky
describes as 'the democratic distribution of light and
space across the whole field'. At the same time, it is
impossible to ignore the environmental and human
cost of what we see. These salt flats are in the Little
Rann of Kutch, in Gujarat, India. For centuries,
workers have made a living extracting salt from there
and more than 100,000 work there today. But with
receding groundwater levels caused by the impact of
global industrial practice, this natural phenomenon
will cease to exist. This image and the series it comes
from, like all of Burtynsky's work, record both the
human and the natural cost of environmental change.

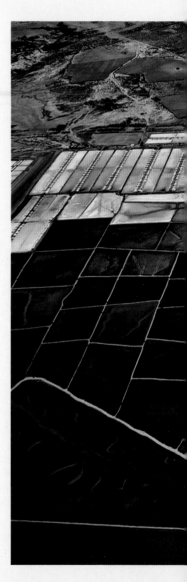

EDWARD BURTYNSKY
Believing more in 'the contemplated moment' than in Cartier-
Bresson's 'decisive moment', Burtynsky produced his early work
using a large-format field camera and 10.1 x 12.7 cm (4 x 5 in) sheet
film. Since 2007 he has worked with a high-resolution digital camera,
which he used to photograph the construction of China's Three
Gorges Dam.

ART **p.31** TOPOGRAPHY **p.35**

Other works by Edward Burtynsky
Grasses, Bruce Peninsula, Ontario (1981)
Nickel Tailings #34, Sudbury, Ontario (1996)
Oil Fields #19 b Belridge, California, USA (2003)

NATURE **p.163** DEATH **p.165** POLITICS **p.172** TECHNOLOGY **p.175**

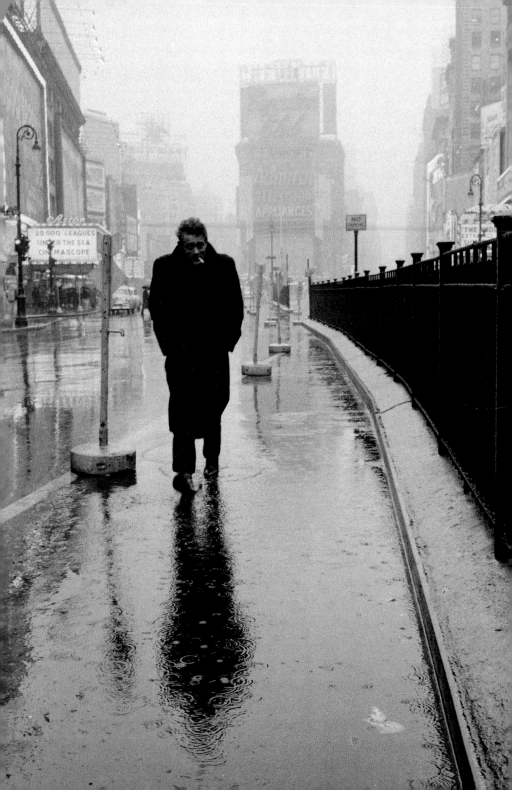

THEMES

Weather

KEY PHOTOGRAPHERS: CARLETON WATKINS • ALFRED STIEGLITZ • KURT HIELSCHER
EDWARD WESTON • ANSEL ADAMS • ERNST HAAS • HIROSHI SUGIMOTO

Technical innovations facilitating greater clarity in composition have embellished the tone, texture and mood of land and seascape photography.

Early pioneers in documentary landscape photography, such as Carleton Watkins, who used a giant plate camera to shoot in Yosemite Valley, accentuated depth of field by emphasizing cloud formation. By contrast, pictorial photographers such as Frank Meadow Sutcliffe and Peter Henry Emerson (1856–1936) edged away from straight photography, applying darkroom techniques that gave background and sky an ethereal quality. The reaction against this movement returned to documentary and embraced abstraction. *Deutschland* (1924), a survey by Kurt Hielscher (1881–1948), presented 304 pastoral

portraits with emphasis on weather conditions. Alfred Stieglitz undertook a 12-year study of cloud formations entitled *Equivalent* (1922–35). The series' abstract qualities would later be reflected in the seascapes of Hiroshi Sugimoto (see page 140), while the ever-changing relationship between earth and sky was captured time and again by Ansel Adams (see page 90).

KEY DEVELOPMENTS
Arriving in 1912 with Captain Scott and his ill-fated team, Herbert Ponting (1870–1935) spent 14 months in Antarctica. The images that he produced were among the most complete early records of conditions there.

The Castle Bay, Herbert G. Ponting, 1910–13, toned gelatin silver print, 55.2 x 75.9 cm (21¾ x 29⅞ in), The J. Paul Getty Museum, Los Angeles, USA

MONOCHROME **p.12** PICTORIALISM **p.13** LANDSCAPE **p.16** ABSTRACTION **p.22** DOCUMENTARY **p.28**
THE MUDLARKS **p.58** BALTIC SEA, RÜGEN **p.140** OVERPASS **p.146**

Architecture

KEY PHOTOGRAPHERS: NICÉPHORE NIÉPCE • WILLIAM HENRY FOX TALBOT • FREDERICK H.
EVANS • FRANCIS BEDFORD • CHARLES SHEELER • THOMAS STRUTH • ANDREAS GURSKY

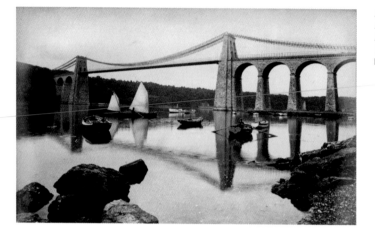

*Boats by the
Menai Suspension
Bridge, Anglesey,
Wales,* Francis
Bedford, c.1865

Architecture's relationship to photography spans the aesthetic and commercial, while also charting cultural change in societies.

The relationship was firmly established by Nicéphore Niépce's *View from the Window at Le Gras* (see page 46) and the interior view of Lacock Abbey (1835) by William Henry Fox Talbot. Buildings were perfectly suited to the lengthy exposure times of these early cameras, but it wasn't until the mid nineteenth century that architectural photography became an established trend. In France, the government-sponsored Missions Héliographiques project aimed to photograph every monument and landmark building in the country. Meanwhile, photojournalists capturing images of the American Civil War would often accentuate partially destroyed structures, and in Britain Francis Bedford (c.1816–94) and Frederick H. Evans took

great interest in churches and cathedrals. Elevation and perspective soon became significant factors, and smaller cameras allowed more imaginative angles. Frank Lloyd Wright (1867–1959) was one of the first architects to realize the potential of photography, while Soviet Constructivist artists and members of the Bauhaus group highlighted radical visions of urban constructions.

KEY DEVELOPMENTS
In the years following World War II there was a shift in the use of architectural photography, from its original role in business to featuring heavily in lifestyle magazines. The buildings people lived and worked in had to be as stylish as the clothes they wore, and in subsequent decades fine art photographers increasingly turned their gaze to architectural design.

STRAIGHT PHOTOGRAPHY **p.14** LANDSCAPE **p.16** STREET PHOTOGRAPHY **p.17**
VIEW FROM THE WINDOW AT LE GRAS **p.46** NEW YORK, NIGHT VIEW **p.78** THE FALLING MAN **p.144**

Beauty

KEY PHOTOGRAPHERS: JULIA MARGARET CAMERON • MAN RAY • GEORGE HURRELL
GEORGE HOYNINGEN-HUENE • CLARENCE SINCLAIR BULL • EDWARD WESTON

The notion of beauty changes across time and cultures. Photography, like fine art and sculpture, has helped to shape our attitudes towards it.

The artist's relationship with beauty has been to take on the role of arbiter in defining how it is represented. Western ideas of beauty, which can be traced back to ancient Greece, permeate photography as much as any other art form before it. (Photography has also played a similar role in other cultures.) Pictorialism in the late nineteenth century harked back to classical forms of portraiture, as evinced by Julia Margaret Cameron's *Beatrice* (see page 56). Straight photography emphasized a more

natural quality, whether recording nature or shooting people, while Abstract photography highlighted beauty of form. A simple utensil such as André Kertész's *The Fork* (see page 70) or Edward Weston's series of nudes emphasized lines and curves, often detached from conventional representation. The arrival of fashion magazines and cinema emphasized the importance of beauty and the nascent industry behind its promotion. Beauty became aspirational and indivisible from glamour and, to a lesser degree, celebrity.

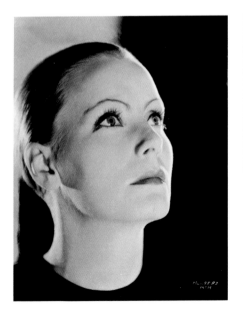

Greta Garbo, Clarence Sinclair Bull, 1931

KEY DEVELOPMENTS
The promotion of cosmetic beauty as a more homogenized image was realized in the 1920s with the expansion of mass media and the production of widely read fashion magazines. Cinema played a significant role in defining beauty, and stars such as Greta Garbo were defined by the images taken of them. Clarence Sinclair Bull understood Garbo's relationship with the camera, and from the actress's first moment in Hollywood he was her only official photographer.

PICTORIALISM **p.13** PORTRAITURE **p.15** NUDE **p.19** ABSTRACTION **p.22** GLAMOUR **p.32** FASHION **p.36**
ADVERTISING **p.37** BEATRICE **p.56** LOVERS IN A PARIS CAFÉ **p.76** THE KISS AT THE HOTEL DE VILLE **p.96**

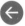

Love

KEY PHOTOGRAPHERS: BRASSAÏ • ROBERT DOISNEAU • ELLIOTT ERWITT
NORMAN PARKINSON • ANNIE LEIBOVITZ

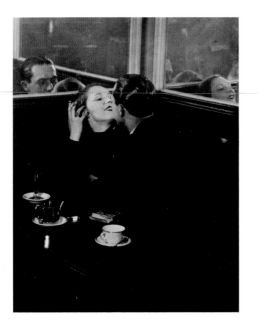

KEY DEVELOPMENTS
The humanist tradition in the post-World War II era helped to shape the image of love in Western society. Even the end of the war itself prompted one of the most iconic photographs: Alfred Eisenstaedt's V-J Day shot of a US sailor kissing a stranger in Times Square captured perfectly the fleeting intensity of love in the moment.

Lovers in a Paris Café, Brassaï, 1932, gelatin silver print, 28.3 x 22.7 cm (11⅛ x 8¹⁵⁄₁₆ in), Musée National d'Art Moderne, Centre Pompidou, Paris, France

Countless photographers have attempted to find perfect expressions of love in all its forms, from familial bonding to youthful infatuation.

Many of the greatest photographs depicting love have been captured in the moment. Some, like a painter's subject, have been choreographed. Robert Doisneau's *The Kiss at the Hotel de Ville* (see page 96) was staged, as was Brassaï's earlier *Lovers in a Paris Café* (see page 76). They presented picture-perfect impressions of young love. Cinema added glamour and celebrity, as evinced by Marcello Geppetti's shot of Richard Burton and Elizabeth Taylor kissing while sunbathing in Italy in 1962.

In *Girl and Movie Poster, Cincinnati, Ohio*, John Vachon (1914–75) showed that even as early as 1938 photographers were marking the contrast between conventional images of love on screen and the realities of everyday life. Elliott Erwitt's *Mother and Child, New York* (1953) is a key humanist photograph, exuding tenderness and sensitivity. *John Lennon and Yoko Ono* (1980) by Annie Leibovitz (b.1949) and the portrait of gay activists Tom Doerr and Marty Robinson by Diana Davies (b.1938) in 1970 exemplify mutual and loving bonds between people.

Religion

KEY PHOTOGRAPHERS: JULIA MARGARET CAMERON • FRED HOLLAND DAY
FREDERICK H. EVANS • EDWARD S. CURTIS • ANDRES SERRANO • DAVID LACHAPELLE • ADI NES

KEY DEVELOPMENTS
The link between photography and the shift away from art's previously close affiliation to religion reflects the state of human progress in the post-industrial age, when societies' day-to-day existence is reliant more on human-made objects than natural products, removing the link that gave religion such a powerful role in daily life.

Photography flourished in an era when religion no longer held sway over art. Its subsequent photographic representation lay more in the recording of faith and the questioning of religious institutions than achieving transcendence through artistic endeavour.

Pictorialists such as Julia Margaret Cameron (see page 56) and Fred Holland Day employed religious iconography to place their work within an artistic context, the latter most famously with his sublime portrait *The Crucifixion* (1898). But earlier photographers, such as Frederick H. Evans, known for his skilfully composed images of French and English cathedrals, cemented the more conventional approach of representing religion from a documentary perspective. Ethnologists followed suit, recording practices among faiths around the world, including Edward S. Curtis's images of Native American rituals and apparel. This approach would continue in the work of Robert Frank and Ian Berry in their studies of, respectively, America and England. And as the role of the Christian church has diminished in the West, photographers have grappled with the part played by religion in an age of consumerism, from Andres Serrano's controversial *Piss Christ* (see page 130) to *Jesus is my Homeboy* (2003) by David LaChapelle (b.1963).

Haschogan (Home God), The Yebichai Hunchback, Edward S. Curtis, 1904, gelatin silver print, Library of Congress, Washington D.C., USA

PICTORIALISM **p.13** COLOUR **p.18** NUDE **p.19** AVANT-GARDE **p.23** POP **p.33** CONCEPTUAL **p.39** PISS CHRIST **p.130**

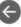

Movement

KEY PHOTOGRAPHERS: EADWEARD MUYBRIDGE • ÉTIENNE-JULES MAREY • GUSTAVE LE GRAY • GJON MILI • ROBERT CAPA • BOB MARTIN

Like painters for thousands of years before them, photographers have attempted to capture movement, and their efforts have resulted in numerous creative and technical innovations.

Eadweard Muybridge explored the nature of motion and presaged the inception of cinema. But a single image was no less capable of conveying movement. Before fast shutter speeds captured an incoming tide in detail, Gustave Le Gray used the blurring of surf in *The Broken Wave, Sète* (1857) to create drama and register motion. Robert Capa's D-Day Landing images (see page 92) similarly employed blurring to capture the kinetic ferocity of war. The grace of movement and the suppleness of the human body were celebrated in the nude stretching back against three clothed women in *Movement Study* (1925) by

Rudolf Koppitz (1884–1936); in the dancers of *Cotillion* (1935) by Alexey Brodovitch (1898–1971); and in the athleticism of *My Brother as Icarus* (1919) by André Kertész. Faster shutter speeds eventually allowed photographers to capture rapidly moving subjects. In Richard Drew's *Falling Man* (see page 144), the clarity of the image gives solemn dignity to a victim of terrorism.

KEY DEVELOPMENTS
Étienne-Jules Marey also experimented with shutter systems and created what was known as a 'chrono-photography' system, best seen in his *Study of a Man Pole-vaulting* (1890–91), which recorded ten images per second on to a single plate.

Animal Locomotion, Eadweard J. Muybridge, 1887, collotype, 23.8 x 30.8 cm (9⅜ x 12⅛ in), The J. Paul Getty Museum, Los Angeles, USA

STRAIGHT PHOTOGRAPHY **p.14** NUDE **p.19** WAR **p.24** PHOTOJOURNALISM **p.27** SCIENCE **p.30** AMERICAN SOLDIERS LANDING ON OMAHA BEACH **p.92**

The Surreal

KEY PHOTOGRAPHERS: MAN RAY • EUGÈNE ATGET • CLAUDE CAHUN • LEE MILLER
HANS BELLMER • DORA MAAR • RENÉ MAGRITTE • MAURICE TABARD

Street Fair Booth,
Eugène Atget, 1925,
gelatin silver print,
17.3 x 22.5 cm (6¹³⁄₁₆
x 8⅞ in), The J. Paul
Getty Museum, Los
Angeles, USA

The Surrealists embraced photography as a way of re-envisioning the everyday or, through the use of effects, exploring and expounding notions of the surreal.

Man Ray's *Ingres' Violin* (see page 66) appeared on the cover of *Littérature* magazine in the year that André Breton (1896–1966) published the first *Surrealist Manifesto*. Photography was seen as a key component of the movement, the images it produced not so much an interpretation of reality as a transcription of it; the most prosaic image could be re-contextualized as something extraordinary. Nowhere was this more evident than in the work of Eugène Atget. In contrast to the way Man Ray and Maurice Tabard (1897–1984) employed double exposure and effects,

René Magritte (1898–1967) created photographic equivalents to his paintings, and Hans Bellmer (1902–75) constructed sexualized images with dolls, Atget's images of frequently deserted Parisian streets offered dream-like views of the city in which the artists lived.

KEY DEVELOPMENTS
Sigmund Freud's essay 'The Uncanny' (1919) had a significant influence over the Surrealists' thinking. In the way that what repulses us – the uncanny – unconsciously reminds us of our own id and those impulses that we repress, so the artwork of the Surrealists was intended to tap into those hidden desires and bring them to the surface of the consciousness.

NUDE **p.19** ABSTRACTION **p.22** ART **p.31** CONCEPTUAL **p.39** INGRES' VIOLIN **p.66**

Nature

KEY PHOTOGRAPHERS: GEORGE SHIRAS • WILLIAM HENRY FOX TALBOT • GUSTAVE LE GRAY
HERBERT PONTING • ANSEL ADAMS • EDWARD WESTON • EDWARD BURTYNSKY

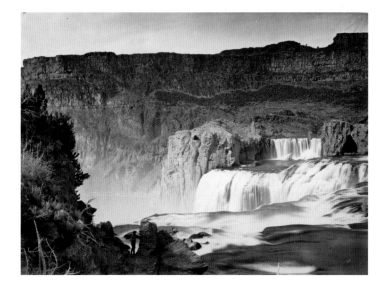

Shoshone Falls, Snake River, Idaho. Mid-day View. Adjacent Walls About 1,000 Feet in Height, Timothy H. O'Sullivan, 1874, albumen silver print, 20.2 x 27.3 cm (7¹⁵⁄₁₆ x 10¾ in), The J. Paul Getty Museum, Los Angeles, USA

Representation of the natural world has shifted from admiration to concern as humanity's environmental impact has become increasingly destructive.

Early nature photography ranged from painterly portraits of local flora, such as William Henry Fox Talbot's *Byronica Dioca – the English* Vine (1839) and Gustave Le Gray's shots of the Forest of Fontainebleau (c.1855), to the vast landscapes captured by Timothy H. O'Sullivan at Shoshone Falls, Idaho (1874). But camera speed and photosensitivity proved limiting. By the time Herbert Ponting joined Captain Scott's Antarctic expedition in 1911 (see page 156), his large glass plates allowed him to capture life in the frozen wastes in exquisite detail. This approach to straight photography continued in the work of Ansel Adams (see page 90). Adams raised concerns about the stability of the environment, and his images remain as vital as the work of Edward Burtynsky (see page 152) in highlighting human impact on the planet.

KEY DEVELOPMENTS

In 1906, *National Geographic* published its first wildlife photographs, 74 images by US Congressman and conservationist George Shiras (1859–1942). He shot mostly at night and used a jacklight – the flame of a kerosene lamp that both illuminated his subject and kept it still, transfixed – and a camera trap connected to a variety of flashes and remotely controlled cameras.

STRAIGHT PHOTOGRAPHY **p.14** LANDSCAPE **p.16** DOCUMENTARY **p.28** TOPOGRAPHY **p.35**
TRANSMISSION LINES IN MOJAVE DESERT **p.90** BALTIC SEA, RÜGEN **p.140**

Animals

KEY PHOTOGRAPHERS: FRANK HAES • GEORGE SHIRAS • HAROLD EUGENE EDGERTON
WILLIAM WEGMAN • ELLIOTT ERWITT • KEITH CARTER • DANIEL NAUDÉ • ANTHONY LEPORE

Animals are as prolific a presence in photographs as people and landscapes, from the earliest images to the present.

We often define our place in the world through our relationship with animals. They can equally be symbolic of the wilderness – to be admired or tamed – or the essence of domesticity. Early photographs of animals were limited by their having to remain still, and consequently they were trapped, dead or household pets, as seen in the daguerreotype *Portrait of Girl with a Deer* (1854) and *Dead Stag in a Sling* by Capt. Horatio Ross (1801–86). As shutter speeds increased, photographers shot creatures in their natural habitat. More recently, the likes of Keith Carter (b.1948) and Daniel Naudé (b.1984) have explored

human impact on the environment, critiquing our relationship to the natural world by placing domestic creatures in the wild. In *Nightbirds* (2009), Anthony Lepore (b.1977) uses digital manipulation to transpose the natural world into a human-made environment.

KEY DEVELOPMENTS

Outside the work of wildlife or animal photographers, Elliott Erwitt is renowned for his series of books featuring photographs of dogs. Eccentric, comical and occasionally anthropomorphic, Erwitt's books are a celebration of the species with which he has such a natural affinity that one colleague described him as being 'half photographer, half dog'.

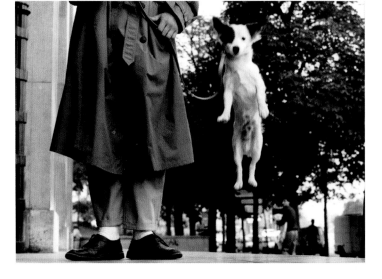

Untitled, Paris, France, 1989, Elliott Erwitt, 1989

Death

KEY PHOTOGRAPHERS: MATHEW BRADY • TIMOTHY H. O'SULLIVAN • ROBERT CAPA
GERDA TARO • DON MCCULLIN

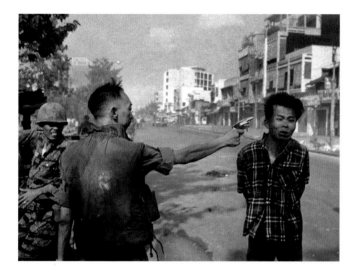

South Vietnam National Police Chief Nguyen Ngoc Loan Executes a Suspected Vietcong Member, Nguyễn Văn Lém, Eddie Adams, 1968, silver print, Associated Press, New York, USA

From Victorian post-mortem photography to images of war, photographs of the dead have been used for posterity, as records of events and even as grim amusement.

Death has played no less significant a role in photography than it has in other art forms. In Victorian times, families used photographs as alternatives to portraits or death masks, even picturing living members alongside the deceased. Roger Fenton's photographs of the Crimean War (1853–56) hinted at the numerous casualties, and the work of photographers covering the American Civil War a decade later showed the horror of the aftermath of battle (see page 52). War photography over the subsequent century brought death into the domestic environment, from Robert Capa's *The Falling Soldier* (1936) to Eddie

Adams (1933–2004) recording a street execution in Saigon in 1968. Some people claim that, through the proliferation of such images, we have become desensitized to death and carnage. But US soldiers' grisly photographs of dead detainees at Iraq's Abu Ghraib prison (2006) and the image of a Syrian infant refugee drowned and washed up on a beach (2015) highlight how shocking images of death remain.

KEY DEVELOPMENTS

The widespread availability of the daguerreotype in the late 1830s offered families a cheaper way of recording and remembering loved ones. Such early photographs are notable for the clarity of the dead family member as opposed to the living surrounding them who were unable to remain stationary for the length of the exposure.

STRAIGHT PHOTOGRAPHY **p.14** PORTRAITURE **p.15** STILL LIFE **p.20** WAR **p.24** PHOTOJOURNALISM **p.27** DOCUMENTARY **p.28** THE FALLING MAN **p.144**

Iconography

KEY PHOTOGRAPHERS: DOROTHEA LANGE • ALBERTO KORDA • ROBERT CAPA
GERDA TARO • IAN BERRY • NICK UT

From the Greek *eikonographia*, meaning a sketch or description, such images of people or key moments shape the way we view public figures or interpret events.

There is no consensus as to what constitutes an iconographic photograph. Some critics have suggested a direct reference to religious imagery in the same way as the term is applied to paintings. A frequently cited example, offering a symbolic parallel, is Nick Ut's shot of Phan Thị Kim Phúc (see page 116). But where would that place Andres Serrano's *Piss Christ* (see page 130), which invokes the rapture of faith while commenting on the

commercialization of religious artefacts? An alternative school of thought suggests that an iconographic photograph is defined by the way it is interpreted. Gerda Taro's and Robert Capa's images from the Spanish Civil War had a huge impact on the way the conflict was viewed. Likewise, Alberto Korda's shot of Che Guevara (see page 104) took on greater meaning after the subject's death, taking root in the consciousness of subsequent generations. It forever defined Che Guevara's public persona.

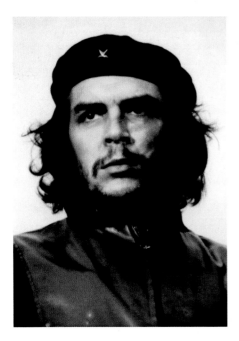

Che Guevara, Alberto Korda, 1960,
silver print

KEY DEVELOPMENTS

Photojournalism can make the everyday iconic and turn ordinary people into central historical figures. Among the most famous examples are *Tank Man* (1989) by Jeff Widener (b.1956), which shows a protestor obstructing the military on Tiananmen Square, Beijing; *Soweto Uprising* (1976) by Sam Nzima (b.1934), a poignant image of a student carrying a young dead boy; and *The Burning Monk* (1963) by Malcolm Browne (1931–2012), showing a Vietnamese Buddhist immolating himself. The series 'Country Doctor' (1948) by W. Eugene Smith (1918–78) is credited as the first photo story.

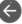

Celebrity

KEY PHOTOGRAPHERS: NADAR • CLARENCE SINCLAIR BULL • SLIM AARONS • EVE ARNOLD
CORNELL CAPA • ALBERTO KORDA • ANDY WARHOL • ANNIE LEIBOVITZ

The growth of mass media resulted in
the rise of celebrity, and photography has
proved key to moulding the individual's
image in the public eye.

It is hard to overstate the importance of
photography's role in the development of
celebrity culture. In late nineteenth century
Paris, Nadar's portraits put public faces to
well-known names, from artists and actors
to politicians and socialites. The arrival of
cinema enhanced the power of photogra-
phy to define stars' lives beyond the screen.
This image by Dennis Stock (1928–2010)
of James Dean in Times Square, New York,
helped to establish the actor's persona
as much as any of his film roles. It lies
somewhere between the intimate official
photographs of Slim Aarons (see page 102)
and the on-the-hoof style of the paparazzi,
whose role is to peer behind the 'image' and
capture the private lives of public figures.
The latter style was appropriated by Andy
Warhol as art and more recently, in the age
of the selfie, has transcended parody in the
celebrity status of Kim Kardashian, who
simultaneously adopts the roles of public
persona, private individual, portraitist and
paparazza.

KEY DEVELOPMENTS

Abraham Lincoln understood the need for
politicians to embrace celebrity; his portraits were
immensely popular. But it was John F. Kennedy's
US Presidential campaign in 1960 that set the
modern standard for image creation. A group
of *Life* magazine photographers and Magnum's
Cornell Capa (1918–2008) captured the politician
as film star.

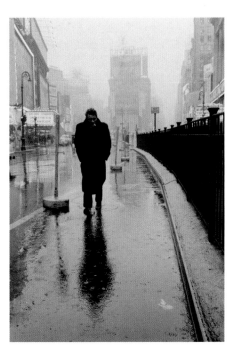

James Dean on Times Square, Dennis
Stock, 1955

PORTRAITURE **p.15** COLOUR **p.18** SELF-PORTRAITURE **p.21** GLAMOUR **p.32** FASHION **p.36** PAPARAZZI **p.38**
THE SELFIE **p.43** KINGS OF HOLLYWOOD **p.102**

Cityscape

KEY PHOTOGRAPHERS: FRÉDÉRIC MARTENS • VICTOR PREVOST • PAUL STRAND
ALEXANDER RODCHENKO • BERENICE ABBOTT • THOMAS STRUTH • ANDREAS GURSKY

The widespread availability of the daguerreo-type popularized cityscape portraits in the mid eighteenth century. The images became more complex as urban centres and photographic processes increased in sophistication.

Nicéphore Niépce's shot across the rooftop of his house (see page 46) was a hint at the importance of photography in documenting the transformation of cities as people moved in unprecedented numbers from the countryside into urban areas. Photographers such as Frédéric Martens (1806–85) and Victor Prévost (1820–81) were content to portray city skylines, showcasing the potential of panoramic photography and the scale of human endeavour in the expansion of Paris and New York. The influence of modernism on photography in the early twentieth century saw the representation of cities take on aesthetic, social and political dimensions, through the work of Alfred Stieglitz, Paul Strand, the Soviet Constructivists and Berenice Abbott (see page 78). Later, the Düsseldorf School (see page 150) and its alumni employed large-scale panoramas and used advances in digital technology to critique urban development.

KEY DEVELOPMENTS

Archive photography plays an important role in understanding the development of city sprawl. Archivists have unearthed photographs from many major cities in the mid nineteenth century. Some were taken by pioneers or enthusiasts, such as Robert Hunt (1830–92) in Sydney, Australia, and French customs officer Jules Alphonse Eugène Itier (1802–77) in Singapore; others by unknown photographers who captured images of Athens, Toronto, Shanghai and Jerusalem.

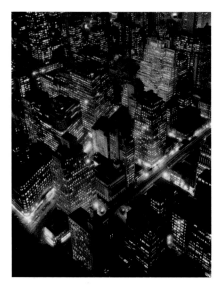

New York, Night View, Berenice Abbott,
1932, gelatin silver print,
34.1 x 27 cm (13⁷⁄₁₆ x 10⅝ in)

STRAIGHT PHOTOGRAPHY **p.14** STREET PHOTOGRAPHY **p.17** ABSTRACTION **p.22**
NEW YORK, NIGHT VIEW **p.78**

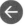

Consumerism

KEY PHOTOGRAPHERS: GEORGE HOYNINGEN-HUENE • JEFF WALL • MARTIN PARR
RICHARD PRINCE • ANDREAS GURSKY • KEITH YAHRLING • RICHARD JOHN SEYMOUR

Consumerism has been a preoccupation of many societies since the fifteenth century. Our relationship to it has merely become more complex over the last century.

From billboards to catalogues, photography has proven a profitable medium for selling lifestyles. As magazines became more popular in the first decades of the twentieth century, they employed photography to promote fashions and build brands. *Vogue* and *Vanity Fair* sought to blur the line between art and commerce, contracting the most prestigious photographers for glamorous fashion shoots. Over subsequent decades, youth culture embraced similar trends and photographers' work could be seen, simultaneously, in fashion-conscious style journals and galleries. At the same time, photographers also documented consumer

society at one remove. Jeff Wall has viewed consumerist society through the anonymity of modern travel, while in Andreas Gursky's *Amazon* (see page 150) a corporation tackles consumerism on a monumental scale.

KEY DEVELOPMENTS
Globalization has played a key role in late twentieth and early twenty-first-century consumer culture. The trend has created a new approach to documenting consumerism, highlighting its dehumanizing aspects. The works of Andreas Gursky, Keith Yahrling (b.1985) and Richard John Seymour (b.1989) all highlight a Ballardian hinterland of vast warehouses, identical malls and anodyne shopfronts.

Overpass, Jeff Wall, 2001, transparency in lightbox, 214 x 237.5 cm (84³/₁₀ x 93½ in)

COLOUR **p.18** GLAMOUR **p.32** FASHION **p.36** CONTEMPORARY ART **p.42** THE SELFIE **p.43** DIVERS **p.72** OVERPASS **p.146** AMAZON **p.150**

Class

KEY PHOTOGRAPHERS: LEWIS HINE • DOROTHEA LANGE • WALKER EVANS • BILL BRANDT
ROBERT FRANK • IAN BERRY • MARTIN PARR

The representation of class in photography was initially defined by the mode through which a social group was represented. The emergence of documentary practices led to a more critical approach.

The well-off sat for portraits in photographic studios, whereas those less fortunate were captured in everyday life, on the street or in their homes. This is a tradition that continues today. Pictorialist photographers, such as Frank Meadow Sutcliffe, made the working class the main subject of their work, but their portrayals emphasized the nobility of their lives. More nuanced portraits of working-class life came with the straight photography of Eugène Atget, August Sander, Alfred Stieglitz and Paul Strand. Lewis Hine charted the impact of mechanization on those employed to operate the machinery,

while the next generation of photographers, who included Dorothea Lange (see page 80) and Walker Evans (see page 82), shifted their focus to the lives of people struggling in rural environments. Class divisions remain in photographic representation. Lifestyle magazines and adverts continue to show the upwardly mobile, while photojournalism and documentaries depict the less fortunate.

KEY DEVELOPMENTS
Ian Berry's *The English*, a study of one country's people in the 1970s, was hugely influenced by Robert Frank's *The Americans* (see page 98), which challenged the notion of his adopted country as a classless society.

A Sunny Sunday Afternoon, Whitby, England, Ian Berry, 1974

Poverty

KEY PHOTOGRAPHERS: OSCAR GUSTAVE REJLANDER • EUGÈNE ATGET • ALICE AUSTEN
JACOB RIIS • BILL BRANDT • WALKER EVANS • DOROTHEA LANGE • GORDON PARKS

Social movements in the late nineteenth and early twentieth centuries prompted a shift in the representation of poverty, while governmental policy and political ideology were radicalized by images of the poor.

Attention shifted towards the urban poor in the late nineteenth century, as thousands teemed into rapidly expanding metropolitan areas. Pioneers such as Oscar Gustave Rejlander (1813–75), Heinrich Zille (1858–1929) and Eugène Atget documented poverty in London, Berlin and Paris. The work was developed further by Jacob Riis and Alice Austen in New York, the latter notable for the dignity she brought to her subjects. Lewis Hine highlighted the exploitation of the poor by industry; Bill Brandt recorded life in London's slums, while Walker Evans, Dorothea Lange, Gordon Parks and their colleagues were

charged by the US government with chronicling the lives of America's rural poor during the Great Depression. After World War II there was a fracturing of the social documentary movement owing to political pressure, particularly from American anti-Communists.

KEY DEVELOPMENTS

Henry Mayhew's articles for London's *Morning Star* newspaper were published in illustrated book form as *London Labour and the London Poor* (1851). Jacob Riis followed suit in 1890 with *How the Other Half Lives: Studies among the Tenements of New York*. It was followed half a century later by *Let Us Now Praise Famous Men* (1941) by James Agee and Walker Evans.

Warm Friends, Mulberry Street, New York, Jacob Riis, c.1895

STRAIGHT PHOTOGRAPHY **p.14** STREET PHOTOGRAPHY **p.17** ETHNOGRAPHY **p.26** PHOTOJOURNALISM **p.27** DOCUMENTARY **p.28** THE MUDLARKS **p.58** MIGRANT MOTHER, NIPOMO, CALIFORNIA **p.80**

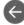

Politics

KEY PHOTOGRAPHERS: MARGARET BOURKE-WHITE • ALBERTO KORDA • IAN BERRY
JOSEF KOUDELKA • NICK UT

A Policeman Throws a Tear Gas Canister to Disperse Crowds During Student Riots in Paris, 17 June, 1968, Reg Lancaster, 1968

A single image can influence the way people think, act and vote.

Photojournalism might not have taken power out of the hands of the powerful, but it gave those in opposition a potent tool. World War I and the Russian Revolution brought about massive social change. The latter highlighted the impact that images could have on the populace, both from a propagandist perspective and to rally support. Beyond the coverage of mainstream politics, photojournalism played a significant role in societal change, particularly in highlighting the plight of the impoverished classes. However, its role in showing the horror of the Spanish Civil War set the tone for the way conflict was represented thereafter. Images could cause public outrage; Nick Ut's iconic photograph

from 1972 (see page 116) accelerated US withdrawal from Vietnam. Photographers showed events in ways that were often at odds with the way they were described by the establishment, such as the uprisings by students and workers in France and elsewhere in May 1968.

KEY DEVELOPMENTS

The advance of camera technology in mobile devices has revolutionized political coverage around the world. In the Arab Spring, which began in 2011, anyone with a phone became a journalist and documented events. Critics have suggested that citizen journalists may not possess the objectivity of official photojournalists, an issue that has seeped into the debate over fake news.

WAR **p.24** PROPAGANDA **p.25** PHOTOJOURNALISM **p.27** DOCUMENTARY **p.28**
CHE GUEVARA **p.104** MALCOLM X **p.106** CLASS **p.170**

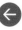

People

KEY PHOTOGRAPHERS: BILL BRANDT • BRASSAÏ • HENRI CARTIER-BRESSON
ROBERT FRANK • IAN BERRY • MARTIN PARR

Beyond portraiture, people are often defined as much by the clothes they wear or the environment they appear in as by the expressions they project to the camera.

The first photograph to feature a person was the view of the Boulevard du Temple by Louis Daguerre in 1838. Since the exposure time was more than ten minutes, the only clear figures in the image are a stationary shoeshiner and a customer. Though too distant to discern specific features, the shot emphasizes the relationship between subject and place that would become key to capturing people in photographs. The details of images such as those of children enjoying a day at the seaside (see page 126), people taking a break on a Sunday afternoon (see page 118) and a couple driving

out to the beach (see page 100) tell us much about the subjects. Bill Brandt's portraits of London in the 1930s and 1940s, like those of Brassaï in Paris, not only chronicled working-class life, but also revealed the workings of social groups, their activities and rituals, allowing us to understand the nature and workings of a given society.

KEY DEVELOPMENTS

Bill Brandt's two collections of photography from the 1930s, *The English at Home* (1936) and *A Night in London* (1938), include some of the most celebrated portraits of everyday life, often juxtaposing the lives of the privileged and working classes at work and play.

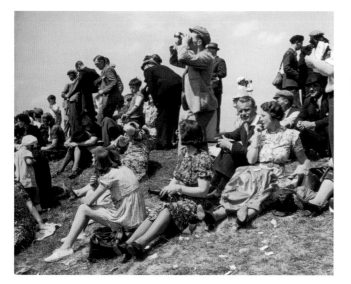

Crowds Watch a Wartime Derby run at Newmarket, England, 18 June, 1941, Bill Brandt, 1941

DOCUMENTARY **p.28** SOCIETY **p.34** THE MUDLARKS **p.58** PARADE, HOBOKEN, NEW JERSEY **p.98**
A SUNNY SUNDAY AFTERNOON, WHITBY, ENGLAND **p.118** NEW BRIGHTON, ENGLAND **p.126**

The Decisive Moment

KEY PHOTOGRAPHERS: HENRI CARTIER-BRESSON • MARTIN MUNKÁCSI • BRASSAÏ
ROBERT DOISNEAU • ELLIOTT ERWITT

Gestapo Informer, Dessau, Germany, Henri Cartier-Bresson, 1945, gelatin silver print

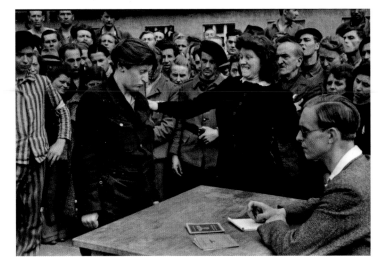

The publication of *Images à la sauvette*, or *The Decisive Moment*, in 1952 cemented Henri Cartier-Bresson's position as one of the most important photographers of the twentieth century.

Cartier-Bresson was one of the leading voices of the humanism movement that emerged after World War II, but his desire to capture the unusual in the everyday was formed by his association with the Surrealists in the 1920s and his world travels in the 1930s. The title is a quotation from the work of the seventeenth-century French Cardinal de Retz: 'There is nothing in this world that does not have a decisive moment.' To Cartier-Bresson, the term marked the perfect confluence of event and form, making the ordinary extraordinary. It gave a certain type of photography

theoretical grounding, and was immensely influential in news and sports coverage. Eventually its overuse dissipated its power, with less skilled photographers ignoring all but its most superficial aspects. However, great photographers such as Robert Frank and William Eggleston, while adopting certain elements of Cartier-Bresson's approach, also showed some of life's indecisive moments.

KEY DEVELOPMENTS

Cartier-Bresson only ever spoke of one photograph influencing him. In 1930 Martin Munkácsi (1896–1963) shot three boys running into the surf of Lake Tanganyika. *Liberia* had a huge impact when Cartier-Bresson saw it, and he later commented: 'I suddenly understood that photography can fix eternity in a moment.'

STRAIGHT PHOTOGRAPHY **p.14** STREET PHOTOGRAPHY **p.17** PHOTOJOURNALISM **p.27** DOCUMENTARY **p.28**
THE KISS AT THE HOTEL DE VILLE **p.96** LEE HARVEY OSWALD **p.108** LOVE **p.159** PEOPLE **p.173**

Technology

KEY PHOTOGRAPHERS: ROGER FENTON • LEWIS HINE • ALFRED STIEGLITZ
CHARLES SHEELER • LÁSZLÓ MOHOLY-NAGY • ALEXANDER RODCHENKO • ANDREAS GURSKY

Louis Bleriot,
George Gratham
Blain, 1909, Library
of Congress,
Washington D.C.,
USA

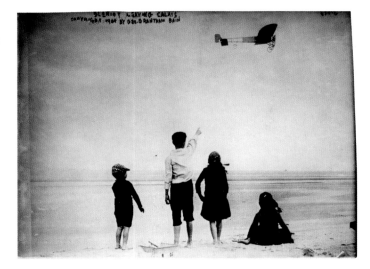

Photography emerged during a period of great industrial and technological change. In tandem with its continued development, it has provided a commentary on how such innovations aided and obstructed society.

Outside the realm of scientific research, modernity provided photographers with an opportunity to explore an industrial landscape that stood in stark contrast to earlier rural and urban settings. Conflict, meanwhile, offered the chance to chart the rapid development of industry. Roger Fenton's photographic reports from the Crimean War illustrated the behemoth of mechanized weaponry that would dominate subsequent conflicts. But it was the rapid developments in the aftermath of World War I that announced the arrival of the machine age. The structures created to

KEY DEVELOPMENTS
Photographers understood the drama of manned flight. Nadar's obsession with ballooning produced some of the earliest aerial photographs, while the Wright brothers' innovations dominated newspapers. But few images capture the excitement of flight as well as that of these young children watching the French pilot Louis Blériot fly by.

house machinery and the machinery itself suited photography more than any other medium. Some photographers captured the immensity of the edifices, while others focused on the workings of the machines. But all emphasized the stark angularity of these worlds, either abstractly or from a clear perspective.

WAR **p.24** SCIENCE **p.30** TOPOGRAPHY **p.35** MECHANIC AND STEAM PUMP **p.64** NEW YORK, NIGHT VIEW **p.78** AMAZON **p.150**

Modernity

KEY PHOTOGRAPHERS: LEWIS HINE • PAUL STRAND • ALEXANDER RODCHENKO
BERENICE ABBOTT • BERND AND HILLA BECHER • EDWARD BURTYNSKY • ANDREAS GURSKY

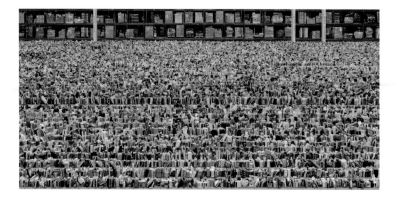

Amazon, Andreas Gursky, 2016, chromogenic print, 207 x 407 x 6.2 cm (81½ x 160¼ x 2½ in)

Photography didn't just record modern life, it became a key part of it. In an increasingly mechanized and densely populated world, images conveyed the complexity of society while highlighting some of its failings.

From recording the growth of urban centres to capturing the changing face of conflict, photography became the perfect medium to document the speed at which the world was developing. Paul Strand's shot of pedestrians dwarfed by a monolithic building in *Wall Street, New York* (1915) pointed out the potential of a city to dehumanize its populace, a theme later taken up by Berenice Abbott (see page 78), while Lewis Hine focused on conditions for the masses employed in industry. By contrast, Soviet propaganda used constructivist art to produce photographs that celebrated progress and the scale of human achievement through the industrialization of a formerly agrarian society. Decades later, Bernd and Hilla Becher produced

large-scale photographs of industrial buildings and factories, often organized in grid patterns. The immensity of their project is matched by the work of Edward Burtynsky (see page 152), which records the impact of these monoliths on the environment.

KEY DEVELOPMENTS

Bernd and Hilla Becher began working together, recording the disappearing industrial landscape of the Ruhr Valley, in 1959. They used a large 20.3 x 25.4 cm (8 x 10 in) view camera and shot from a number of angles – on overcast days to avoid shadows – but always with an objective point of view. Their grid-system approach influenced a generation of students taught by them, including Thomas Struth, Andreas Gursky, Candida Höfer and Thomas Ruff.

ABSTRACTION **p.22** AVANT-GARDE **p.23** DOCUMENTARY **p.28** MECHANIC AND STEAM PUMP **p.64**
NEW YORK, NIGHT VIEW **p.78**

Texture

KEY PHOTOGRAPHERS: ROGER FENTON • JULIA MARGARET CAMERON • ANDRÉ KERTÉSZ
EDWARD WESTON • LÁSZLÓ MOHOLY-NAGY • ANDY WARHOL • NAN GOLDIN • ANDREAS GURSKY

Texture is as important a component in the processing of a photographic print as it is of the object being photographed.

In attempting to equate photography with fine art, pictorialism aimed to achieve the texture of a painting, as evinced by Edward Steichen's *The Pond – Moonrise* (1904). Straight photography eschewed these painterly aspects, but photographers found alternative methods of employing texture in their work, from Edward Weston's pepper series (see page 74) to Alfred Stieglitz's decade-long project photographing clouds, *Equivalent* (1922–35), whose approach to abstraction is echoed in *Atlas Sheet 327 Clouds* (1976) by Gerhard Richter and in Hiroshi Sugimoto's seascapes (see page 140). László Moholy-Nagy, Man Ray and Lotte Jacobi (1896–1990) did away with cameras

to create photogram images, and other photographers' experiments with solarization (see page 205) produced stark contrasts with light. Saul Leiter and William Eggleston led the way in exploring the textural qualities of colour photography, while developments with Polaroid and digital cameras dramatically altered textural composition.

KEY DEVELOPMENTS
Images produced without cameras have existed for almost as long as camera-produced photographs and display a wide range of textures. Experiments by Man Ray, László Moholy-Nagy and Lotte Jacobi with, respectively, the Rayograph, the Luminogram and Photogenics added complexity and played with depth of field, while experiments with chemigrams by Pierre Cordier (b.1933) have continued the earlier artistic tradition.

Nasturtium Shadows, Ernst Hass, c.1955

PICTORIALISM **p.13** COLOUR **p.18** FASHION **p.36** THE MUDLARKS **p.58** PEPPER (NO. 30) **p.74**
PHOTOGRAM **p.84**

Gender

KEY PHOTOGRAPHERS: BRASSAÏ • CLAUDE CAHUN • ANDY WARHOL • DIANE ARBUS
NAN GOLDIN • CINDY SHERMAN • BRUCE WEBER • GILLIAN WEARING

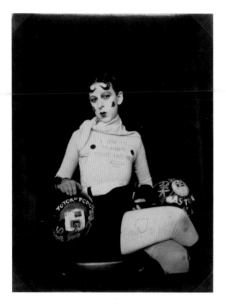

KEY DEVELOPMENTS
Claude Cahun is arguably the most important artist from the early twentieth century to use photography to question gender norms. With her partner, Marcel Moore, she created an impressive body of work that was comprised mainly of self-portraits in various guises.

Self-Portrait (I Am in Training, Don't Kiss Me), Claude Cahun, 1927, gelatin silver print, 11.5 cm x 9 cm (4½ x 3½ in), Courtesy of the Jersey Heritage Collections, Jersey Museum and Art Gallery, St Helier, UK

Beginning with the Victorian era's guarded playfulness in front of the camera, gender conventions and identity have played a key role in society.

Before mainstream acknowledgement of trans identity, the notion of gender-specificity fascinated photographers and revealed how representations of femininity and masculinity have changed with each generation. Although photography in the nineteenth century mostly reinforced stereotypes of men's strength and women's beauty and fragility, there were exceptions, particularly images of men in drag. In 1920s Paris, Man Ray photographed the artist Marcel Duchamp's female alter ego Rose Sélavy and the

American acrobat and female impersonator Barbette. In the clubs of the French capital, Brassaï captured life in which gender norms were flouted. This approach to the fluidity of gender identity can be seen in the work of Diane Arbus, Andy Warhol, Nan Goldin and Gillian Wearing, who all reject simplistic classification. Trans models now appear in mainstream magazines: in 2015 Annie Leibovitz shot Caitlyn Jenner for the cover of *Vanity Fair.*

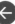

Age

KEY PHOTOGRAPHERS: BILL BRANDT • WALKER EVANS • ROBERT FRANK • IAN BERRY
MARTIN PARR • RICHARD AVEDON

Representation of the old in photographs not only reflects societal attitudes to ageing, but also the stark contrast between genders.

The representation of older generations in nineteenth-century photography, like that of the young, was stereotypical. Images either elicited sympathy or portrayed power and wisdom. From the ethnographic studies – particularly of Native American tribe leaders shot by the likes of Edward S. Curtis, Benedicte Wrensted (1859–1949), and the husband-and-wife team Hannah and Richard Maynard (1832–1907 and 1834–1918) – to Nadar's photographs of Paris society and even the work of Julia

Margaret Cameron, men were shot as dignified, their age conferring a degree of stature. By contrast, women were often viewed as matronly. Street photography and the shift in mores in the early twentieth century tilted the balance, but men still tended to fare better. More recently, the very nature of the ageing process has been scrutinized. *The Brown Sisters* by Nicholas Nixon (b.1947) began in 1975 as a one-off image of four siblings, but he has continued to photograph them every year for over 40 years, detailing the ageing process.

KEY DEVELOPMENTS
Fashion photography has always celebrated youth. However, people are now living longer than ever before and many retain significant spending power into old age; consequently businesses have changed the focus of their marketing, and this has caused a marginal shift in the age groups represented in advertising. Magazines now typically feature models aged over 50 in order to appeal to this burgeoning market.

Victor Hugo, Nadar, 1883, albumen silver print, 10.5 × 14.5 cm (4⅛ x 5¾ in), The J. Paul Getty Museum, Los Angeles, USA

PICTORIALISM **p.13** PORTRAITURE **p.15** STREET PHOTOGRAPHY **p.17** DOCUMENTARY **p.28** FASHION **p.36** PARADE, HOBOKEN, NEW JERSEY **p.98** DEATH **p.165**

Power

KEY PHOTOGRAPHERS: TIMOTHY H. O'SULLIVAN • NADAR • ALBERTO KORDA • EVE ARNOLD
RICHARD AVEDON • THOMAS STRUTH • PLATON

Beyond portraiture, photography became an essential tool in portraying the powerful in action, reinforcing their status in the public eye.

For much of its existence, the camera has conferred legitimacy on its subjects. Those aware of its potential availed themselves of it regularly. Queen Victoria made extensive use of it throughout her reign, exhibiting strength even in the most challenging times. US Presidents before Abraham Lincoln had sat for portraits, but during the Civil War Lincoln understood the need for the country's figurehead to be portrayed with strength, dignity and wisdom. Military leaders on opposing sides of that conflict also recognized the importance of the image, and all posed for the camera. Likewise, the powerful needed to be seen as people of action. News of the Confederate defeat in 1865 was not enough for the Union, so Timothy H. O'Sullivan was present to witness Robert E. Lee's surrender at Appomattox Court House. More than 150 years later, White House photographer Pete Souza (b.1954) recorded the moment President Barack Obama and his national security team witnessed live the killing of Osama bin Laden.

KEY DEVELOPMENTS
The American Civil War saw wide dissemination of images featuring African Americans. Key to these was the significant number of portraits featuring the black social reformer Frederick Douglass. From early daguerreotypes in the 1840s through to Mathew Brady's elderly statesman portraits in later years, Douglass's image challenged the foundation of Confederate supremacist ideology.

*Queen Victoria
Wearing a Black
Dress,* W. & D.
Downey, 1873

PORTRAITURE **p.15** WAR **p.24** PROPAGANDA **p.25** STAGED **p.40** CHE GUEVARA **p.104** MALCOLM X **p.106**

Crime

KEY PHOTOGRAPHERS: ALPHONSE BERTILLON • ARCHIBALD REISS • WEEGEE

The public has a voracious appetite for crime stories, and images of crime scenes sell newspapers.

Crime photography generally refers to images of the scene of an incident, rather than of the crime itself. However, there have been cases of photographers being in the right place at the right time, most famously Robert H. Jackson with Lee Harvey Oswald (see page 108) and Yasushi Nagao (1930–2009) with the assassination of Asanuma Inejiro; both photographers were awarded Pulitzer Prizes for their extraordinary images. In the 1930s and 1940s, American newspapers gave the name 'Murder Inc.' to the battles waged by the Italian-American Mafia, the Jewish mobs and other criminal organizations plaguing US cities. In Manhattan, Weegee's images came to dominate the headlines (see page 86).

This infamous crime photographer made crime a spectator sport. His images shocked some and were a match for the hyperbole of the yellow press. But there was an artfulness to his images, and his prolific body of work has been hugely influential over the way crime has been reported since.

KEY DEVELOPMENTS
In 1903, the French police officer Alphonse Bertillon (1853–1914) developed a system for documenting crime scenes. He used a large-format camera with a wide-angle lens that was positioned directly above the victim and recorded every detail that could then be used in court. His photograph *Murder of Madame Langlois* (1905) highlights his precision while retaining a grisly tone.

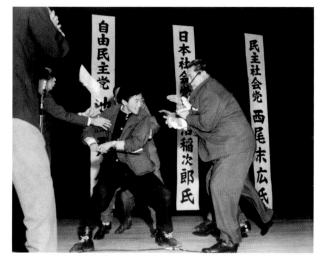

Assassination of Asanuma Inejiro, Yasushi Nagao, 1960

MONOCHROME **p.12** STRAIGHT PHOTOGRAPHY **p.14** STREET PHOTOGRAPHY **p.17** PHOTOJOURNALISM **p.27** SOCIETY **p.34** PAPARAZZI **p.38** COP KILLER **p.86**

Family

KEY PHOTOGRAPHERS: FRIEDRICH ADOLPH PANETH • WALKER EVANS • DOROTHEA LANGE
MARTIN PARR • RICHARD BILLINGHAM • ZED NELSON

Photographic representations of the family have documented changes in domestic life since the mid nineteenth century.

From the 1840s onwards, families unable to afford a painted portrait found a cheaper alternative in photography. Small studios profited and, years later, historians had a treasure trove of records spanning almost every stratum of society. As cameras became more affordable, families began to own their own and documented their lives in greater detail, from special occasions to day trips and holidays. Socially committed photographers travelling around America in the 1930s highlighted the way poverty blighted family life (see

page 82), while more recent photographers such as Martin Parr have employed a satirical eye to draw a line between family, class and consumerism (see page 126). *Ray's a Laugh* (1996), a photobook by Richard Billingham, is more personal, presenting an unvarnished record of alcoholism and abuse within his own family. The frankness of his images shocked audiences when they were exhibited at the Royal Academy of Arts in London in 1997.

KEY DEVELOPMENTS

In his controversial *Gun Nation* series (2000), Zed Nelson (b.1965) looks at the role of weaponry in everyday American life. This shot of a man, his daughter and his handgun highlights the disparity between the intention of the subject (to project an image of strength by protecting his family) and the way the image can be read through the way the gun is held.

Mike, father and gun owner, with baby, Dallas, Texas, 'It's my constitutional right to own a gun and protect my family', Zed Nelson, 1998, gelatin silver print, 91 x 74 cm (36 x 29 in)

STREET PHOTOGRAPHY **p.17** PROPAGANDA **p.25** DOCUMENTARY **p.28** HUMANISM **p.29** CLASS **p.170** PEOPLE **p.173** AGE **p.179**

Vernacular

KEY PHOTOGRAPHERS: E.J. BELLOCQ • JOHN HINDE • ROBERT CRUMB
STEPHEN SHORE • MARTIN PARR • THOMAS WALTHER • WOLFGANG TILLMANS

New Brighton, England,
from 'The Last Resort'
series, Martin Parr,
1985,chromogenic
colour print

The number of photographs taken every day has increased significantly since cameras became widely available. The challenge for modern curators is to decide which images have artistic value beyond their original use.

Vernacular photography is not new, but the way it is received shifted during the last century. From the vast archive of Friedrich Adolf Paneth (see page 62) and Eugène Atget's images of Paris life to Walker Evans's shots of farmers (see page 82) and Martin Parr's British tourists (see page 126), all are recordings by a mechanical device that, unlike most photographers, has been critically acclaimed. The catalogue *The Photographer's Eye* by the director of New York's Museum of Modern Art, John Szarkowski's, published to accompany the exhibition of the same name in 1966, was one of the first serious examinations of the entire photographic oeuvre, drawing on art, photojournalism, tourism, advertising, commerce and domestic life. Its aim was to elevate vernacular photography, to take it out of the album and into the gallery.

KEY DEVELOPMENTS
Postcards have become much-collected examples of vernacular photography. Martin Parr has long championed John Hinde (1916–97) and his colleagues, who published colourful images of British holiday camps in the 1960s and 1970s, but whose work was never exhibited because its original purpose was commercial not artistic.

STRAIGHT PHOTOGRAPHY **p.14** STREET PHOTOGRAPHY **p.17** COLOUR **p.18** SOCIETY **p.34** THE SELFIE **p.43**
ALGIERS, LOUISIANA **p.114** NEW BRIGHTON, ENGLAND **p.126**

Sport

KEY PHOTOGRAPHERS: ARTHUR GRIMM • MARTIN MUNKÁSCI • BOB MARTIN
NEIL LEIFER • WALTER IOOSS • HY PESKIN

World Welterweight Title, Carmen Basilio victorious after knocking out Tony DeMarco at Boston Garden, Boston, MA, USA, Hy Peskin, 1955

The velocity of sport has often demanded the most of photographic technology.

From a galloping racehorse to a man pole-vaulting, early scientific investigations gravitated towards sporting activity. In the 1880s Germany and the United States conducted studies of the movement of athletes, but technology hampered any detailed analysis. The replacement of the collodion process by dry plates permitted faster shutter speeds, and by the early 1900s the first sports photographers had begun to appear. Their coverage was initially limited to more elitist activities, and shots of rapid or sudden movement remained impossible to capture accurately. After World War I photographers in North America gravitated to baseball, which allowed iconic, static

shots of the sport's stars. The technology employed at the 1936 Berlin Olympics by Leni Riefenstahl (1902–2003) and Arthur Grimm (1908–90) was both innovative and revolutionary compared with that used by their predecessors, and set the standard for future sports photography.

KEY DEVELOPMENTS

Boxing has provided some of the most dramatic sporting images. Although photographers are often close to the fight, they have had to employ ingenuity to stand out from their peers. Unusual angles or aerial shots have worked, but as Hy Peskin (1915–2005) shows here, playing with light and shadow often produces the most dramatic results.

MONOCHROME **p.12** PORTRAITURE **p.15** ABSTRACTION **p.22** PHOTOJOURNALISM **p.27**
DOCUMENTARY **p.28**

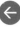

Music

KEY PHOTOGRAPHERS: NADAR • ALFRED WERTHEIMER • FRANCIS WOLFF
ANTON CORBIJN • JONATHAN MANNION

Image is almost as important to musicians as the works they write and perform.

Among the composers who passed through Nadar's studio were Massenet, Chopin, Debussy, Bizet, Saint-Saëns, Rossini, Offenbach and Liszt – a roll-call that reflects a perceived need to be seen as well as heard. As recorded music became more prevalent in the twentieth century, so images captured musicians at work or were used to promote them. Nowhere more so than in jazz. Early images of performances at the Cotton Club and of Josephine Baker singing at the Folies Bergère helped to define the 1920s. Modern jazz, capturing the spirit of Bebop, was defined by

photographers such as Francis Wolff (1907 –71), whose work featured on Blue Note record covers. Rock and pop emphasize the artist's look. Prominent examples include the images of the young Elvis Presley taken by Alfred Wertheimer (1929–2014); David Bowie and Twiggy by Justin de Villeneuve (b.1939) on the cover of the *Pin Ups* album (below); the moody photography of Anton Corbijn (b.1955) for *New Musical Express*; and more recent work documenting the club, pop and hip-hop scenes by Jonathan Mannion (b.1970).

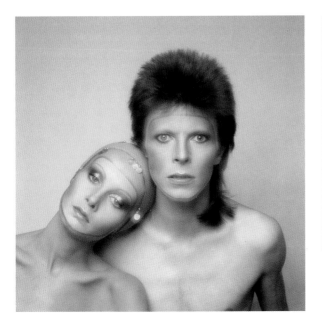

Pin Ups, Justin de Villeneuve, 1973

KEY DEVELOPMENTS
Photography and music found the perfect union with the album cover. George Michael's *Listen Without Prejudice Vol 1.* featured Weegee's *Crowd at Coney Island* (1940). An image by Anders Petersen (b.1944) was used by Tom Waits for *Rain Dogs* and William Eggleston photographed a range of bands, from Big Star to Primal Scream. Man Ray originally designed the cover for The Rolling Stones' seminal *Exile on Main St* (1972), but in the end the band opted for a collage of Robert Frank's images.

PORTRAITURE **p.15** GLAMOUR **p.32** POP **p.33** ADVERTISING **p.37** PERFORMANCE **p.41**

Youth Culture

KEY PHOTOGRAPHERS: ED VAN DER ELSKEN • ROGER MAYNE • BRUCE DAVIDSON
CHRIS STEELE-PERKINS • LARRY CLARK • KAREN KNORR • NAN GOLDIN • WOLFGANG TILLMANS

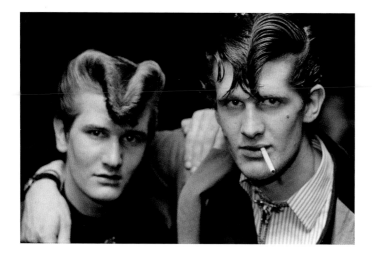

Brothers, Red Deer,
Croydon, London,
Chris Steele-Perkins,
1976, gelatin silver
print, 40.6 x 50.8
cm (16 x 20 in)

A relatively recent phenomenon, youth culture rapidly shifted from being the subject of ethnographic and sociological studies to a major creative and economic force in popular culture, particularly in urban areas.

Before World War II, society was defined by two age groups: child and adult. The late 1940s and early 1950s brought the emergence of youth culture, which had a significant impact on all aspects of contemporary life. It was emboldened by trends in fashion and music, reflected in movies and documented by photographers. *Love on the Left Bank* by Ed van der Elsken (1925–90) focused on bohemian Paris. In *W10*, Roger Mayne (1929–2014) charted the lives of working-class boys and girls in the North Kensington district of London. In New York, Bruce Davidson documented

gang life in Brooklyn. As youth culture became more fragmented, photographers focused on specific subcultures: Nan Goldin portrayed life in Boston and New York in the 1970s; Chris Steele-Perkins (b.1947) documented the 1970s revival in Britain of the 1950s Teddy Boy culture.

KEY DEVELOPMENTS

The term 'teen-ager' first appeared in *Popular Science Monthly* in 1941, but the notion of this youth phenomenon was cemented by a photo-essay in *Life* magazine by Neena Leen (1909–95) in 1944. Her images heralded the arrival of the postwar generation.

STRAIGHT PHOTOGRAPHY **p.14** COLOUR **p.18** DOCUMENTARY **p.28** POP **p.33** FASHION **p.36**
THE SELFIE **p.43** NEW BRIGHTON, ENGLAND **p.126** LUTZ & ALEX SITTING IN THE TREES **p.134**

Appropriation

KEY PHOTOGRAPHERS: MARCEL DUCHAMP • ROBERT RAUSCHENBERG • RICHARD PRINCE
SHERRIE LEVINE • MARTHA ROSLER

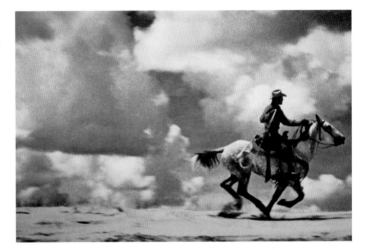

Untitled (Cowboy),
Richard Prince, 1989,
Ektacolor photograph,
127 x 178 cm
(50 x 70 in)

Originating in early twentieth-century art movements, appropriation found a natural home in photography.

Appropriation is the art of using pre-existent images (or objects) with almost no change made to them, often with the aim of questioning or re-contextualizing the original meaning of a work, or even of questioning the notion of authorship. It has incurred the wrath of certain critics and led to lawsuits over accusations of plagiarism. In early examples, photography was often just part of an artwork. The silkscreens of Robert Rauschenberg featured portraits or newspaper cuttings with photographs. Andy Warhol went further: his silkscreens were coloured variations of existing images of public figures. Most controversial is Richard Prince, whose work involves re-photographing other people's images

and, by dint of his counter-interpretation, making them his own. Most famously, in 1993 he re-photographed the cowboy advert for Marlboro cigarettes, originally by Sam Abell (b.1945), renamed it *Untitled (Cowboy)* (above) and sold it at Christie's New York for $1 million.

KEY DEVELOPMENTS

Richard Prince has brought his brand of art into the age of social media through his appropriation of images that appear on his Instagram feed. Some people have challenged him in court, while others, such as members of the nude pin-up site SuicideGirls, have started selling their own derivative works based on Prince's derivative works of their original works.

PORTRAITURE **p.15** COLOUR **p.18** ART **p.31** ADVERTISING **p.37** CONCEPTUAL **p.39**

Ceylon

TECHNIQUES

Camera Obscura

KEY PHOTOGRAPHERS: NICÉPHORE NIÉPCE • LOUIS DAGUERRE
WILLIAM HENRY FOX TALBOT • ABELARDO MORELL

Its name derived from the Latin words for 'room' and 'dark', the camera obscura was first used by scientists in their experiments and by artists in understanding perspective.

An optical phenomenon, the camera obscura is essentially an inverted image projected on to an interior wall after passing through a small aperture, reflecting the exact image from outside. Versions that occurred naturally are believed to have inspired Palaeolithic cave paintings. The study of camerae obscurae began in earnest during China's Han dynasty (206 BCE–220 CE) and was continued by the Arab physicist Alhacen in his *Book of Optics* (1021) and by Leonardo da Vinci (1452–1519). In the sixteenth century scientists began to use lenses to adjust aperture size, and in 1604 the astronomer Johannes

Kepler (1571–1630) used the term 'camera obscura' in a scientific journal. Portable versions produced later in the seventeenth century bore a noticeable resemblance to early cameras. By the nineteenth century, scientists were experimenting with light-sensitive materials to find a way of recording a single permanent image from the box.

KEY DEVELOPMENTS
Giambattista della Porta (c.1535–1615), an Italian polymath, was the first person to suggest using a convex mirror to reflect an image on to paper for use as a drawing aid. In later versions of camerae obscurae, the mirror is placed before the lens, allowing an elevated perspective similar to that produced by a periscope.

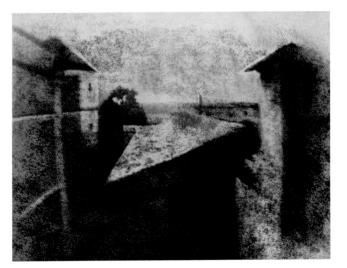

View from the Window at Le Gras, Nicéphore Niépce, 1826–27, heliograph, 16.5 x 20 cm (6⅝ x 7⅞ in)

LANDSCAPE **p.16** COLOUR **p.18** SCIENCE **p.30** TOPOGRAPHY **p.35**
VIEW FROM THE WINDOW AT LE GRAS **p.46**

Daguerreotype

KEY PHOTOGRAPHERS: LOUIS DAGUERRE • MATHEW BRADY • JAMES PRESLEY BALL
THOMAS MARTIN EASTERLY • CHUCK CLOSE • ADAM FUSS

It was not the first photographic process, but for 20 years it was the most popular, until further advances resulted in less expensive ways to produce images.

Louis-Jacques-Mandé Daguerre had already invented the diorama by the time he met Nicéphore Niépce (see page 46). They collaborated on photographic methods until Niépce's early death in 1833. Daguerre's continued experimentation resulted in 1839 in the daguerreotype, which required a piece of copper, plated with silver, to be polished to the quality of a mirror. It was then exposed to iodine vapours, which made it sensitive to light, and was placed in a camera obscura. The exposure time required depended on the strength of light around the subject, and from it an invisible latent image was pro-

duced. After being removed, the plate was exposed to mercury fumes in a specially designed box. It was then washed carefully with a chemical treatment to remove its light-sensitive qualities. Owing to the sensitivity of the plate's surface, glass would have covered the plate; depending on the angle at which it was viewed, it can appear as a positive or negative.

KEY DEVELOPMENTS
In the thirteenth century the Dominican friar and future saint Albertus Magnus (c.1200–80) had noted the photosensitive properties of silver nitrate. The German polymath Johann Heinrich Schulze (1687–1744) mixed chalk with silver to produce similar results, but it was not until the discovery of the halides iodine, bromine and chlorine that the process became manageable.

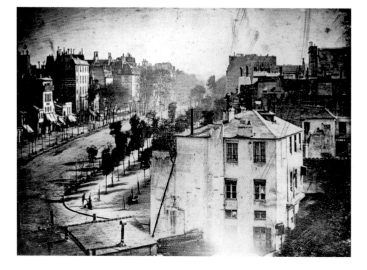

Boulevard du Temple, Paris, Louis-Jacques-Mandé Daguerre, c.1838, daguerreotype, 15 x 18.5 cm (5¼ x 7¼ in)

MONOCHROME **p.12** LANDSCAPE **p.16** SCIENCE **p.30** SOCIETY **p.34** PEOPLE **p.173**

Calotype

KEY PHOTOGRAPHERS: WILLIAM HENRY FOX TALBOT • ROGER FENTON • ROBERT ADAMSON
DAVID OCTAVIUS HILL • BENJAMIN COWDEROY • BENJAMIN BRECKNELL TURNER

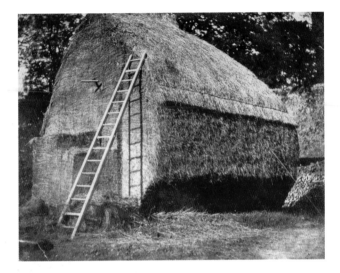

The Haystack, William Henry
Fox Talbot, 1844, calotype,
16 × 21 cm (6½ × 8¼ in)

The calotype – its name derived from the Greek words for 'beautiful' (*kalos*) and 'impression' (*tupos*) – appeared at a time of intense invention and anticipated the industrialization of photography.

The calotype was alternatively known as the Talbotype after William Henry Fox Talbot, who invented it in 1841. It was an advance on his previous salt print process, which required a far longer exposure time to produce an image. The calotype used sturdy paper that could withstand a coating of silver nitrate and, after that had dried, being dipped in potassium iodide. It was only when the paper was brushed with a further compound of silver nitrate, acetic acid and gallic acid that it became light-sensitive. Washing in a solution of potassium bromide or sodium thiosulphate

helped to stabilize the resulting image. The process was cheaper than the daguerreotype, but the images produced were less clear, and the contrast between light and dark less sharp. However, because it used paper the process was cheaper, and Talbot's ability to reproduce images soon attracted business investment for the medium.

KEY DEVELOPMENTS

Unlike Daguerre, who received a stipend from the French government in return for allowing his process to be made universally available, Talbot ensured that his invention was patented. This may have stymied its widespread availability, although Talbot's friend David Brewster convinced him to limit the patent to England, enabling Brewster to found the Edinburgh Calotype Club. Opened in 1843, it was the world's first photography club.

Cyanotype

KEY PHOTOGRAPHERS: JOHN HERSCHEL • ANNA ATKINS • JAMES WELLING
JOHN DUGDALE • JAI TYLER • BEVERLY EVANS

Used as alternatives to the conventional photographic process involving silver nitrate, salts of iron produced good-quality images that were cheap to reproduce in multiple copies.

As its name denotes, the cyanotype, an invention of 1842 by the British scientist and astronomer John Herschel (1792–1871), produced images with a strong bluish hue. It soon became popular with engineers and designers, who used it to reproduce what became known as 'blueprints' of their work. Although the stark Paris Blue colour limited the cyanotype's commercial use, its qualities were perfect for scientists such as Anna Atkins. A friend of Herschel and one of the earliest female members of the Botanical Society of London, Atkins had previously used watercolours to illustrate her father's scientific studies. But in 1843 she began using the cyanotype process for a series of photogram studies that were published in three volumes as *Photographs of British Algae: Cyanotype Impressions* (1843–53). The first ever photographically illustrated books, they contained highly detailed images of small plants.

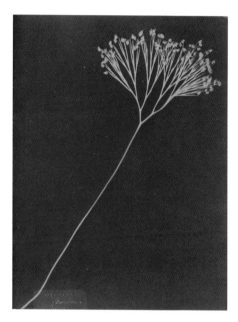

Ceylon, Anna Atkins and Anne Dixon, 1853, cyanotype, 25.4 x 19.4 cm (10 x 7⅝ in), The J. Paul Getty Museum, Los Angeles, USA

KEY DEVELOPMENTS
Owing to its modest cost and ease of use, of all the early processes cyanotype has been particularly popular with contemporary photographers. Most have opted to follow in the footsteps of Anna Atkins and her photograms. But when the artist John Dugdale (b.1960) was blinded by an HIV-related illness in the early 1990s, he resorted to nineteenth-century photographic practices, including cyanotypes produced by large-format camera, to create rapturous, poetic images.

STILL LIFE **p.20** AVANT-GARDE **p.23** SCIENCE **p.30** ART **p.31** NATURE **p.163**

Collodion

KEY PHOTOGRAPHERS: GUSTAVE LE GRAY • FREDERICK SCOTT ARCHER
ALEXANDER GARDNER • JULIA MARGARET CAMERON • TIMOTHY H. O'SULLIVAN • NADAR

Potentially lethal, flammable and messy at best, the collodion process was nevertheless an advance on both the daguerreotype and the paper negatives of the calotype.

Originally invented as a form of surgical dressing, collodion was the gelatinous result of dipping pyroxylin (also known as 'flash paper', 'gun cotton' and 'cellulose nitrate') in a mixture of ether and ethanol. Its potential use in photography was discovered simultaneously by Gustave Le Gray and Frederick Scott Archer (1813–57). Le Gray theorized the idea but it was Archer who had success in employing wet collodion to produce a negative on a glass plate. The process was faster than the daguerreotype and easier to produce images from than the calotype, but the whole procedure – from coating and exposure to development – had to be completed in 10–15 minutes. That required a portable darkroom outside a studio. Despite its limitations, by the end of the 1850s the collodion process had almost completely replaced the daguerreotype. It was then replaced in turn in the 1880s by the safer gelatin silver print.

KEY DEVELOPMENTS
The collodion wet plate was particularly sensitive to the colour blue, which rendered skies featureless. Gustave Le Gray's solution to this problem is best seen in his photograph *The Great Wave* (1857). He exposed two plates, one that took account of the light level of the sea, the other that of the sky. They were then developed together to produce one final, detailed print.

President Abraham Lincoln, Major General John A. McClernand (right), and E.J. Allen (Allan Pinkerton, left), Chief of the Secret Service of the United States, at Secret Service Department, Headquarters Army of the Potomac, near Antietam, Maryland, Alexander Gardner, 1862, negative, glass, wet collodion, Library of Congress, Washington D.C., USA

MONOCHROME **p.12** PICTORIALISM **p.13** PORTRAITURE **p.15** LANDSCAPE **p.16** STILL LIFE **p.20**
A HARVEST OF DEATH **p.52** BEATRICE **p.56**

Albumen Paper

KEY PHOTOGRAPHERS: ROGER FENTON • ANDRÉ-ADOLPHE-EUGÈNE DISDÉRI
FRANCIS FRITH • JULIA MARGARET CAMERON • ÉMILE BÉCHARD

The speed of exposure may have quickened as photography developed in the nineteenth century, but the process of obtaining a print remained arduous. Albumen paper speeded up that process and began the industrialization of photographic practice.

The first commercially available method of producing a photographic print on a paper base from a negative was invented in 1847 by Louis Désiré Blanquart-Evrard (1802–72). He separated egg whites from yolks, then salted and frothed them before allowing them to return to liquid form. Specially produced paper, generally made from cotton, was soaked in the liquid and allowed to dry. It could then be stored until needed. To make it ready for use, a coating of silver nitrate was applied and allowed to dry; the negative was then laid on top

and the paper exposed to light. A bath of sodium thiosulphate fixed the exposure, and a toner could be applied to prevent fading. In addition to speeding up the process, albumen prints had a glossy surface that revealed more detail than their matte-surface counterparts.

KEY DEVELOPMENTS
By 1855 albumen paper dominated the emerging photographic market. Workshops producing it proliferated in France and Germany, particularly in Dresden, which became the centre of the industry. Most prints of the era use albumen paper, particularly the popular cartes de visite. It remained popular until the mid 1890s, when silver gelatin prints appeared.

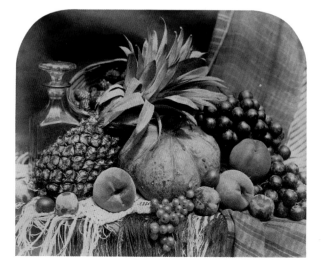

Still Life with Fruit and Decanter,
Roger Fenton, 1860, albumen silver print, 35.4 x 43.2 cm (13 ¹⁵⁄₁₆ x 17 in), The J. Paul Getty Museum, Los Angeles, USA

Gelatin Silver Prints

KEY PHOTOGRAPHERS: EDWARD WESTON • CECIL BEATON • WALKER EVANS
ANSEL ADAMS • SEBASTIÃO SALGADO

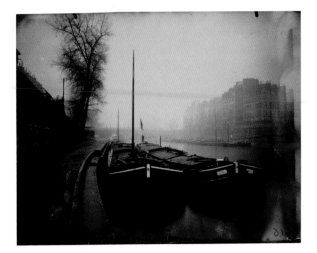

KEY DEVELOPMENTS
Glossy prints were slow to catch on. Albumen paper bucked the trend for matte finishes, while the introduction of a baryta layer added more gloss to each print. By the 1920s high-gloss prints were most in demand, which reflected a shift in photographic trends, particularly the adoption of straight photography and the increase in photojournalism.

Pont Neuf, Eugène Atget, 1923, gelatin silver chloride printing-out paper print, 17.9 x 22.9 cm (7¹⁄₁₆ x 9 in), The J. Paul Getty Museum, Los Angeles, USA

Offering the widest tonal range and eclipsing all materials that had gone before it, the gelatin silver print rapidly became the most sought-after way of producing photographs and resulted in the appearance of the professional printer.

Richard Leach Maddox (1816–1902) introduced the process. He noticed the harmful effects of exposure to the vapours produced by the collodion process and set about creating an alternative. He hit upon the idea of coating a combination of the sensitizing chemicals cadmium bromide and silver nitrate in gelatin on a glass plate. Charles Harper Bennett (1840–1927) perfected the process by increasing the sensitivity of gelatin dry plates and making them commercially available. By the mid 1890s the paper was being mass-produced by machines. The addition of a baryta layer, a barium sulphate coating, was first tried out commercially in 1894; in 1900 the practice was adopted by Kodak. The increased importance of the darkroom in the process stimulated the growth of the ancillary printing industry, which later shrank again after the arrival of digital photography. Likewise, gelatin silver prints remained popular until monochrome was superseded by colour.

MONOCHROME **p.12** PORTRAITURE **p.15** LANDSCAPE **p.16** STREET PHOTOGRAPHY **p.17**
PHOTOJOURNALISM **p.27**

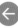

Platinum Prints

KEY PHOTOGRAPHERS: PETER HENRY EMERSON • FREDERICK H. EVANS
GERTRUDE KÄSEBIER • ROBERT MAPPLETHORPE

For the group of nineteenth-century photographers who defined their vocation as art rather than hobby or commercial enterprise, this expensive process was the natural choice. It prioritized aesthetics over mass production.

While many photographers and scientists were experimenting with silver in the early decades of the nineteenth century, in 1804 the German chemist Adolph Ferdinand Gehlen (1775–1815) had observed the effect of light on platinum. His countrymen Heinrich Gustav Magnus (1802–70) and Johann Wolfgang Döbereiner (1780–1849) added a variety of compounds, and the latter discovered that ferric oxalate was an effective enhancer. This compound remains in use today. John Herschel and Robert Hunt (1807–87) carried out further experiments, but the cheaper albumen printing would soon dominate. With the arrival of the Pictorialist movement, platinum printing found its home. It brought out abstract qualities in landscape photography and emphasized a tone that reflected the romanticism that many pictorial photographers were aiming to achieve. The reaction against this movement in favour of a more realist aesthetic might have caused a dip in the popularity of platinum prints, but some artists have reprised the process, most notably Robert Mapplethorpe (1946–89) with his series of nudes.

Gargoyle, Gertrude Käsebier, 1901, platinum print, 19.2 x 13.5 cm (7⁹⁄₁₆ x 5⁵⁄₁₆ in), The J. Paul Getty Museum, Los Angeles, USA

KEY DEVELOPMENTS
To emphasize the painterly quality of their platinum prints, the Pictorialists also adopted a gum bichromate process, which allowed prints to be tinted with diochromates, a moderately strong oxidizing agent. However, this added a significant amount of labour to an already costly process that, with the commencement of World War I and the need of platinum for armaments, found its days as a popular method numbered.

PICTORIALISM **p.13** PORTRAITURE **p.15** ART **p.31** NATURE **p.163**

Hand-colouring

KEY PHOTOGRAPHERS: JOHANN BAPTIST ISENRING • JEAN GARNIER • FELICE BEATO
RAIMUND VON STILLFRIED • YOKOYAMA MATSUSABURŌ • UCHIDA KUICHI • PIERRE ET GILLES

This meticulous artistic practice, which added warmth to early photographs, was introduced shortly after the daguerreotype.

More than a century before colour achieved dominance over monochrome, the art of hand-colouring photographs was an established practice. The first known examples were by the Swiss painter and printmaker Johann Baptist Isenring (1796–1860). He applied a mixture of gum arabic and pigments with the aid of heat. Within a few years, the practice had expanded to encompass the majority of processes. Portraits were first, allowing greater warmth in skin tones. They were followed by landscapes. Images were sometimes transferred to canvas, resulting in a hybrid of photograph and painting. There was a practical advantage to hand-painted prints: even after being fixed, most photographs began to fade over time, but colouring a print would ensure a longer life for it. It was a trend that developed almost simultaneously around the world and is best represented today in the kitsch, pop culture worlds created by Pierre et Gilles.

Koboto Santaro, Felice Beato, 1866–67, hand-coloured albumen silver print, 27.5 x 21.9 cm (10⁹/₁₆ x 8⅝ in), The J. Paul Getty Museum, Los Angeles, USA

KEY DEVELOPMENTS
Although they originated in Europe, hand-painted photographs became an established art form in Japan. The photographer Charles Parker moved to Yokohama in 1863 and was followed by the illustrator and cartoonist Charles Wirgman (1832–91). Yokoyama Matsusaburō (1838–84) became the first Japanese artist to take hand-painting seriously, followed by Uchida Kuichi (1844–75) and Ogawa Kazumasa (1860–1929). Stillfried & Andersen, a studio co-founded in Yokohama by Baron Raimund von Stillfried (1839–1911), was renowned for its detailed colouring of landscapes and included the hand-painted photographs of Felice Beato (1832–1909; left).

PORTRAITURE **p.15** LANDSCAPE **p.16** COLOUR **p.18** ETHNOGRAPHY **p.26** NATURE **p.163** TEXTURE **p.177**
DAGUERREOTYPE **p.191**

Colour

KEY PHOTOGRAPHERS: AUGUSTE AND LOUIS LUMIÈRE • FERENC BERKO
SAUL LEITER • MARIE COSINDAS • WILLIAM EGGLESTON • STEPHEN SHORE

Colour photography was conceived for scientific purposes and shunned by the establishment until a new generation embraced its qualities.

A complex and lengthy trial-and-error period led to the introduction of colour film. The first durable colour photograph – an image of a tartan ribbon – was presented in 1861 by the Scottish mathematical physicist James Clerk Maxwell. Maxwell developed the three-colour system, which involved taking three identical photographs, each shot through a primary colour filter, and recombining them to create one colour composite. It was an early version of the additive process that uses red, green and blue as its basis. In 1868 Louis Arthur Ducos du Hauron patented the subtractive process, which involved the layering of identical images exposed to orange, green and violet light. This was also the process behind dye transfer. On these foundations, research continued until the arrival of Kodachrome in 1935. The use of colour in 'serious' photography came much later, with the work of Marie Cosindas, William Eggleston and Stephen Shore.

KEY DEVELOPMENTS
Cinema pioneers Auguste and Louis Lumière unveiled Autochrome, the first commercially successful colour process, in 1907. Colour was gleaned from the blended coating of microscopic grains of potato starch dyed red-orange, green and blue-violet, and lampblack, or soot particles.

Badlands National Monument, South Dakota, July 14, 1973, Stephen Shore, 1973, chromogenic print

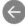

Double Exposure

KEY PHOTOGRAPHERS: CHARLES F. BRACY • OSCAR GUSTAVE REJLANDER
FRANCIS GALTON • MAN RAY • CONSTANTIN BRÂNCUȘI • HARRY CALLAHAN

KEY DEVELOPMENTS
In 1917 cousins Elsie Wright (1901–88) and Frances Griffiths (1907–86) claimed to have photographed themselves with fairies in a field near their home in Cottingley, Yorkshire. Many people, including Sir Arthur Conan Doyle, the creator of Sherlock Holmes, were convinced that the fairies existed, and the story attracted a lot of publicity for a time. The two girls maintained their story as they grew up, only to recant decades later and for tests to show that they had employed one of the simplest photographic tricks.

Double-Exposure Portrait of a Woman,
Unknown, c.1860, daguerreotype, 6.4
x 5.1 cm (2½ x 2 in), The J. Paul Getty
Museum, Los Angeles, USA

This is a process with no equivalent in any other art form. It was discovered through error, but its practice now ranges from art and science to humour.

The process of achieving a double or multiple exposure is simple. Light-sensitive material is exposed twice, resulting in the overlay of two images. If one of the areas is covered for the first exposure, the result can merge two separate images. Repeating the process creates a more complex image, but also increases the risk of over-exposure. Likewise, in the early days of photography, when exposure times were long, any movement would cause a ghosting of the image. This was exploited in the late eighteenth century by some photographers who

used double exposures to create spectral presences around the sitters. The geneticist Francis Galton (1822–1911) believed that multiple exposures of criminals' heads, one superimposed upon another, would demonstrate that felons had common physical characteristics. With the development of darkroom practices, in-camera multiple exposure was replaced by post-production practices. Digital technology now allows the creation of almost any effect.

PORTRAITURE **p.15** AVANT-GARDE **p.23** SCIENCE **p.30** THE SURREAL **p.162** TEXTURE **p.177**

Photogram

KEY PHOTOGRAPHERS: ANNA ATKINS • MAN RAY • LÁSZLÓ MOHOLY-NAGY
ANDREAS WALSER • JAMES WELLING • SUSAN DERGES • ADAM FUSS

A process that requires no camera and produces images that feature a deceptive depth of field, play with space and light, and are often extraordinarily beautiful, the photogram has been embraced by scientists, artists and amateur photographers.

William Henry Fox Talbot produced a variation on it with his photogenic drawing *Bryonia dioica – the English Wild Vine* (c.1839). Anna Atkins preferred the cyanotype process to create her detailed photograms of English flora, while artists in the twentieth century employed the technique to explore abstraction. The process is relatively simple. In a darkroom, objects are arranged on top of a piece of photography paper. They are then exposed to light and the paper is processed, washed and dried. The resulting image is a combination of the objects' details and the light around them, not dissimilar to an X-ray. The more imaginative the objects and their placement, the more complex the final composition. The process is best exemplified by the work of László Moholy-Nagy (see page 84) and Man Ray, who preferred the term Rayograph, as well as more recent artists such as Lotte Jacobi, Susan Derges (b.1955) and James Welling (b.1951), who blur the line between photograms and conventional photography.

Ice-skater at the 'Eislaufverein', Vienna,
Christian Skrein, 1962, photogram

KEY DEVELOPMENTS
The photogram provided a perfect opportunity for Dadaist artists to engage with photography. The movement was based on rebellion against societal conventions and norms, so what better way to work against photographic practice than to do away with the camera completely? Photograms were no less radical a form of expression and artistic practice than collage, montage or assemblage. Christian Schad (1894–1982) was one of the earliest artists to play with the form, leading the way to the more intricate work of Man Ray and Moholy-Nagy.

ABSTRACTION **p.22** AVANT-GARDE **p.23** SCIENCE **p.30** PHOTOGRAM **p.84**
TEXTURE **p.177** CYANOTYPE **p.193**

Artificial Light

KEY PHOTOGRAPHERS: NADAR • JULIA MARGARET CAMERON • ROGER FENTON
DOROTHEA LANGE • RICHARD AVEDON • ROBERT MAPPLETHORPE • ANNIE LEIBOVITZ

The word 'photography' was coined in 1839 by John Herschel. Its Greek roots, when joined together, mean 'drawing with light'. Without light, there would be no image.

Only natural light was used in early photography. But later the use of sources other than the sun gave photographers greater creative opportunities and enabled them to move indoors. In 1839 Levett Landon Boscawen Ibbetson (1799–1869) used limelight to illuminate microscopic objects he was photographing. Development continued significantly with Nadar, who used battery-operated lighting for his series documenting the Paris sewer network in the early 1860s. He also adopted

innovations with studio lighting introduced by Henry Van der Weyde (1838–1924), and thereby created some of the most technically impressive portraits of the nineteenth century. At the same time, Julia Margaret Cameron's use of lighting aimed for the sublime (see page 56), while Roger Fenton's series of still lifes used lighting to enhance the richness of his subject (see page 50). Every photographic movement has rewritten the rules of lighting; the current convention is the three-point method.

Beatrice, Julia Margaret Cameron,
1866, albumen silver print, 33.8 x 26.4
cm (13⅜₁₆ x 10⅜ in), The J. Paul Getty
Museum, Los Angeles, USA

KEY DEVELOPMENTS
The essence of studio portraits, as well as film and theatre, three-point lighting involves the positioning of three light sources. The key light, as its name suggests, is the main source of illumination of a subject. It can be a lamp, a torch or even the sun. The fill light, placed to the side or at an angle to the subject, illuminates shading or any stark contrasts between light and dark. Finally, the back light separates the subject from the background, or highlights contours.

Aerial Photography

KEY PHOTOGRAPHERS: NADAR • JAMES WALLACE BLACK • EDUARD SPELTERINI
BERENICE ABBOTT • MARGARET BOURKE-WHITE • EDWARD BURTYNSKY

Aerial photography allowed audiences an opportunity to savour a bird's-eye view of the world.

The first aerial photograph was taken in 1858 by Nadar. The earliest surviving aerial shot was taken by James Wallace Black (1825–96) as he floated 600 m (2,000 ft) above Boston, Massachusetts, on 13 October 1860. Most early aerial photographs were taken from kites such as those developed by the British meteorologist E.D. Archibald. During World War I many technical innovations were introduced for reconnaissance aircraft flying behind enemy lines. Successive wars and military-driven innovations have led to the deployment of powerful cameras in orbit around the Earth. Meanwhile, commercial and scientific projects have assisted the mapping of both urban and inaccessible areas of the world. More recently, Edward Burtynsky (see page 152) and Yann Arthus-Bertrand (b.1946) have employed aerial photography to highlight the human threat to the planet's ecosystem.

KEY DEVELOPMENTS
In 1912 Frederick Charles Victor Laws (1887–1975) overlapped a series of photographs by approximately 60 per cent, discovering that it was possible to create a stereoscopic effect that allowed more detailed analysis of landscape.

Aerial View of Paris, France, from a Balloon, showing the Seine River and the Eiffel Tower at centre, and Buildings of the Exposition Universelle, Alphonse A. Liébert, 1889, albumen silver print, Library of Congress, Washington D.C., USA

Cropping

KEY PHOTOGRAPHERS: HENRI CARTIER-BRESSON • W. EUGENE SMITH • ARNOLD NEWMAN
ALBERTO KORDA • NICK UT

Great Deodar, 42 Feet in Circumference, Samuel Bourne, 1863, albumen silver print, 23 x 29 cm (9¹⁄₁₆ x 11⁷⁄₁₆ in), The J. Paul Getty Museum, Los Angeles, USA

A simple technical process, cropping can emphasize one aspect of an image or even mislead a viewer by changing its context.

The more sophisticated photographic processing became, the easier it was to manipulate images. Cropping is the most basic editing of an image, allowing a photographer to remove extraneous features or emphasize a particular aspect of an image. Henri Cartier-Bresson was opposed to it, believing it to be anathema to the purity of photography. However, the real dangers of cropping lie in photojournalism, where it not only alters how an image looks, but can also alter its context completely. Alberto Korda's original photograph of Che Guevara (see page 104) featured a man to the left and a tree to the right. Through cropping, Korda removed all distractions, channelling our focus towards the guerrilla leader. Nick Ut's photograph from Vietnam (see page 116) was initially turned down by Associated Press because he would not crop the image so that the public didn't see a naked child. He believed that cropping the photograph would rob it of its power.

KEY DEVELOPMENTS

One way of ensuring the legitimacy of an image in the digital age is to have a record of the original. Some digital camera software houses a repository of all images shot. This is particularly important for press organizations, which can request information from a camera should there be any doubt over an image submitted to them.

PORTRAITURE **p.15** PHOTOJOURNALISM **p.27** CHE GUEVARA **p.104** PHAN THỊ KIM PHÚC **p.116**
THE DECISIVE MOMENT **p.174**

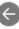

Solarization

KEY PHOTOGRAPHERS: ARMAND SABATIER • MAN RAY • LEE MILLER
FRANCIS BRUGUIÈRE • MINOR WHITE

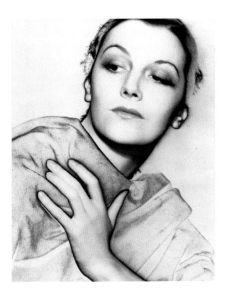

*Solarized Portrait (thought
to be Meret Oppenheim),
Paris, France, 1932,
Lee Miller, 1932*

KEY DEVELOPMENTS
An additional effect of solarization is the presence of what became known as the Mackie line, a border that forms between areas of high and low density in an image. If the negative is treated, the line is light, resulting in a dark line in the print. If the print is treated, the line remains white or light around areas of high contrast. It is particularly effective in portraits, where a fine line appears around a subject.

An accident in a darkroom resulted in an effect that was embraced by the Surrealists for its dream-like qualities and that has allowed photographers to continue experimenting with form.

Solarization is the method by which a negative or a print is partially or wholly reversed in tone, allowing dark areas to appear light and vice versa. In his early experiments, Daguerre was aware of the effects of over-exposure to the sun. The term 'solarization' was coined by John William Draper in the 1840s, but it did not gain general currency until it was embraced by the Surrealists. A darkroom accident by Man Ray's then assistant Lee Miller resulted in one image being exposed to light. Ray was impressed with the ethereal qualities

produced and set about transforming the accident into a process, creating images as radical as *The Primacy of Matter over Thought* (1929) alongside portraits, including one of Miller in profile. Miller would also employ solarization in her work. Introduced in 1972, Agfacontour Professional Film gave the impression of solarization without photographers having to go through the usual process to achieve it. More recently solarization has been superseded by digital effects.

MONOCHROME **p.12** PORTRAITURE **p.15** AVANT-GARDE **p.23** SCIENCE **p.30** GLAMOUR **p.32**
THE SURREAL **p.162**

Stop Time

KEY PHOTOGRAPHERS: EADWEARD MUYBRIDGE • ÉTIENNE-JULES MAREY • THOMAS EAKINS
PETER SALCHER • BERLYN BRIXNER • GJON MILI • HAROLD EUGENE EDGERTON

The ability to capture motion with perfect clarity has developed from studies in human and animal locomotion to recording images in a fraction of time.

Stop time, also known as high-speed photography, was pioneered by Eadweard Muybridge, Étienne-Jules Marey and Thomas Eakins (1844–1916). Chronophotography, as it became known, presented a stark contrast to classical artworks depicting human movement. It was a technological advance that aroused the interest of scientists. In 1886 the Austrian physicist Peter Salcher (1848–1928) photographed a bullet moving through air at supersonic speed. In the 1930s Harold Eugene Edgerton,

professor of electrical engineering at the Massachusetts Institute of Technology, worked with the engineer and *Life* magazine photographer Gjon Mili (1904–84) on ways of capturing images using a stroboscope. Mili found the rapid flash of light effective in his particular style of portrait photography, as evinced by his shot of Betty Friedman jumping. Edgerton employed the technology to freeze infinitesimal moments of time, as in his *Milk Drop Coronet* (1957).

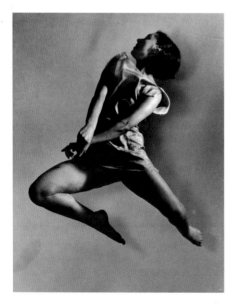

Betty Friedman Jumping in Photographer's Studio,
Gjon Mili, 1937

KEY DEVELOPMENTS
In the 1940s Edgerton developed the Rapatronic camera, which was capable of an exposure time as short as 10 nanoseconds. The complex shutter system was comprised of two polarizing filters mounted at 90 degrees to each other in order to block any incoming light, and a Faraday cell that acted as a shutter. In 1952 the camera captured a nuclear explosion less than one millisecond after detonation.

WAR **p.24** DOCUMENTARY **p.28** SCIENCE **p.30** MOVEMENT **p.161** SPORT **p.184**

Kodachrome

KEY PHOTOGRAPHERS: STEVE MCCURRY • PETER GUTTMAN • ALEX WEBB

Kodachrome was durable and capable of capturing subtle and bold colours alike, and the millions of slides featuring domestic life would provide a rich archive of family histories covering six decades.

Eastman Kodak introduced its non-substantive, colour-reversal film in 1935. In contrast to the Lumière brothers' earlier Autochrome, Kodachrome employed a subtractive, rather than additive colour method (see page 199). It was a development of earlier two-colour film experiments carried out by John Capstaff (1879–1960) that was perfected by Leopold Godowsky, Jr (1900–83) and Leopold Mannes (1899–1964). It initially appeared as 16 mm moving-image film, with 35 mm released in 1936. After World War II its popularity grew enormously. The richness of colour was far superior to anything that had come before it. However, because it was available only as a transparency, domestic use was limited to slides. It was the perfect format for photojournalists working in colour. This photograph by Steve McCurry (b.1950) of the Afghan refugee Sharbat Gula, taken for *National Geographic*, highlights the sharpness and extraordinary colours available through the film.

KEY DEVELOPMENTS

The complex process involved in developing Kodachrome, along with the rise in popularity of digital photography, resulted in the cessation of all production in 2009. The last roll was given to McCurry, who used the 36 shots to photograph people and locations in New York and India before using up the last three frames in Parsons, Kansas, the home of Dwayne's Photo, the last remaining Kodak-certified developing facility.

Afghan Girl, Steve McCurry, 1984, Kodachrome

STRAIGHT PHOTOGRAPHY **p.14** PORTRAITURE **p.15** COLOUR **p.18** DOCUMENTARY **p.28** PEOPLE **p.173**

SLR

KEY PHOTOGRAPHERS: ROBERT CAPA • HENRI CARTIER-BRESSON • ALBERTO KORDA
NICK UT • RICHARD DREW

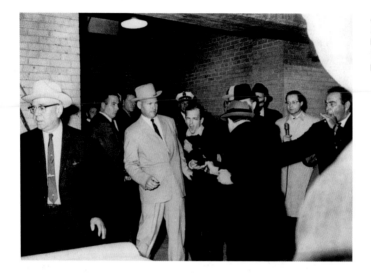

*Jack Ruby Killing
Lee Harvey Oswald*,
Robert H. Jackson,
1963, gelatin silver
print

With the incorporation of a mirror and prism, the single-lens reflex camera allowed photographers to see the exact image they were shooting.

The first SLR was developed by Thomas Sutton (1819–75) in 1861, the same year that he aided James Clerk Maxwell in taking the first colour photograph (see page 199). Variations were also being developed in Europe, Japan and the United States, where the Graflex reflex was launched in 1898. All these models were large and operated at waist level, with the photographer looking down at the ground glass, often wearing a hood to keep out light. The Leica I, launched in 1925, was a more portable version of the SLR, and the models that followed reflected a change in the way photography was practised, allowing increased mobility. This was particularly useful for photojournalists. The next 60 years brought improvements and additions to the format, from the introduction of interchangeable lenses and built-in light meters to auto focus and built-in flash, until the advent of the digital camera in the early 2000s obviated the need for film.

KEY DEVELOPMENTS

The SLR camera reached its optimum design in the 1960s and subsequent designs varied little. The launch of the Olympus OM-1 in 1971 took standardization further by creating a bayonet lens mount that would accept almost any SLR lens, thus opening the market for companies specializing solely in lens production.

STRAIGHT PHOTOGRAPHY **p.14** STREET PHOTOGRAPHY **p.17** PHOTOJOURNALISM **p.27** PAPARAZZI **p.38**
PARADE, HOBOKEN, NEW JERSEY **p.98** ALGIERS, LOUISIANA **p.114** THE FALLING MAN **p.144**

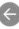

Long Exposure

KEY PHOTOGRAPHERS: NICÉPHORE NIÉPCE • ROBERT CAPA • MICHAEL WESELY
JONATHON KEATS • ALEXEY TITARENKO

KEY DEVELOPMENTS
In post-Soviet Russia, Alexey Titarenko (b.1962) produces images of metropolitan life that draw on past and present through their use of long exposures. People appear as ghostly apparitions, while landmarks and streets are clear, their form unchanging, in contrast to the lives of those who rush past them.

Crowd trying to enter subway station, St Petersburg, Russia, from 'City of Shadows' series, Alexey Titarenko, 1992

Although necessary at first, extended exposure times became a way of accentuating movement or transforming the familiar.

The limitations of technology in the early days of photography meant that long exposures were required. Nicéphore Niépce's *View from the Window at Le Gras* (see page 46) took days to produce. With improvements in the speed of film, the quality of lenses and the sophistication of shutters, a more accurate representation of the world could be achieved. However, a longer exposure allowed an alternative way to capture movement. With people, it could be a blurring of form. Traffic at night would be transformed into bands of light on a road. And incoming waves would take on a silky form, their crashing on to rocks visibly calmer in tone. A longer exposure could be employed to reinforce a mood or perspective. Robert Capa's images taken during the D-Day landings (see page 92) were shot alongside soldiers as they emerged from the water, on to the beach and into a barrage of German gunfire. The blurring of the images captures not only the sense of rapid movement but also the chaos of battle.

WAR **p.24** PHOTOJOURNALISM **p.27** SCIENCE **p.30** VIEW FROM THE WINDOW AT LE GRAS **p.46**
AMERICAN SOLDIERS LANDING ON OMAHA BEACH, D-DAY, NORMANDY, FRANCE, JUNE 6, 1944 **p.92**

Flash Photography

KEY PHOTOGRAPHERS: WEEGEE • LOUIS BOUTAN • CLARENCE SINCLAIR BULL • CECIL BEATON • SLIM AARONS

This immediate burst of light allowed photographers to capture images in the darkest environments.

Flash photography was first developed in the mid nineteenth century. A combination of various chemicals to produce an incendiary powder that emitted a bright light was originally used, but the results were uneven and often dangerous. Edward Sonstadt began experimenting with magnesium in 1862, and by the 1880s lamps using the metal were widely available. At the same time, battery-operated lighting was also employed, albeit with limited success. It was with the introduction of the flash bulb, first used by the pioneering underwater photographer Louis Boutan (1859–1934), that an effective artificial light became available.

It is at its most brazen when it is the sole or primary form of lighting in a dark environment. American crime reporting from the 1930s to the 1950s features flash photography at its boldest (see page 86). Along with the paparazzi photography of the era, it sensationalized a subject that was already popular with newspaper readers.

KEY DEVELOPMENTS

Flash bulbs were first produced commercially in Germany in 1929. Intended for a single use, after which each bulb was discarded, they contained a small chemical explosion within a glass casing. The bulbs were later coated in plastic to maintain their integrity and so that they could be handled without the risk of burning.

Cop Killer, Weegee, 1941, silver print, 23.5 x 30.5 cm (9¼ x 12 in), International Center of Photography, New York, USA

PORTRAITURE **p.15** PHOTOJOURNALISM **p.27** GLAMOUR **p.32** FASHION **p.36** PAPARAZZI **p.38** COP KILLER **p.86** CELEBRITY **p.167** VERNACULAR **p.183**

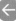

Polaroid

KEY PHOTOGRAPHERS: ANDY WARHOL • DAVID HOCKNEY • LUCAS SAMARAS
ELSA DORFMAN • CHRISTOPHER MARKOS • MARIPOL • STEFANIE SCHNEIDER

Before the arrival of digital photography, the instant camera was the only way to capture and see an image 'in the moment'.

Edwin Land developed his original ideas about light polarization while a student at Harvard in the 1920s, but it wasn't until 1947 that he unveiled the first instant camera. The first commercial Polaroid camera was sold in late 1948, and by 1956 a total of more than one million cameras were privately owned in 45 countries.

Although modified across various models – the 600 series is arguably the best – the function of the Polaroid has remained much the same. It is the perfect point-and-shoot camera, offering instant results. This was exploited by Andy Warhol during his various 'happenings', capturing celebrity at its most unvarnished. Other photographers followed suit, including Maripol (b.1955), with her famous series charting the early years of Madonna's career. Surprising exponents of the Polaroid included the more 'classically' inclined photographers Ansel Adams and Walker Evans, making the most of the medium's limitations by losing sharpness in favour of a more abstract aesthetic. David Hockney (b.1937) used instant photography to create photomontages (see page 212) – a multiplicity of images forming one large portrait.

Joni Mitchell, Ginny Winn, 1976, Polaroid

KEY DEVELOPMENTS
It was during a holiday with his family in 1943 when Edwin Land's 3-year-old daughter asked him why she couldn't see the picture he had just taken of her. After three years of experimentation and development, Land unveiled the prototype of his instant camera at a meeting of the Optical Society of America.

PORTRAITURE **p.15** COLOUR **p.18** SELF-PORTRAIT IN DRAG **p.120** CELEBRITY **p.167** VERNACULAR **p.183**

Photomontage

KEY PHOTOGRAPHERS: OSCAR GUSTAVE REJLANDER • HENRY PEACH ROBINSON
JOHN HEARTFIELD • ALEXANDER RODCHENKO • LOLA ÁLVAREZ BRAVO • DAVID HOCKNEY

Fading Away, Henry Peach Robinson, 1858, albumen silver print

The mass production of images in the Victorian era enabled people to cut and paste portraits and landscapes into imaginative new scenarios.

The earliest known example of the use of photographs to form a completely new image is by Oscar Gustave Rejlander: his *The Two Ways of Life* (1857) comprised 32 individual images. The process, then known as combination printing, was also used effectively by Henry Peach Robinson for his sombre portrait *Fading Away* (1858). Postcards employing this effect were hugely popular and endured into World War I. Shortly afterwards, the German Dadaists elevated photomontage to an art form and the Surrealists continued the trend, while the Russian Constructivists employed it as a political tool, creating propaganda out of the juxtaposition of individual images. More recently, the artist David Hockney

has branched out into photomontage to create a series of portraits and landscapes, including his celebrated *Grand Canyon with Ledge, Arizona* (1982). Digital technology has made photomontage easy, but, as with cropping and photo manipulation, there has been much discussion about the ethics of its use.

KEY DEVELOPMENTS

One of the most effective users of photomontage was the German John Heartfield (1891–1968). Originally produced in collaboration with George Grosz (1893–1959), his designs were highly sophisticated by the time the Nazis came to power. Heartfield created 240 *Photomontages of the Nazi Period* before escaping to Czechoslovakia in 1933, where he continued to ridicule Hitler and his party. By the time he left for England in 1939 he was the Nazis' fifth most wanted person.

AVANT-GARDE **p.23** PROPAGANDA **p.25** ART **p.31** ADVERTISING **p.37** VERNACULAR **p.183**
DOUBLE EXPOSURE **p.200**

Photo Manipulation

KEY PHOTOGRAPHERS: MATHEW BRADY • BERNARR MACFADDEN • JOHN HEARTFIELD
NARCISO CONTRERAS

The ability to transform images in the digital age has become so widespread that it is easy to forget that the manipulation of photographs has existed for almost as long as the medium itself.

A portrait of Abraham Lincoln from the early 1860s shows him standing regally in an office. However, it is a composite of the President's head from a seated portrait by Mathew Brady and the body of former Vice President John C. Calhoun. In another Brady Civil War portrait of a group of Union generals surrounding William Tecumseh Sherman, General Blair was added at a later date. In early photo manipulation, compositing separate photographs was common. As technology developed, changes were made with a greater degree of sophistication. Whatever the circumstances, photo manipulation raises serious issues. It can be an effective tool of propaganda and, in some instances, terror. It has also insinuated itself into most areas of the media, raising ethical questions over the way that lifestyle magazines regularly alter models' physical appearance.

Portrait (Retouched) of Jossif Wissarionowitsch Stalin, Unknown, c.1930

KEY DEVELOPMENTS
The Soviet leader Joseph Stalin (1878–1953) often manipulated images to erase figures in his government who had fallen out of favour. Leon Trotsky (1879–1940) was removed from countless photographs. Stalin's own image was also manipulated to make him look younger or more stately (see above).

Soft Focus

KEY PHOTOGRAPHERS: JULIA MARGARET CAMERON • GUSTAVE LE GRAY
PETER HENRY EMERSON • NICOLA PERSCHEID • CECIL BEATON • CLARENCE SINCLAIR BULL

The increasing sophistication of lenses gave photographers greater control over their images, enabling them to emphasize certain aspects by bringing them more clearly into focus, or by blurring backdrops for dramatic effect.

Soft focus is the intentional blurring of part or the whole of an image to achieve a specific aim. In the nineteenth century it might have been caused by a lens flaw involving spherical aberration, whereby more light enters the edge of a lens than the centre, preventing the image from being focused to a sharp point. Julia Margaret Cameron, who was criticized by many of her peers for her lack of technical prowess, was one of the first photographers to take full advantage of the possibilities of soft focus. Her portraits possess an ethereal quality as the image around her subject blurs into haziness. Peter Henry Emerson, a Pictorialist, believed that the contrast between sharp and soft image reflected the operation of the human eye, which prioritizes the central area of focus. In the twentieth century glamour and fashion photography found merit in the controlled use of soft focus, and soft-focus filters allow distortion with even the finest lenses.

KEY DEVELOPMENTS
Nicola Perscheid (1864–1930) practised and taught photography throughout central and northern Europe in the early part of the twentieth century. His speciality was portraiture, and it was while he was perfecting his art that he created what is now known as the Perscheid lens. Produced by Emile Busch AG in 1920, following Perscheid's strict instructions, it was a soft-focus lens with a wide depth of field that was particularly suited to large-format portraits.

László Moholy-Nagy,
Lucia Moholy,
c.1925–26, gelatin silver
print, 25.6 x 20 cm
(10¹⁄₁₆ x 7⁷⁄₈ in),
Metropolitan Museum
of Art, New York, USA

PICTORIALISM **p.13** PORTRAITURE **p.15** GLAMOUR **p.32** FASHION **p.36** BEATRICE **p.56** TEXTURE **p.177**

Digital Photography

KEY PHOTOGRAPHERS: ANDREAS GURSKY • EDWARD BURTYNSKY • SEBASTIÃO SALGADO
ANNIE LEIBOVITZ • GREGORY CREWDSON

Film became obsolete; photographers could take as many shots as their camera's memory card would allow. This was a seismic shift in photographic practice, and it came with serious implications in terms of veracity and ethics.

In 1957 the engineer Russell Kirsch scanned a photograph of his infant son to produce a 176 x 176 pixel digital image. It wasn't until 1975 that an Eastman Kodak engineer, Steve Sasson, invented the first digital camera. Key to its functioning was the essential element of all digital cameras, the charged-couple device, invented by George E. Smith and Willard Boyle at Bell Laboratories in 1969. By 1975 it had been developed to capture colour. In 1988 Fuji launched the DS-1P, the first fully digital consumer camera, and over the following three decades digital cameras increased in sophistication. Problems with the use of digital imagery first came to a head in 1982, when a photograph of the Pyramids of Giza by Gordon Gahan (1945–84) was published on the cover of *National Geographic*. It was digitally manipulated to fit a portrait format. This sparked a debate about the merits of digital photography that continues unabated.

KEY DEVELOPMENTS
The increasing sophistication of mobile technology has allowed photographers to use their smartphones to take photographs of high enough quality for print publication. When Michael Christopher Brown's SLR was damaged while he was covering the Libya conflict in 2011, he turned to his iPhone. Its small size allowed him closer access to his subjects and the action (see below).

Libya, March 2, 2011, Michael Christopher Brown, 2011

COLOUR **p.18** PHOTOJOURNALISM **p.27** FASHION **p.36** ADVERTISING **p.37** AMAZON **p.150**
SALT PANS #13 **p.152** PHOTO MANIPULATION **p.213**

Index

Museums

Works from the following museums and institutions
are featured in this book.

FRANCE
Musée National d'Art Moderne, Centre Pompidou,
Paris

GERMANY
Kunsthalle, Hamburg

UK
Jersey Museum and Art Gallery, St. Helier, Jersey
Royal Photographic Society, Bath

USA
International Center of Photography, New York
Library of Congress, Washington, D.C.
Metropolitan Museum of Art, New York, USA
Museum of Fine Arts, Houston, Texas
Museum of Modern Art, New York
National Archives, Washington, D.C.
Philadelphia Museum of Art, Philadelphia
The J. Paul Getty Museum, Los Angeles, California

er 224

Picture Credits

10 The J. Paul Getty Museum, Los Angeles. **12** The J. Paul Getty Museum, Los Angeles. **13** The J. Paul Getty Museum, Los Angeles. **14** National Archives, USA. **15** Library of Congress. **16** The J. Paul Getty Museum, Los Angeles. **17** The J. Paul Getty Museum, Los Angeles. **18** Getty Images/Royal Photographic Society. **19** The J. Paul Getty Museum, Los Angeles. **20** Copyright Joel Meyerowitz. Courtesy Howard Greenberg Gallery. **21** The J. Paul Getty Museum, Los Angeles. **22.** The J. Paul Getty Museum, Los Angeles. **23** © 2017. Digital image, The Museum of Modern Art, New York/Scala', Florence. **24** The J. Paul Getty Museum, Los Angeles. **25** Getty Images. **26** Getty Images. **27** © 2016 The Associated Press. Nick Ut/AP/REX/Shutterstock. **28** The J. Paul Getty Museum, Los Angeles. **29** Bert Hardy/Getty Images. **30** NASA. **31** © 2017. Christie's Images, London/Scala, Florence. **32** Getty Images. **33** © 2017. The Andy Warhol Foundation for the Visual Arts, Inc./Artists Rights Society (ARS), New York and DACS, London 2017. Photo Scala, Florence/bpk, Bildagentur fuer Kunst, Kultur und Geschichte, Berlin. **34** © Bruce Davidson/Magnum Photos. **35** Sonnabend Gallery, New York. © Estate Bernd and Hilla Becher. **36** Condé Nast/Getty Images. **37** Getty Images. **38** Ron Galella, Ltd/Getty Images. **39** © Gillian Wearing, courtesy Maureen Paley, London. **40** Getty Images/Gamma-Rapho. **41** Courtesy of the artist and Metro Pictures, New York. **42** © Maurizio Cattelan and Pierpaolo Ferrari, courtesy Damiani Editore. **43** © Alec Soth/Magnum Photos. **44** Getty Images/Gamma-Rapho. **46–47** Getty Images. **49** The J. Paul Getty Museum, Los Angeles. **51** The J. Paul Getty Museum, Los Angeles. **52–55** The J. Paul Getty Museum, Los Angeles. **57** The J. Paul Getty Museum, Los Angeles. **59** Getty Images. **61** The J. Paul Getty Museum, Los Angeles. **62–63** Getty Images/Royal Photographic Society. **65** The J. Paul Getty Museum, Los Angeles. **67** © Man Ray Trust/ADAGP, Paris and DACS, London 2017/Scala, Florence. **69** © Rodchenko & Stepanova Archive, DACS, RAO 2017/Getty Images. **70–71** © Estate of André Kertész – RMN-Grand Palais. Image © Centre Pompidou, MNAM-CCI, Dist. RMN-Grand Palais /Jacques Faujour. **73** Condé Nast/Getty Images. **75** © Center for Creative Photography, The University of Arizona Foundation/DACS 2017. Museum of Fine Arts, Houston, Texas, USA/Museum purchase funded by the Caroline Wiess Law Accessions Endowment Fund, The Manfred Heiting Collection/Bridgeman Images. **77** © Estate Brassaï – RMN-Grand Palais. Image © Centre Pompidou, MNAM-CCi, Dist. RMN-Grand Palais/Philippe Migeat. **79** Berenice Abbott/Getty Images. **81** Library of Congress. **83** The J. Paul Getty Museum, Los Angeles. **85** © 2017. Christie's Images, London/Scala, Florence. **86–89** Weegee (Arthur Fellig)/International Center of Photography/Getty Images. **90-91** National Archives. **92–93** Robert Capa © International Center of Photography/Magnum Photos. **94–95** Margaret Bourke-White/Time & Life Pictures/Getty Images. **96–97** Getty Images/Gamma-Rapho. **99** © Robert Frank, from The Americans. **100–101** Elliott Erwitt/Magnum Photos. **102–103** Slim Aarons/Getty Images. **105** © ADAGP, Paris and DACS, London 2017/Scala, Florence. **107** Eve Arnold/Magnum Photos. **108–109** Mondadori Collection/UIG/REX/Shutterstock. **110–113** NASA. **115** © Eggleston Artistic Trust. Courtesy Cheim & Read, New York. **116–117** © 2016 The Associated Press. Nick Ut/AP/REX/Shutterstock. **118–119** Ian Berry/Magnum Photos. **121** © 2017. The Andy Warhol Foundation for the Visual Arts, Inc./Artists Rights Society (ARS), New York and DACS, London 2017. Photo Scala, Florence/bpk, Bildagentur fuer Kunst, Kultur und Geschichte, Berlin. **122–123** Courtesy of the artist and Metro Pictures, New York. **124–125** Courtesy of the artist. **126–129** Martin Parr/Magnum Photos. **131** Courtesy of the artist and Nathalie Obadia Gallery. **132–133** © Thomas Struth. **135** © Wolfgang Tillmans, courtesy Maureen Paley, London. **137** © Gillian Wearing, courtesy Maureen Paley, London. **139** Courtesy of the artist and Marian Goodman Gallery. **140–141** © Hiroshi Sugimoto. **142–143** © Nobuyoshi Araki/Courtesy of Taka Ishii Gallery, Tokyo. **144–145** Richard Drew/AP/REX/Shutterstock. **146–147** Courtesy of the artist. **148–149** © Gregory Crewdson. Courtesy Gagosian. **150–151** © Andreas Gursky. Courtesy: Sprüth Magers Berlin London/DACS 2017. **152–153** © Edward Burtynsky, courtesy Metivier Gallery, Toronto/Flowers Gallery, London. **154** Dennis Stock/Magnum Photos. **156** The J. Paul Getty Museum, Los Angeles. **157** Getty Images. **158** John Kobal Foundation/Getty Images. **159** © Estate Brassaï – RMN-Grand Palais. Image © Centre Pompidou, MNAM-CCi, Dist. RMN-Grand Palais/Philippe Migeat. **160** Library of Congress. **161** The J. Paul Getty Museum, Los Angeles. **162** The J. Paul Getty Museum, Los Angeles. **163** The J. Paul Getty Museum, Los Angeles. **164** Elliott Erwitt/Magnum Photos. **165** Eddia Adams/AP/REX/Shutterstock. **166** © ADAGP, Paris and DACS, London 2017/Scala, Florence. **167** Dennis Stock/Magnum Photos. **168** Berenice Abbott/Getty Images. **169** Courtesy of the artist. **170** Ian Berry/Magnum Photos. **171** Jacob Riis/Getty Images. **172** Reg Lancaster/Getty Images. **173** Bill Brandt/Picture Post/Getty Images. **174** Henri Cartier-Bresson/Magnum Photos. **175** Library of Congress. **176** © Andreas Gursky. Courtesy: Sprüth Magers Berlin London/DACS 2017. **177** Ernst Haas/Getty Images. **178** Courtesy of the Jersey Heritage Collections. **179** The J. Paul Getty Museum, Los Angeles. **180** Getty Images. **181** Bettmann/Getty Images. **182** © Zed Nelson, courtesy of the artist. **183** Martin Parr/Magnum Photos. **184** Hy Peskin/Getty Images. **185** Justin de Villeneuve/Getty Images. **186** Chris Steele-Perkins/Magnum Photos. **187** © Richard Prince. Courtesy Gagosian. **188** The J. Paul Getty Museum, Los Angeles. **190** Getty Images. **192** SSPL/Getty Images. **193** The J. Paul Getty Museum, Los Angeles. **194** Library of Congress. **195** The J. Paul Getty Museum, Los Angeles. **196** The J. Paul Getty Museum, Los Angeles. **197** The J. Paul Getty Museum, Los Angeles. **198** The J. Paul Getty Museum, Los Angeles. **199** © Stephen Shore. Courtesy 303 Gallery, New York. **200** The J. Paul Getty Museum, Los Angeles. **201** Imagno/Getty Images. **202** The J. Paul Getty Museum, Los Angeles. **203** Library of Congress. **204** The J. Paul Getty Museum, Los Angeles. **205** © Lee Miller Archives, England 2017. All rights reserved. www.leemiller.co.uk **206** Gjon Mili/The LIFE Picture Collection/Getty Images. **207** Steve McCurry/Magnum Photos. **208** Mondadori Collection/UIG/REX/Shutterstock. **209** © Alexey Titarenko. Courtesy Nailya Alexander Gallery, New York. **210** Weegee (Arthur Fellig)/International Center of Photography/Getty Images. **211** Ginny Winn/Michael Ochs Archives/Getty Images. **212** SSPL/Getty Images. **213** Getty Images. **214** © 2017 The Metropolitan Museum of Art/Art Resource/Scala, Florence. **215** Michael Christopher Brown/Magnum Photos.